GRAFUS

JUST WHAT IS IT THAT MAKE

magazine design + more

TYPOGRAPHICS 5

PHIC
ION

ODAY'S MAGAZINES SO...?

GENERAL EDITOR: ROGER WALTON

JUST WHAT IS IT

CONT

334971 741·6/WAL

TYPOGRAPHICS 5

First published in 2003 by:
HBI, an imprint of HarperCollins Publishers
10 East 53rd Street
New York, NY 10022-5299
United States of America

Distributed to the trade and art markets
in the U.S. by:
North Light Books,
an imprint of F&W Publications, Inc.
4700 East Galbraith Road
Cincinnati, Ohio 45236
Tel: (800) 289-0963

Distributed throughout the rest
of the world by:
HarperCollins International
10 East 53rd Street
New York, NY 10022-5299
Fax: (212) 207-7654

ISBN: 0-06-008767-6

Conceived, created, and designed by:
Duncan Baird Publishers
6th Floor, Castle House
75–76 Wells Street, London W1T 3QH

Designers: Rebecca Johns and Paul Reid at Cobalt id
Editors: Marek Walisiewicz and Kati Dye at Cobalt id
Project Co-ordinator: Tamsin Wilson

10 9 8 7 6 5 4 3 2 1

Typeset in Meta Plus
Color reproduction by Scanhouse, Malaysia
Manufactured in China by Imago

NOTE
All measurements listed in this book
are for width followed by height.

FOREWORD 07

SECTION ONE
Features 09

SECTION TWO
Columns 73

SECTION THREE
Departments 139

INDEX 200

ENTS

JUST WHAT IS IT
FORE

WORD

In the natural history of communication, magazines are the consummate opportunists. They evolve constantly, multiplying to fill every conceivable niche, match every imaginable interest, and exploit every new market. To succeed and flourish, they need to take risks, and it's no surprise that some of the most imaginative, experimental, and edgy work in graphic design finds expression between the covers of magazines.

Typographics 5: Graphic Fusion presents a stunning cross section of design work from around the world, with a focus on magazine graphics drawn from mainstream publications, specialist journals, as well as self-initiated projects.

Magazines reflect and respond to broader movements in fashion and culture, but they are simultaneously agents of change, subverting the norm and establishing radical new approaches to style and content. Here today and (often) gone tomorrow, they thrive on the urgency of deadlines and the constant demand for novelty and innovation. The work captured and displayed on the pages of *Typographics 5: Graphic Fusion* forms a unique snapshot of the best in contemporary magazine design, making the book an essential addition to the collection of all today's graphics practitioners and all tomorrow's design historians.

ROGER WALTON

SECTION

Features

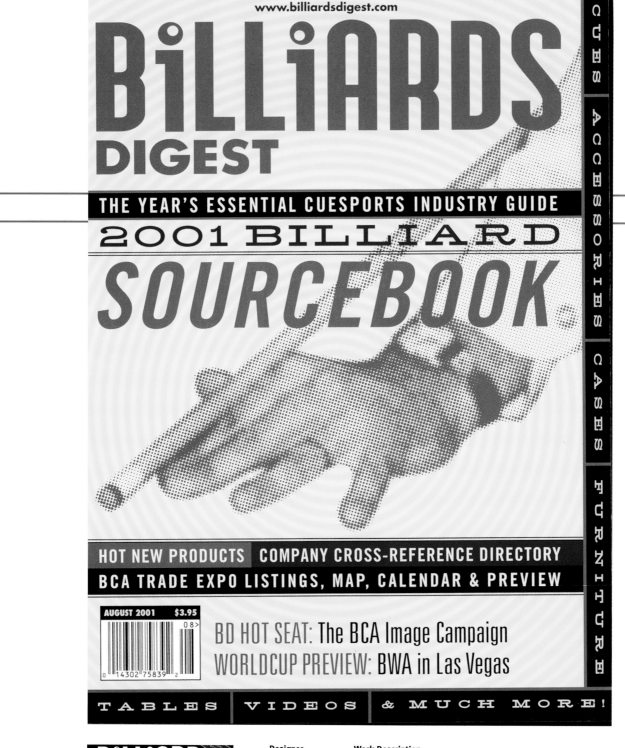

www.billiardsdigest.com

BiLLiARDS DIGEST

THE YEAR'S ESSENTIAL CUESPORTS INDUSTRY GUIDE

2001 BILLIARD SOURCEBOOK

CUES ACCESSORIES CASES FURNITURE

HOT NEW PRODUCTS COMPANY CROSS-REFERENCE DIRECTORY

BCA TRADE EXPO LISTINGS, MAP, CALENDAR & PREVIEW

AUGUST 2001 $3.95

0 14302 75839 2
08>

BD HOT SEAT: The BCA Image Campaign
WORLDCUP PREVIEW: BWA in Las Vegas

TABLES VIDEOS & MUCH MORE!

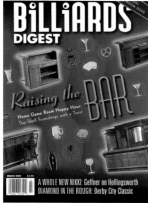

Designer
Jon Resh

Art Director
Jon Resh

Photographer
Mike Panozzo

Design Company
Viper press

Country of Origin
USA

Work Description
Front covers
(above and left)
from *Billiards
Digest* magazine

Dimensions
8$^{1}/_{4}$ x 10$^{7}/_{8}$ in
210 x 276 mm

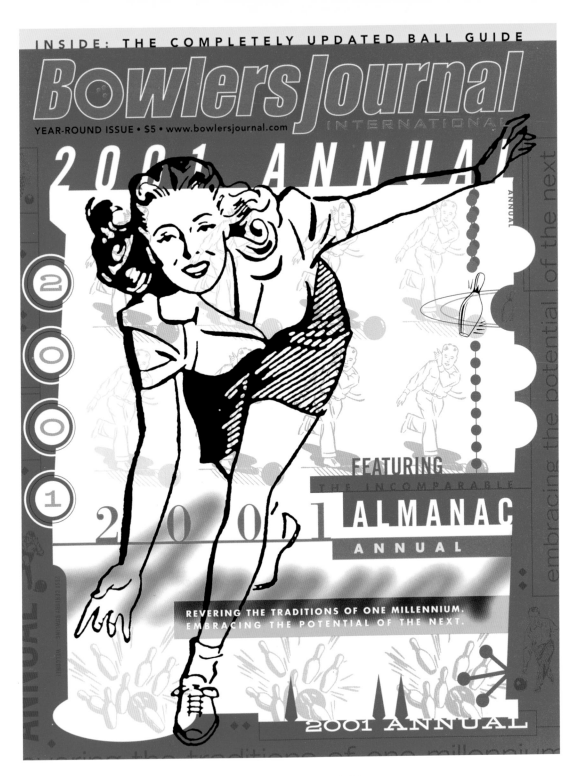

INSIDE: THE COMPLETELY UPDATED BALL GUIDE

BowlersJournal
INTERNATIONAL

YEAR-ROUND ISSUE • $5 • www.bowlersjournal.com

2001 ANNUAL

FEATURING THE INCOMPARABLE ALMANAC ANNUAL

2001

REVERING THE TRADITIONS OF ONE MILLENNIUM.
EMBRACING THE POTENTIAL OF THE NEXT.

2001 ANNUAL

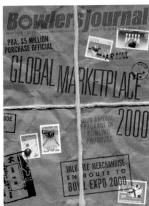

Designer
Jon Resh

Art Director
Jon Resh

Design company
Viper press

Country of Origin
USA

Work Description
Front covers from
Bowlers Journal
International 2001
Annual (above), and
Bowlers Journal
Global Marketplace
2000 (left)
magazines

Dimensions
8¹/₄ x 10⁷/₈ in
210 x 276 mm

Designer
Shahrokh Na'el

Art Director
Shahrokh Na'el

Design Company
Shahrokh 1345 Ltd.

Country of Origin
UK

Work Description
Web pages from
www.shahrokh1345.com,
a website featuring the
company's promotional
print-based material
transferred to the web

Dimensions
Scalable website

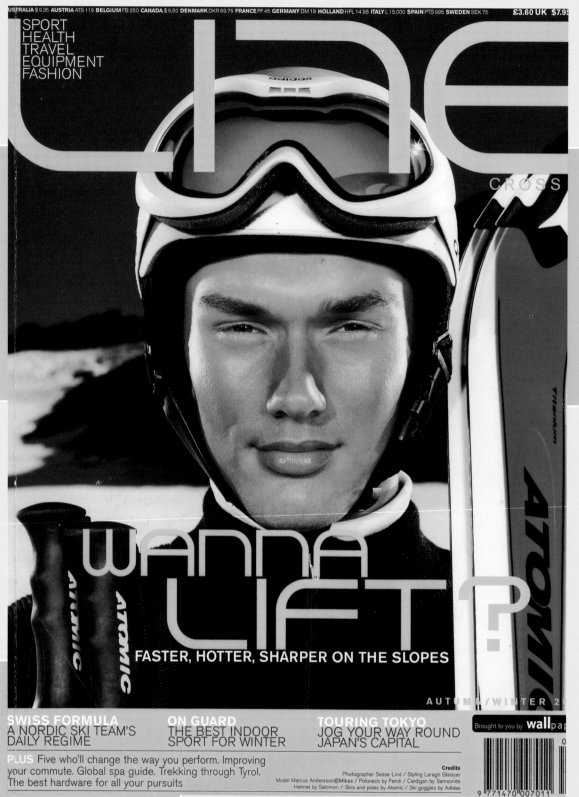

AUSTRALIA $ 9.35 AUSTRIA ATS 119 BELGIUM FB 250 CANADA $ 9.50 DENMARK DKR 69.75 FRANCE FF 45 GERMANY DM 18 HOLLAND HFL 14.95 ITALY L 15,000 SPAIN PTS 995 SWEDEN SEK 75 £3.60 UK $7.95

SPORT
HEALTH
TRAVEL
EQUIPMENT
FASHION

Line

CROSS

WANNA LIFT?
FASTER, HOTTER, SHARPER ON THE SLOPES

AUTUMN/WINTER 2

Brought to you by **wall**paper

SWISS FORMULA
A NORDIC SKI TEAM'S
DAILY REGIME

ON GUARD
THE BEST INDOOR
SPORT FOR WINTER

TOURING TOKYO
JOG YOUR WAY ROUND
JAPAN'S CAPITAL

PLUS Five who'll change the way you perform. Improving
your commute. Global spa guide. Trekking through Tyrol.
The best hardware for all your pursuits

Credits
Photographer Sesse Lind / Styling Laragh Glaisyer
Model Marcus Andersson@Mikas / Poloneck by Fendi / Cardigan by Samsonite
Helmet by Salomon / Skis and poles by Atomic / Ski goggles by Adidas

9 771470 007011

Designer
Sam Wilson

Photographers
Sesse Lind
Philip Karlberg

Illustrator
Bo Lundberg

Art Director
Richard Spencer Powell

Design Company
Wallpaper*

Country of Origin
UK

Work Description
Cover (left) and
spreads from *Line*
magazine

Dimensions
9 x 11³/₄ in
230 x 300 mm

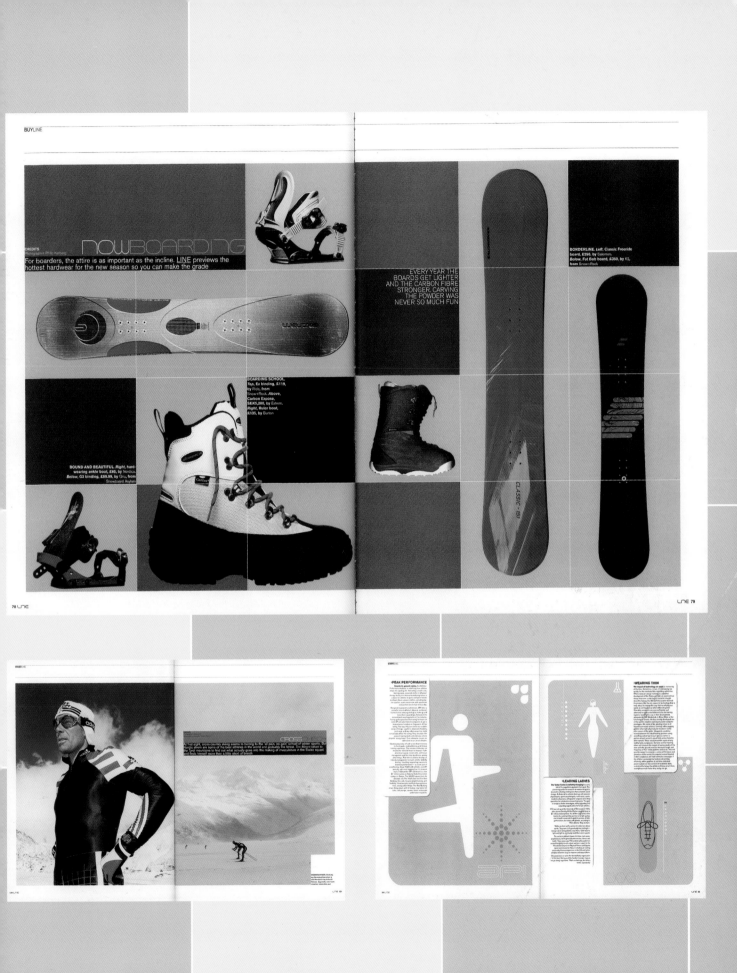

NOWBOARDING

CREDITS
Photographer Philip Karlberg

For boarders, the attire is as important as the incline. LINE previews the hottest hardwear for the new season so you can make the grade

EVERY YEAR THE BOARDS GET LIGHTER AND THE CARBON FIBRE STRONGER. CARVING THE POWDER WAS NEVER SO MUCH FUN

BORDERLINE. *Left*, Classic Freeride board, £250, by Salomon. *Below*, Fat Bob board, £350, by K2, from Snow+Rock

BOARDING SCHOOL. *Top*, Ex binding, £119, by Rido, from Snow+Rock. *Above*, Carbon Expose, SEK5,200, by Extrem. *Right*, Ruler boot, £135, by Burton

BOUND AND BEAUTIFUL. *Right*, hard-wearing ankle boot, £65, by Nordica. *Below*, G3 binding, £89.99, by Gnu, from Snowboard Asylum

CROSS

At first sight, cross country skiing seems to be the 'all pain, no gain' school of winter sports. But Nordic skiers are some of the best athletes in the world and probably the fittest. Tim Moore takes to the Tyrol mountains to find out what actually goes into the making of masculinity in the Swiss squad, and finds himself more than a little short of breath

PEAK PERFORMANCE

WEARING THIN

LEADING LADIES

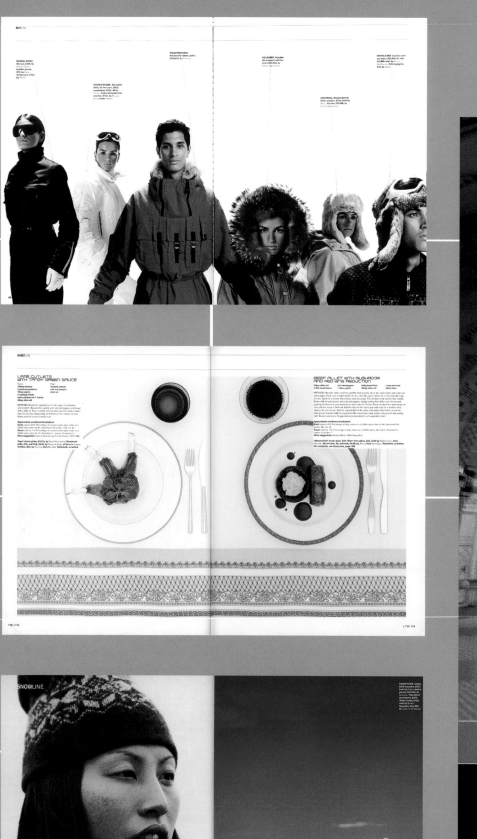

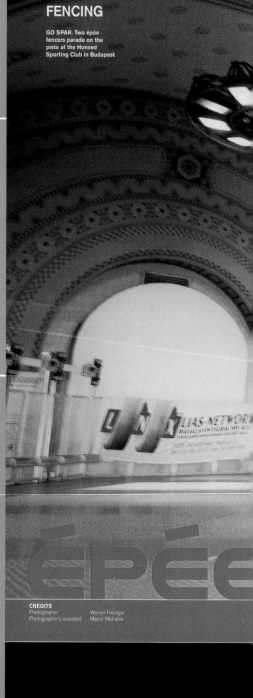

FENCING

GO SPAR. Two épée
fencers parade on the
piste at the Honved
Sporting Club in Budapest

ÉPÉE

CREDITS
Photographer Werner Hinniger
Photographer's assistant Marco Michalke

138 LINE

SNOWLINE

COLD CUTS

FOR THE 2000/01 SKI SEASON, THE BIG LABELS HAVE TONED DOWN ON THE TECHNICAL AND
HAVE RETURNED THE SILHOUETTE TO SOMETHING A BIT MORE SWINGING SUN VALLEY

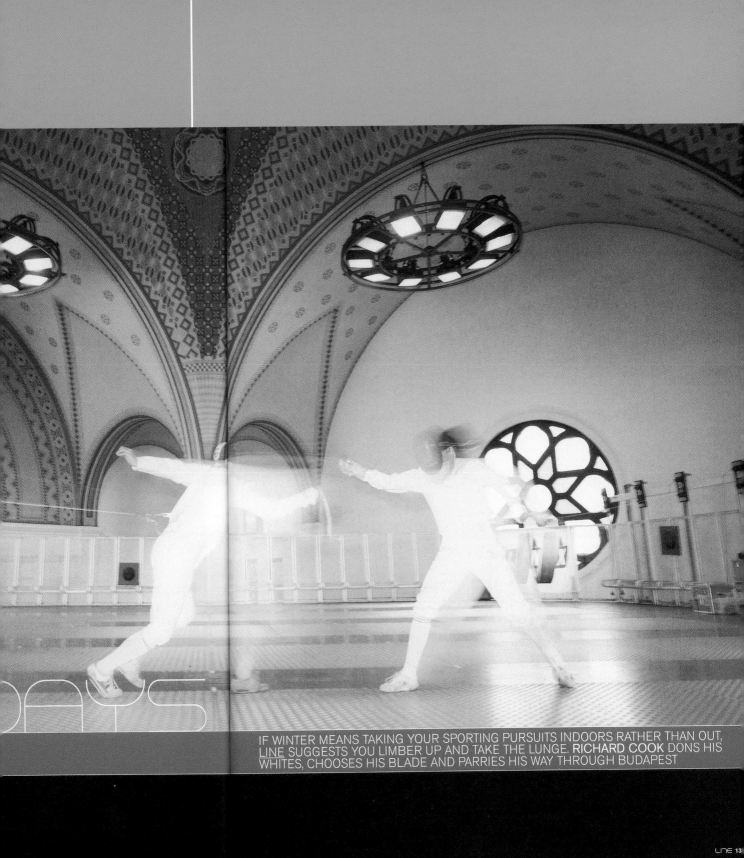

IF WINTER MEANS TAKING YOUR SPORTING PURSUITS INDOORS RATHER THAN OUT, LINE SUGGESTS YOU LIMBER UP AND TAKE THE LUNGE. **RICHARD COOK** DONS HIS WHITES, CHOOSES HIS BLADE AND PARRIES HIS WAY THROUGH BUDAPEST

£3.75

N°185 | JULY 2001 | ARCHITECTURE, DESIGN & CONTEMPORARY CULTURE

9 770268 492008

07

Anderson country

Welcome to Peter Anderson's world of words...

Type meets architecture | Hotels on the moon | The Eritrean city | Advertising as art | BOA profile

Designer
Peter Anderson

Illustrator
Peter Anderson

Photographer
Peter Anderson

Art Director
Peter Anderson

Design Company
Interfield

Country of Origin
UK

Work Description
Front cover design
incorporating
photo/typographic
self portrait and
magazine portrait for
Blueprint magazine

Dimensions
38⅝ x 12⅞
990 x 330 mm

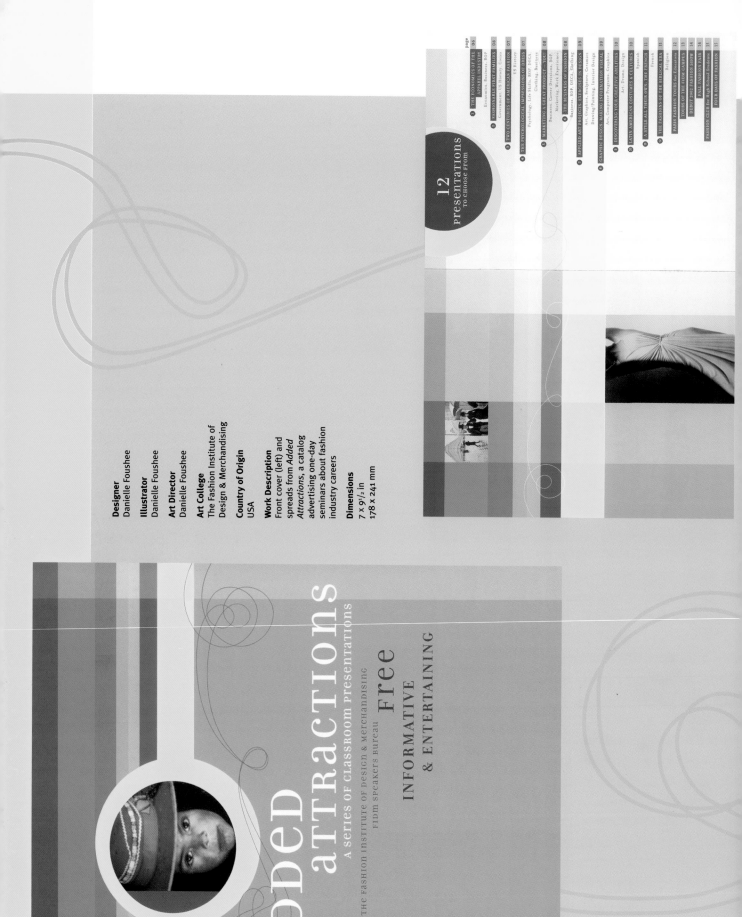

Designer
Danielle Foushee

Illustrator
Danielle Foushee

Art Director
Danielle Foushee

Art College
The Fashion Institute of
Design & Merchandising

Country of Origin
USA

Work Description
Front cover (left) and
spreads from *Added
Attractions*, a catalog
advertising one-day
seminars about fashion
industry careers

Dimensions
7 x 9½ in
178 x 241 mm

added
attractions
A SERIES OF CLASSROOM PRESENTATIONS

THE FASHION INSTITUTE OF DESIGN & MERCHANDISING
FIDM SPEAKERS BUREAU

Free

INFORMATIVE
& ENTERTAINING

12
presentations
TO CHOOSE FROM

page
06 THE ECONOMICS OF THE APPAREL INDUSTRY
 Economics, Business, ROP
06 FASHIONABLE FIRST FAMILIES
 Government, US History, Civics
07 TWO CENTURIES OF AMERICAN FASHION
 US History
07 THE PSYCHOLOGICAL IMPRESSIONS OF DRESS
 Psychology, Life Skills, ROP, DECA, Clothing, Business
08 MARKETING A GREAT PRODUCT — YOU!
 Business, Career Decisions, ROP, Marketing, Work Experience
08 THE BUSINESS OF FASHION
 Business, ROP, DECA, Clothing
09 APPLIED ART PROJECTS, EXERCISES IN DESIGN
 Art, Graphics, Sculpture, Ceramics, Drawing/Painting, Interior Design
09 GRAPHIC DESIGN: MAKING INFORMATION VISUAL
 Art, Computer Programs, Graphics
10 DISCOVERING YOUR CREATIVE ABILITIES
 Art, Drama, Design
10 LATIN AMERICAN COSTUMES & CULTURES
 Spanish
11 A STYLE ALL THEIR OWN: THE FRENCH
 French
11 THE FASHIONS OF THE BIBLICAL ERA
 Religion
12 PARIS FASHION TOURS for Educators
13 TOURS OF THE FIDM CAMPUS
14 DEBUT 2002 FASHION SHOW
14 FALL FASHION FAIR
15 FASHION CLUB for High School Students
15 FOUR DAYS OF FASHION

THE ECONOMICS OF THE APPAREL INDUSTRY

The theories of economics come to life as students follow a pair of 501 jeans from the manufacturing plant to the retailer. From the denim trimmings, and findings to the manufacturing, distribution, and sales each cost is analyzed. Where the students are asked to guess the profit on a pair of 501's, they usually answer in the $20 to $40 range. Imagine their surprise when they realize that they're not even in the ballpark! This presentation is an enlightening step into the worlds of business and economics.

SUGGESTED CLASSES:
Economics, Business, ROP

TWO CENTURIES OF AMERICAN FASHION

History and fashion have a unique connection. Fashion is a reflection of our social, political, and economic times. Students will enjoy this visual presentation featuring the evolution of many changes in our country over the last century, and see the beginning of a new century. For example, the beginning of the 1900's was a reflection of the Victorian Era, followed by Hollywood's influence in the 30's, WWII's patriotic style, and the 70's hippie movement. The entertainment industry's influence at the end of the 20th century looks toward a new historical and fashionable future.

SUGGESTED CLASSES:
US History

FASHIONABLE FIRST FAMILIES

America's First Families are observed in this unique look at the influences and contributions the White House has made to fashion. Whether discussing the multi-million dollar industry Jackie Kennedy launched with her pillbox hat or the false teeth worn by George Washington, who in his time was considered the epitome of fashion, not all of the presidents' influences were political. Through one of a kind presentation, students will be viewing an American institution via a very different social avenue.

SUGGESTED CLASSES:
US History, Civics, Government

THE PSYCHOLOGICAL IMPRESSIONS OF DRESS

Come with us and explore the appearance factors that influence the important, difficult-to-change first impression. Learn how appearance perception, the halo effect, cognitive inconsistency, and unintentional signification are part of the internal processing that occurs in our first encounters with one another. Although most young people today are very "fashion conscious," they may not be aware of the underlying psychology of color and style. Through "Impression Management," students will learn how to create a very special professional or social image.

SUGGESTED CLASSES:
Psychology, Business, Life Skills
Clothing, ROP, DECA

06

07

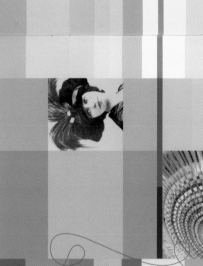

Dear Educator,

THE FASHION INSTITUTE OF DESIGN & MERCHANDISING'S Office of Community and Educational Affairs is pleased to offer you and your students added attractions. A Series of Classroom Presentations for the new academic year. We have twelve stimulating and visually exciting presentations that have been developed to enhance and compliment a variety of subjects. Each topic has been thoroughly researched and is presented in a professional, informative, and entertaining manner. You will find a listing of course titles on page 5 for your review. These presentations are available to your class at no fee, and we are able to schedule as many periods as you request. To schedule a presentation, please call our Speakers Bureau at 1.800.262.3436 or 818.990.2241, or visit our website at www.fidm.edu.

FIDM is a 2-year private, specialized, co-educational college which is accredited by WASC with its Interior Design program accredited by FIDER. FIDM has four campuses with over 4,000 full-time students and offers Associate of Arts, A.A. Professional Designation, and A.A. Advanced Study Degree Programs that lead to careers in the Retail, Fashion, Entertainment, Textile Design, Interior Design, and Graphic Design industries. FIDM's goal is to create an educational environment where students can learn and grow that fuses student desires with career realities.

FOR INFORMATION OR TO
SCHEDULE A PRESENTATION,
PLEASE CALL
800.262.3436 OR 818.990.2241
OR LOG ONTO WWW.FIDM.EDU

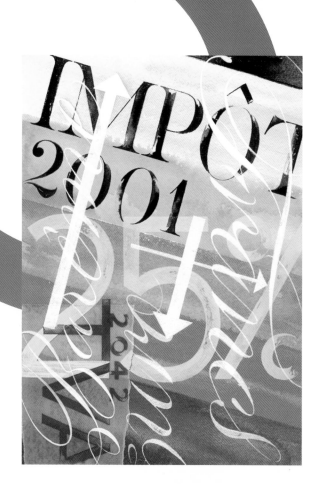

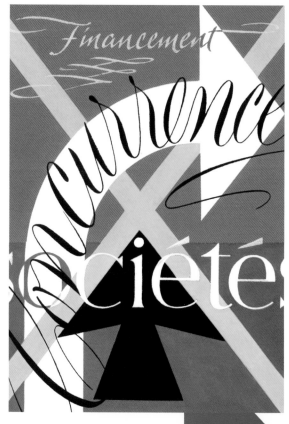

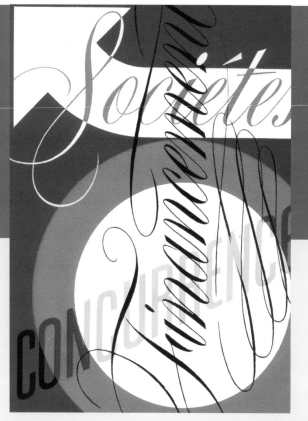

Designer
Peter Horridge

Art Director
Peter Horridge

Design Company
Peter Horridge Designs

Country of Origin
France

Work Description
Front covers from *Droit & Patrimoine* magazine

Dimensions
9³/₄ x 7 in
176 x 245 mm

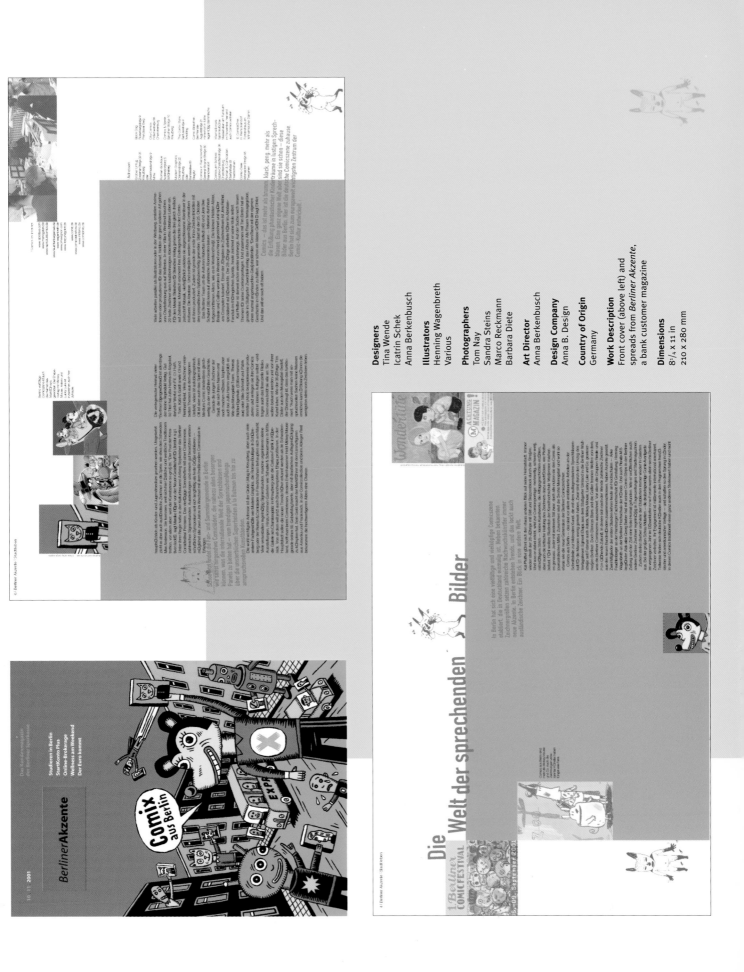

Designers
Tina Wende
Icatrin Schek
Anna Berkenbusch

Illustrators
Henning Wagenbreth
Various

Photographers
Tom Nay
Sandra Steins
Marco Reckmann
Barbara Diete

Art Director
Anna Berkenbusch

Design Company
Anna B. Design

Country of Origin
Germany

Work Description
Front cover (above left) and
spreads from *Berliner Akzente*,
a bank customer magazine

Dimensions
8¹/₄ x 11 in
210 x 280 mm

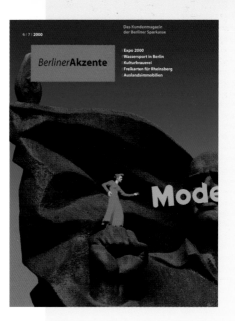

6 | 7 | 2000

Das Kundenmagazin
der Berliner Sparkasse

BerlinerAkzente

- Expo 2000
- Wassersport in Berlin
- Kulturbrauerei
- Freikarten für Rheinsberg
- Auslandsimmobilien

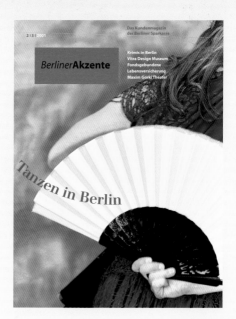

2 | 3 | 2001

Das Kundenmagazin
der Berliner Sparkasse

BerlinerAkzente

- Krimis in Berlin
- Vitra Design Museum
- Fondsgebundene
 Lebensversicherung
- Maxim Gorki Theater

Tanzen in Berlin

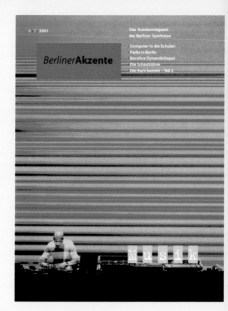

6 | 7 | 2001

Das Kundenmagazin
der Berliner Sparkasse

BerlinerAkzente

- Computer in die Schulen
- Parks in Berlin
- Berolina DynamikDepot
- Die Schaubühne
- Der Euro kommt – Teil 2

Musik

MODE IN BERLIN

Fotos: Uwe Hauth, Sandra Stein

Als „Respectmen" in die Mitte zog, war Berlins neues Herz noch Baustelle:
die Bürgersteige aufgerissen, Schutt vor den Haustüren und eine Wolke
Staub für jeden, der die freche Kollektion des Labels im Schaufenster begut-
achten wollte. Frech, weil Karin Warburg, Alfred Warburg und Dirk Seidel
die Herrenhosen schmal und die dazugehörigen Sakkos auf Figur schnitten
und beim Stoff gern zu apfelgrünem Cord oder falscherSchlange griffen.
„Als ein Freund seinen ersten Anzug von Respectmen trug, begriff ich,
wie erotisch ein Herrenanzug sein kann", entfuhr es der Modejournalistin
Cornelia Kubitz. So viel Lob von allen Seiten hatte Folgen: Der schmal
geschnittene Anzug aus Samt, Satin oder Frottee beförderte Karin Warburg,
Absolventin der Berliner Modeschule, und Modellmacher Seidel zur Avant-
garde und brachte ihnen 1996 den ersten Preis der AVE, Berlins unkonven-
tioneller Modemesse.

Designers
Tina Wende
Icatrin Schek
Anna Berkenbusch

Illustrators
Henning Wagenbreth
Various

Photographers
Tom Nay
Sandra Steins
Marco Reckmann
Barbara Diete

Art Director
Anna Berkenbusch

Design Company
Anna B. Design

Country of Origin
Germany

Work description
Covers (left) and
spreads from
Berliner Akzente,
a bank customer
magazine

Dimensions
8¼ x 11 in
210 x 280 mm

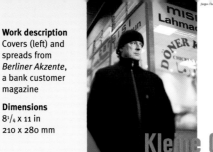

Kleine Gauner Große Krimis

Emmi hat Angst und allen Grund dazu. Jeden Abend fährt sie die Strecke nach Erkner mit der S-Bahn, um von dort durch die unbeleuchteten Kleingärten in ihre eigene Laube zu gelangen. Das Haus in der Skalitzer Straße, in dem Emmi und Albert bis August 1940 gewohnt haben, ist längst im Bombenhagel zerstört, ihr Mann jede Nacht als Triebwagenführer unterwegs. Emmi spürt, dass ihr jemand durch die Dunkelheit folgt – vielleicht der *S-Bahn-Mörder*, der seit Monaten sein Unwesen treibt? | Dass Emmi die Begegnung überlebt, verdankt sie Horst Bosetzky. In seinen wohl berühmtesten Krimi *Wie ein Tier* hat sie der Berliner Autor als fiktive Figur eingewoben – in eine ansonsten wahre Geschichte. Ab 1939 zog der biedere und eher unauffällige Paul Ogorzow zwei Jahre lang eine blutige Spur durch Berlin. Acht Frauen fielen ihm zum Opfer. Bosetzky, der lange anonym als -ky schrieb und nicht nur im Krimigenre, sondern auch als Professor für Soziologie tätig ist, treibt allerdings nicht die Lust an Mord und Totschlag. Ihm geht es um ein sensibles Psychogramm der realen Geschichte und um die Frage, warum Ogorzow so lange nicht zu fassen war, obwohl die Nazis auch das halb zerstörte Berlin noch fest im Griff hatten. | Die Stadt ist ein heißes Pflaster für Verbrechen, egal ob auf dem Papier oder in Wirklichkeit. Nicht nur im Fernsehen spielen immer mehr Krimis vor der einmaligen Berliner Kulisse. Schon Alfred Döblin entließ seine Romanfigur Franz Biberkopf aus dem Gefängnis Berlin-Tegel in die vermeintliche Freiheit jener gleißenden Métropole, die den einfachen Mann ständig straucheln lässt. Mit dem Titel seines Romans aus den 20er Jahren hat Döblin der Stadt ein literarisches Denkmal

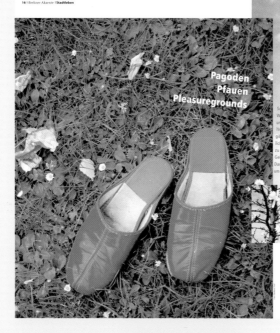

Pagoden Pfauen Pleasuregrounds

Sollen sie nun wieder den grünen Rauchtee nehmen oder mal die Ingwervariante ausprobieren? Eine schwere Wahl für die beiden Damen aus Tegel. Sie sind schon zum vierten Mal zur Teezeremonie nach Marzahn gekommen und waren bisher von allen Sorten begeistert. Zu den Teeblättern serviert die chinesische Bedienung stilvolle Thermoskannen mit heißem Wasser, mit dem man sich den Aufguss nach Belieben zubereiten kann, außerdem gibt es zartes Kokosgebäck. Aber nicht nur deshalb nehmen die Frauen den knapp zweistündigen Weg mit öffentlichen Verkehrsmitteln auf sich. Sie kommen vor allem, um im Garten des wiedergewonnenen Mondes spazieren zu gehen. Auf dem zweieinhalb Hektar großen Gelände im Erholungspark Marzahn, das im Stil eines chinesischen Gelehrtengartens angelegt ist, wachsen Kiefern, Zierahorne und viele andere Pflanzen aus dem Reich der Mitte. Daneben plätschern Wasserfälle, stehen ein Felsengarten und pagodenartige Pavillons. Die spiegeln sich wieder um in einem 5.000 Quadratmeter großen See, auf dem ganz beschaulich ein Holzboot schwimmt.

*Der chinesische Garten
im Marzahn ist der
jüngste Park Berlins.
Er wurde vor rund
9 Monaten der Öffent-
lichkeit übergeben*

Wie ein Tier - der S-Bahn-Mörder, dtv-Verlag 1997, 16,90 DM
Alte (toime) Mörder, Rowohlt Taschenbuch Verlag 2001, 208 Seiten, ab Februar im Handel

Jürgen Ebertowski:
Unter den Linden Messeuier Büro, Olibolo-Verlag 1999, 416 Seiten, 16,90 DM
Kehm-Connection, Olibolo-Verlag 2001 Seiten, 14,90 DM

Thea Dorn:
Berliner Aufklärung, Rotbuch-Verlag 1994, 198 Seiten, 25 DM
Die Hirnkönigin, Rotbuch-Verlag 2000, 299 Seiten, 36 DM

Pieke Biermann:
Vier, fünf, sechs, Goldmann-Verlag 1997, 282 Seiten, 12,90 DM
Herzrasen, Goldmann-Verlag 2000, 378 Seiten, 14,90 DM

Anne Chaplet:
Nichts als die Wahrheit, Antje Kunstmann-Verlag, 320 Seiten, 34,80 DM

Philip Kerr:
Feuer in Berlin, Rowohlt-Verlag 2000, 334 Seiten, 16,90 DM
Im Sog der dunklen Mächte, Rowohlt-Verlag 2000, 384 Seiten, 16,90 DM
Alte Freunde, neue Feinde, Rowohlt 2000, 378 Seiten, 16,90 DM

Frank Goyke:
Schlußer, Jahres, über Goldmann-Verlag 2000, 255 Seiten, 14,90 DM

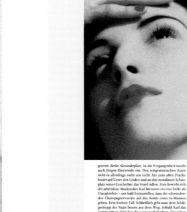

gesetzt. Berlin Alexanderplatz. In die Vergangenheit taucht auch Jürgen Ebertowski ein. Den zeitgenössischen Autor zieht es allerdings mehr ans Licht, hin zum alten Prachtboulevard Unter den Linden und an den mondänen Schauplatz seiner Geschichte: das Hotel Adlon. Hier bewirbt sich der arbeitslose Akademiker Karl Mesmer um eine Stelle als Hausdetektiv – und bald fratzenstellen, dass die schwindelnden Champagnerpreise auf das Konto eines so-Mannes gehen. Kein leichter Fall. Schließlich gerät man dem Schürgetrupp der Nazie besser aus dem Weg. Sobald Karl das Hotel verlässt, folgt ihm der Leser nach Pankow. Das Leben der kleinen Leute hier beschreibt Ebertowski ebenso anschaulich wie die Vorgänge im Adlon, die die großen politischen Ereignisse wie ein Mikrokosmos spiegeln. Auch das wieder erbaute Grandhotel kommt in seinen Büchern vor. *Kehm-Connection* widmet sich ganz der verbrecherischen Gegenwart und wechselt nemlos zwischen Kreuzberg, Hotel Adlon und dem Warberg für einen Veranstalter im Luxushotel das Schlimmste verhindern soll. In einem Reisebus wurde Heroin gefunden. | Das Krimigenre, denken viele, hat mit simplem Plots und dürftigen Stereotypen. Die flüchtige Lektüre mit heißer Nadel gestrickt und artem auf Schock- oder Gruseleffekte, wenn wieder ein Mensch um die Ecke gebracht wird. Wer sich jedoch anstecken lässt von der Mixtur aus historischer Realität und wohl kalkulierten Erfindungen, wie etwa Bosetzky und Ebertowski sie liefern, der wird bald festzustellen, dass zum Thrill auch her...

vorragende Sitten- und Zeitgemälde gehören werden. „Als es mit dem neuen deutschen Kriminalroman Mitte der 80er Jahre so richtig begann", klagt Horst Bosetzky, „war der Mordkommissariat dennoch die diskussionswürdig. Bei Berliner Kriminschreiber noch sehr schlimmer." 1986 gründete er deshalb das Syndikat, von dem Genre von zweifelhaftem Ruf ein Forum zu geben. 250 Autoren zählt der Verein heute als Mitglieder, darunter prominente Schriftsteller wie Ingrid Noll. Den mit 10.000 Mark dotierten Kreimipreis des Syndikats, den „Glauser", bekannen schon hervorragende Autoren, zum Beispiel Bernhard Schlink. „Normand schreibt einen Krimi, um reich zu werden", sagt Thea Dorn. Dabei gilt die 30-jährige Berlinerin durch ihren Krimis nicht nur als Autorin, die über alles Brutalitäten schildert. Für *Berliner Aufklärung* und *Die Hirnkönigin* heimste sie nacheinander erst den Raymond-Chandler-Preis und den Deutschen Krimispreis 2000 ein. Dass beide Bücher in Berlin spielen, versteht sich eigentlich von selbst, auch aber, dass Thea Dorn auf weibliche Mörder und Spürnasen setzt. So jagt Journalistin Kyra Berg einer gandenlosen Unbekannten nach, die Kytas eigenen Chefredakteur im wahrsten Wortsinn kopflos gemacht hat. „Jetzt dominieren Powerfrauen, die eher Männer um die Ecke bringen, die Szene", stellt Bosetzky fest. Ein Grund sei sicher, dass „richtige Frauen

Christian Koch, Inhaber der Harmon-Kriminalbuchhandlung in Kreuzberg. Der Buchhändler muss es wissen: Schließlich verkauft er in seinem Laden ausschließlich Geschichten von Gangstern, Detektiven und Verbrechen. Dass der Krimiboom ausnicht zu enden ist, bekräftigt auch er: „Die Nachfrage steigt und empfiehlt eine erstklassige Krimi-Trilogie von Philip Kerr. Original schrieb er ja schon ende der 80er Jahre über seinen Privatdetektiv Bernhard Gunther in der Hauptstadt. 1936 soll er geschttene Juwelen finden, zwei Jahre später einen wahnsinnigen Mörder. Nach dem Krieg hilfen dann die Schwarzmarktgeschäfte, während Gunther den Fall eines ermordeten Nazigegen erforscht. Ein großes Lob sings der engagierte Krimi-Händler auch auf Frank Goyke. Seine spannende Erzählung über die Machenschaften, einiger vergeblicher Sacbenmänner, die Olympia ins Leben rufen wollen, hat der Goldmann-Verlag gerade noch einmal aufgelegt. Doch es gibt auch schon gute Nachrichten für Krimifans: Gerade jetzt bringt er ein neues Werk heraus. *Alle meine Mörder* heißt das Buch, in dem Horst Bosetzky auch bester Manier Fakten und Fiktion vermischt. Zuletzt ist der renommierte Autoren feiner Dische genannt, der auf diesem jüngsten Buch *Femome Lügen extra, Krimnalroman"* hat vermerken lassen und damit das strenge Reglement des Buchmarkts unterläuft.

Kleine Gauner Große Krimis

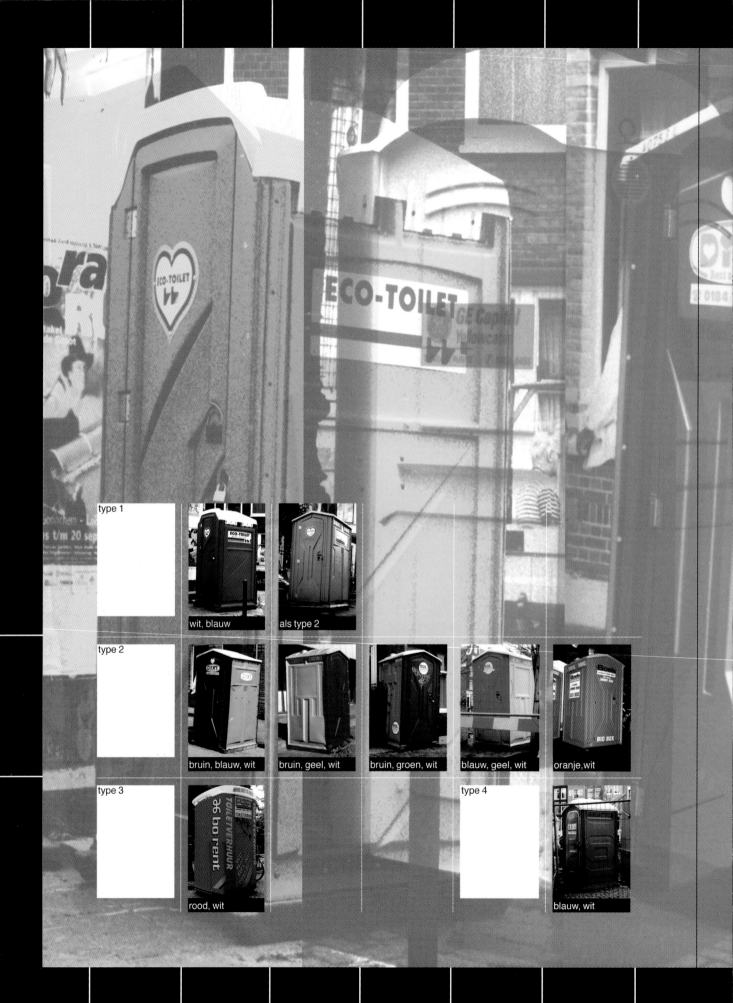

type 1

wit, blauw

als type 2

type 2

bruin, blauw, wit

bruin, geel, wit

bruin, groen, wit

blauw, geel, wit

oranje,wit

type 3

rood, wit

type 4

blauw, wit

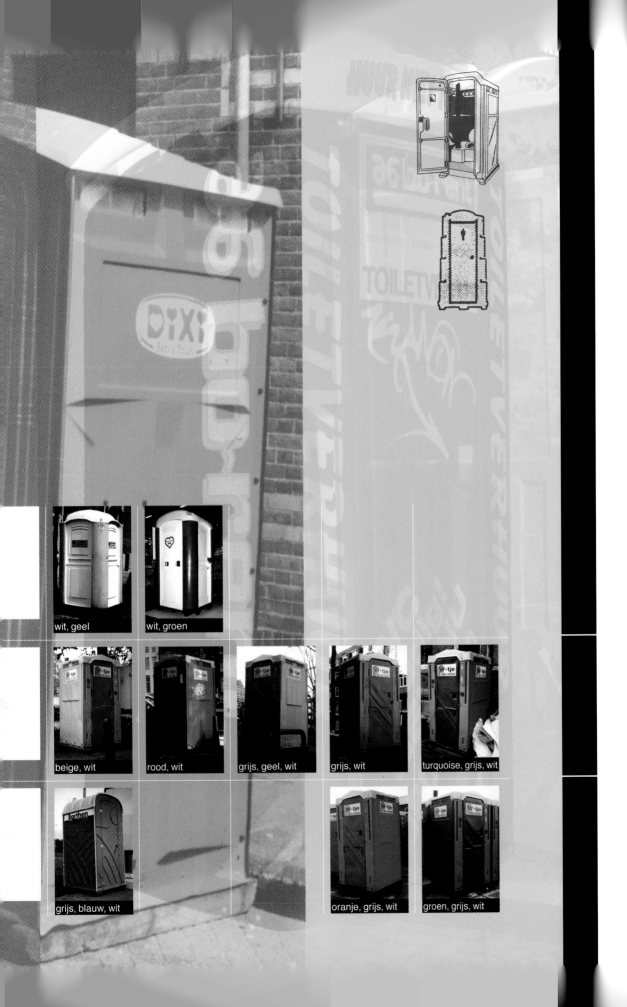

wit, geel

wit, groen

beige, wit

rood, wit

grijs, geel, wit

grijs, wit

turquoise, grijs, wit

grijs, blauw, wit

oranje, grijs, wit

groen, grijs, wit

wit, geel

Designer
Martijn Oostra

Photographer
Martijn Oostra

Country of Origin
The Netherlands

Work Description
Spread from *Omdat bouwvakkers ook wel eens moeten (Construction workers have to go sometimes too)*, a photographic essay

Dimensions
$9^{3}/_{8}$ x $12^{7}/_{8}$
240 x 330 mm

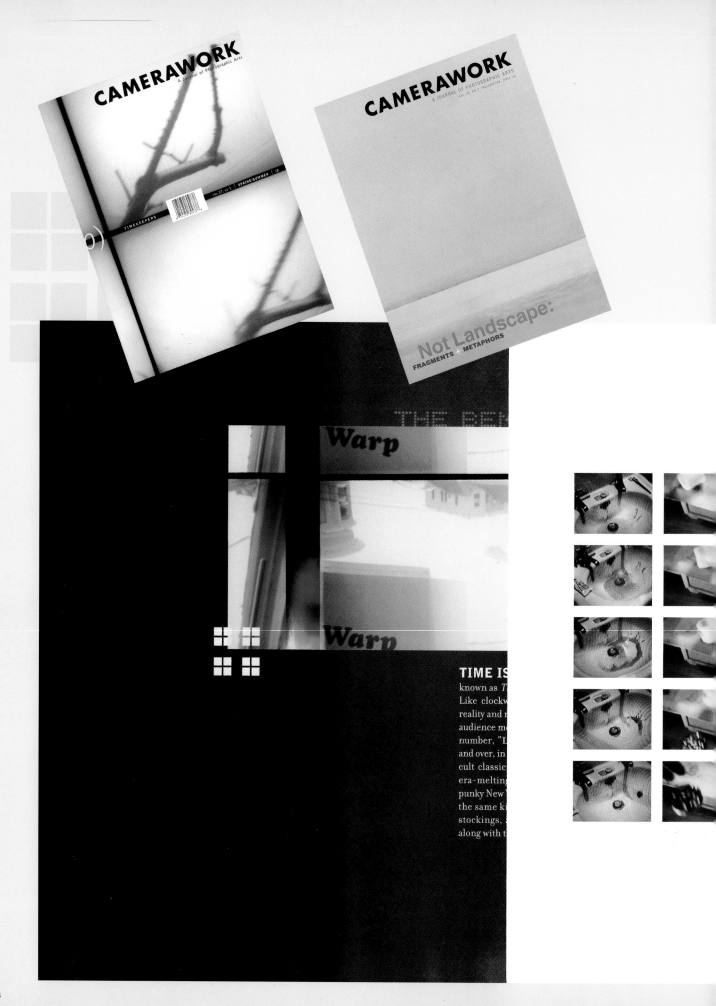

CAMERAWORK A Journal of Photographic Arts

VOL. 27, NO. 1 | SPRING/SUMMER | 18

TIMEKEEPERS

CAMERAWORK A JOURNAL OF PHOTOGRAPHIC ARTS
VOL. 28, NO. 2 FALL/WINTER 2001-04

Not Landscape:
FRAGMENTS + METAPHORS

Warp

Warp

THE BEH

TIME IS
known as *T*
Like clockw
reality and n
audience me
number, "L
and over, in
cult classic
era-melting
punky New Y
the same ki
stockings, a
along with t

Designers
Tom Sieu
John Givens

Photographers
Various

Art Directors
Tom Sieu
John Givens

Design Company
Tom & John: A design
collaborative

Country of Origin
USA

Work Description
Front covers (left),
gate-fold spread
(below) and spreads
(see p.30–31) from
Camerawork, a
quarterly journal
produced by the
non-profit arts
organization, San
Francisco Camerawork

Dimensions
9 x 12 in
228 x 304 mm

BARRETT LANGLIMAIS *Revert*, 1998, video stills

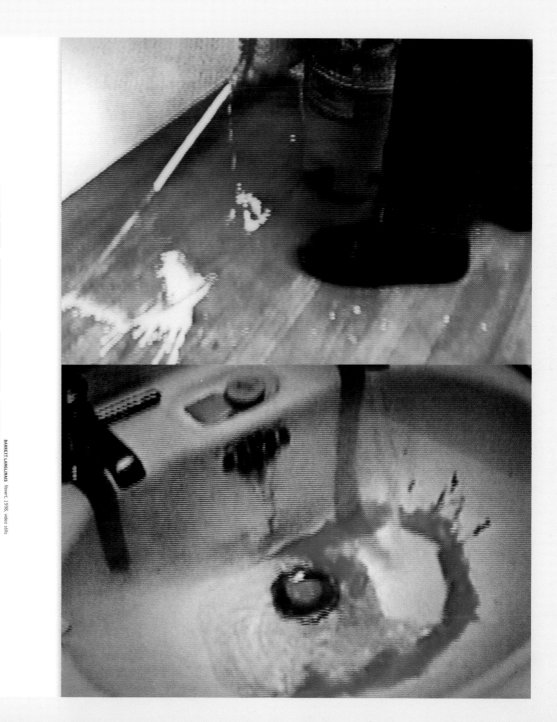

Being able to control time has proven to be a basic component of film language and an enduring cinematic fantasy. Think of all the movies that find people stopping time and reviewing their foibles—in *It's a Wonderful Life*, Jimmy Stewart lives in a total time bubble—and sometimes go back to correct their romantic or mortal mistakes by taking different trains or opening alternate doors. Think *Run Lola Run*, where time accelerates and repeats, fueling the fantasy that time is of little consequence. We can always remix, rewind, and replay. And who wouldn't want to be able to revert to a more innocent moment before they made that big mistake and things went horribly wrong? It's the dream of undoing, only in *Revert* there is no exit.

difficult to tell one

(+16)

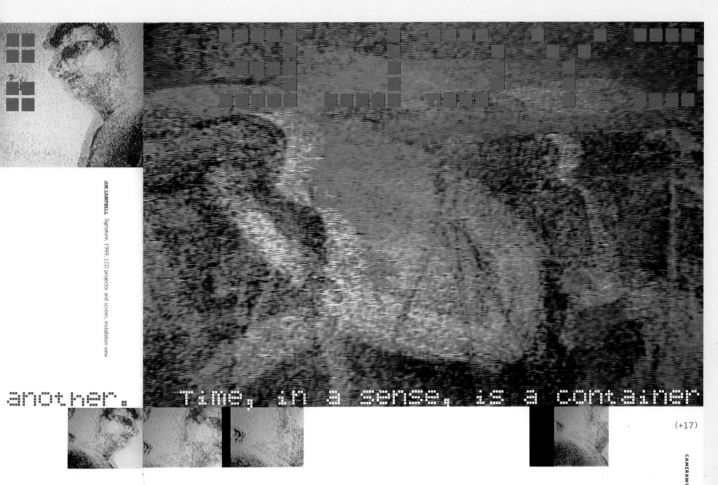

JIM CAMPBELL *Signature*, 1999, LCD projector and screen, installation view

another. Time, in a sense, is a container

(+17)

CAMERAWORK a journal of photographic arts

Meanwhile, in another part of the warp speed blur...

Sometimes it's difficult to remember what went on in there. Our subjectivity filters the experience of time in various ways. Perceptions, after all, take place in an instant affected by so many factors—mood, blood sugar, light, atmosphere, among others. One nanosecond is never the same as another. Why, for example, do our reflections look so different to us each time we look in the mirror? Are those fleeting perceptions mere illusions? (+16) **JIM CAMPBELL** has long been interested in trying to chart those fleeting moments and creates metaphors for our desire to hold onto them. Using scientific and technological tools, he makes seemingly magical installations that fuse past with present and future and inserts you, the viewer, into the equation.

In *Signature* he presents us with a hanging screen with a video image of the room we're standing in. It looks live, as there's a visible camera. But the person standing in that image is not you, but rather someone who inhabited that same space some time in the recent past. Later they'll see you. You, however, don't get to see yourself and can only imagine how you might appear, how you've left a mark. All who behold this piece enter into a strange cycle of inhabiting its place and pondering questions that Campbell's work invariably raises. Does space hold our presence? Do walls have eyes? Do mirrors have memories?

Bill Viola has said that he's fascinated by the way architecture soaks up time. He said this during a sermon at a gray Gothic cathedral in San Francisco, a setting that conjures up the idea of what the walls of centuries-old religious buildings must have witnessed. As an artist, he seemed to want to soak up some of that history by capturing the passage of time in video space. This idea fuels much of the rhetoric around the millennial interest in videotape. Campbell, however, ups the ante by adding the present to the equation.

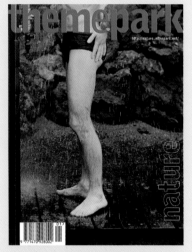

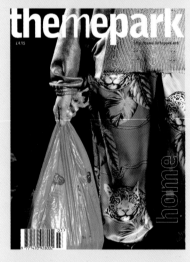

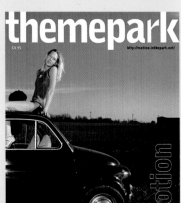

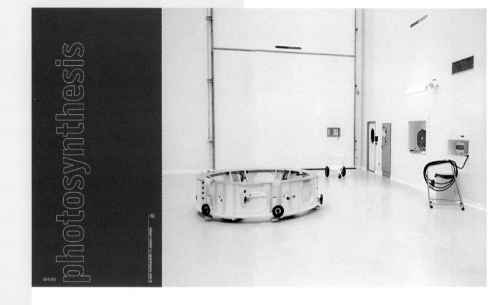

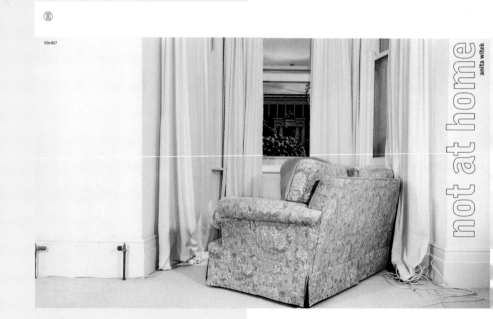

Designers
Brian Switzer
Esther Mildenberger

Illustrators
Various

Photographers
Various

Design Company
envision+

Country of Origin
Germany/UK

Work Description
Front covers (left)
and spreads (see
also p.34–35) from
themepark magazine,
a themed publishing
project in three
media: magazine,
website, and event

Dimensions
5⁷⁄₈ x 7⁷⁄₈ in
150 x 200 mm

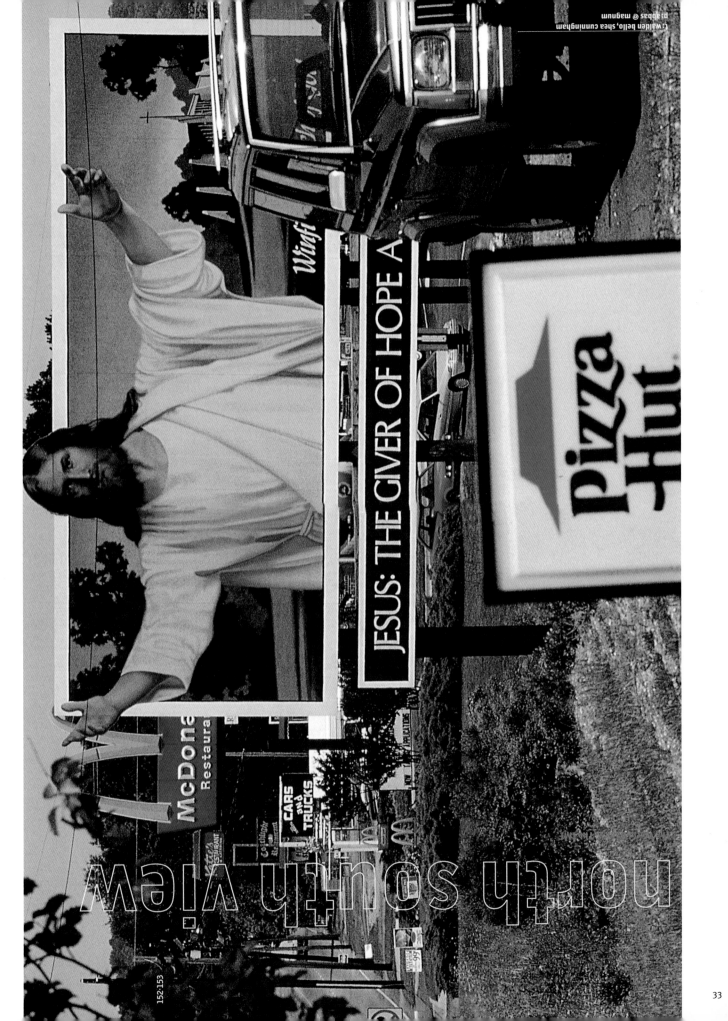

north south view

JESUS: THE GIVER OF HOPE A...

152·153

(: walden bello, shea cunningham
p: abbas @ magnum

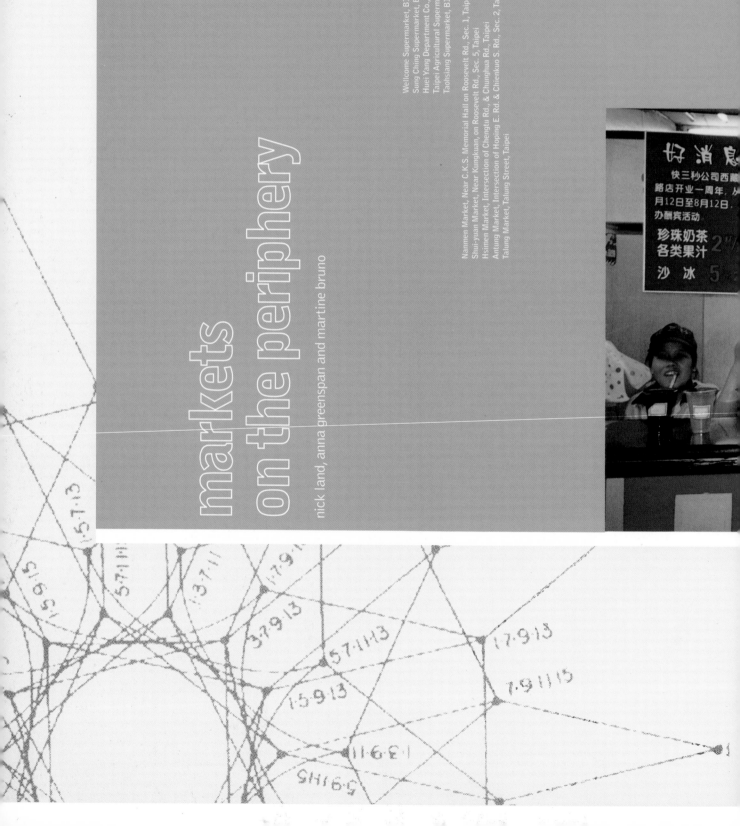

markets
on the periphery

nick land, anna greenspan and martine bruno

Wellcome Supermarket, B1, 71 Chunghsiao E. Rd., Sec. 4, Taipei
Sung Ching Supermarket, B1, 230 Hsinyi Rd., Sec. 2, Taipei
Huei Yang Department Co., B1, 225 Pateh Rd., Sec. 3, Taipei
Taipei Agricultural Supermarket, B1, 153 Hsinyi Rd., Sec. 3, Taipei
Taohsiang Supermarket, B1, 163-1 Minsheng E. Rd., Sec. 5, Taipei

Nanmen Market, Near C.K.S. Memorial Hall on Roosevelt Rd., Sec. 1, Taipei
Shui-yuan Market, Near Kungkuan, on Roosevelt Rd., Sec. 5, Taipei
Hsimen Market, Intersection of Chengtu Rd. & Chunghua Rd., Taipei
Antung Market, Intersection of Hoping E. Rd. & Chienkuo S. Rd., Sec. 2, Taipei
Talung Market, Talung Street, Taipei

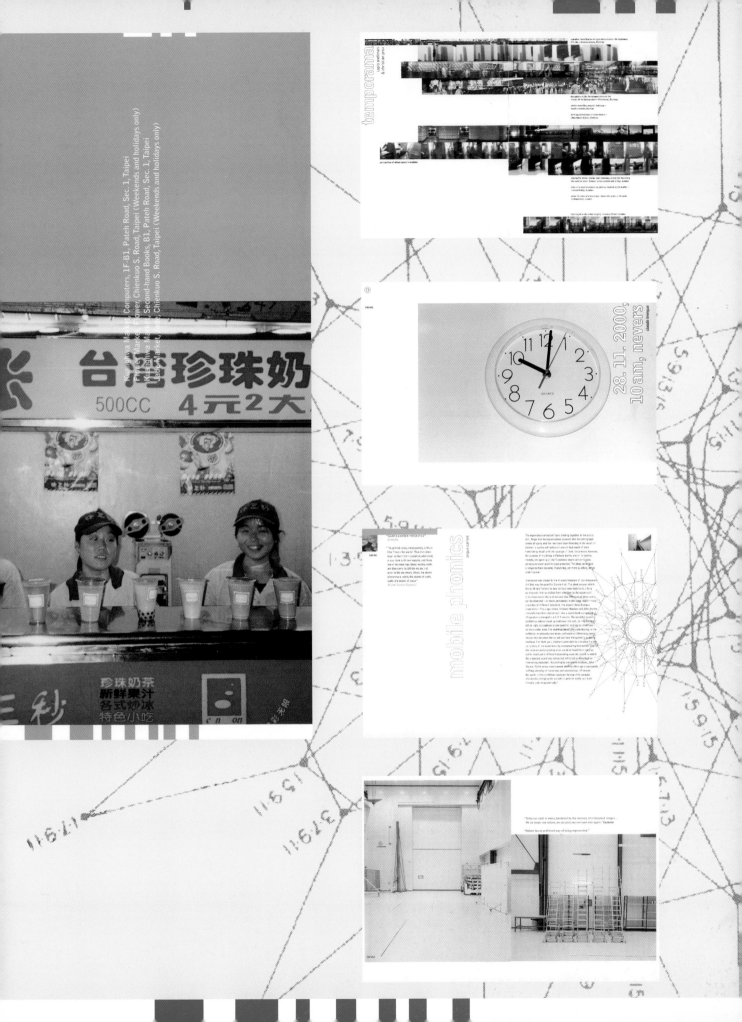

台灣珍珠奶
500CC　4元2大

Kumahwa Market, Computers, 1F-B1, Pateh Road, Sec. 1, Taipei
Flower Market, Flower, Chienkuo S. Road, Taipei (Weekends and holidays only)
Kumahwa Market, Second-hand Books, B1, Pateh Road, Sec. 1, Taipei
(Jade Market, Jade, Chienkuo S. Road, Taipei (Weekends and holidays only)

珍珠奶茶
新鮮果汁
各式炒冰
特色小吃

三秒

temporama

mobile phonics

28. 11. 2000,
10am, nevers
claude leveque

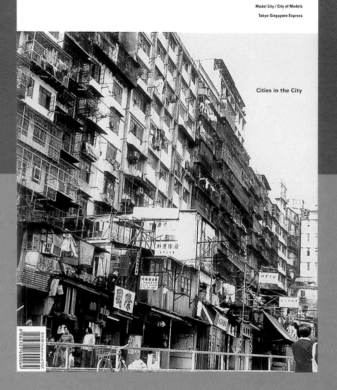

SINGAPORE ARCHITECT

#202:99

Big City Rooms
Far East Square
Model City / City of Models
Tokyo-Singapore Express

Cities in the City

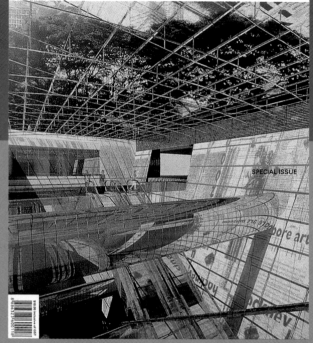

SINGAPORE ARCHITECT

#207:00

MARINAline Architectural Design Competition

SPECIAL ISSUE

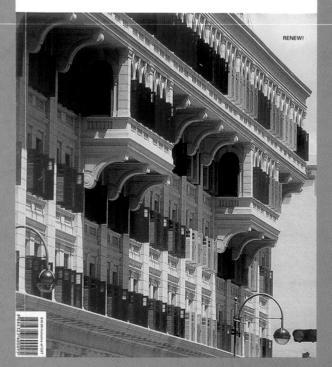

SINGAPORE ARCHITECT

#205:00

Onward En Bloc!
Architecture / Nation / Identity
What Should the Community Club Represent?
Representation in HDB Upgrading

RENEW!

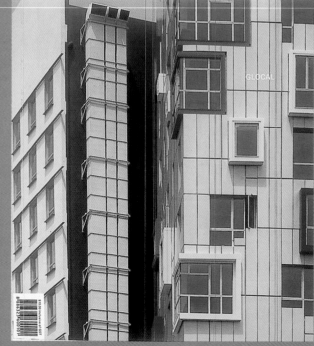

SINGAPORE ARCHITECT

#206:00

Jurong Island
Tourism Unlimited
Being Grand and Number One: Fullerton Square
The Glocal Project of the Gallery Evason Hotel

GLOCAL

STRUCTURE

THIS IS THE REFERENCE TO THE PHYSICAL AND RATIONAL CONSTRUCTS THAT SURROUND AND OCCUPY THE LANDSCAPE IN WHICH WE LIVE IN. AT ANOTHER LEVEL, THE COMPOSITION OF PHYSICAL CONSTRUCTS (EG. CLUSTERS OF BUILDINGS) WILL DICTATE THE NATURE OF SPACES IN BETWEEN. HENCE PATHWAYS AND VOIDS WILL ALSO CONSTITUTE THE CITY'S STRUCTURE.

EXPERIENCE

THE SETTING OF PHYSICAL CONSTRUCTS WILL NECESSITATE, OR INFLUENCE THE SETTING FOR THE FORMATION OF EVENTS IN THE CREATED SPACES. SPACES BECOME ENDOWED WITH THE MEMORIES OF THESE EVENTS, AND BEGIN TO FORM A TRANSIENT ORDER OF EVENTS.

Marina Square
One Raffles Link
digital TV
War Memorial
Suntec City
Theatres-on-the-bay
Raffles City
Odeon Tower
One Raffles Link
War Memorial
digital TV

Between Structure + Experience: An urban analysis of the city, hence, can take the form of mapping onto a shared or 'common' territory of rational structure against lived experience, or in the mapping of (urban) events onto (urban) memories.

Designer
Hanson Ho

Art Director
Hanson Ho

Design Company
H55 (H Fifty Five)

Country of Origin
Singapore

Work Description
Front covers (far left) and spreads (above and left; see also p.38–41) from *Singapore Architect*, a quarterly journal for the Singapore Institute of Architects

Dimensions
8¹/₄ x 11¹/₂ in
210 x 297 mm

● Essay

A CITY CAN BE READ, MAPPED OR ANALYSED IN VARIOUS LAYERS. THESE LAYERS OF THE CITY WILL BE OF PARTICULAR INTEREST: STRUCTURE, EXPERIENCE, AND PERCEPTION (THE IMAGINED). TO A LARGE EXTENT, THEY ENCOMPASS THE WHOLE ESSENCE OF THE CITY AND ITS SPATIAL PRACTICES.

A VOID

by Derek Chan

MEMORIAL

A Day's Allure (24 hrs in the life of us)

BUILDINGS

SHOP

PARADIZ

38

STREET

TRANSIT

● Essay

Big City Rooms 2

Containers The development of modern architecture can be narrated along the lines of discourses that theorise the relation between the inside and the outside. Modern architecture in this light is seen as a radical effort to break down the walls of historical canons of architecture, deemed no longer morally valid, with a new transparency afforded by new materials and technologies. Briefly in the early 1980s, there was a futile attempt to recuperate the lost symbolic dimension of architecture that modern architecture failed to deliver, by invoking an instrumental reinvention of symbolism in so-called 'postmodern' architecture. It did however, bring about a renewed capacity in buildings, so as to allow those same fragments of 'symbolism' to be applied as accessories onto architecture. We have thus Venturi's 'decorated

By Tan Kok Meng

This essay is an elaboration of 'Big City Rooms' with images by Joyce Sng, published in Singapore Architect #202 June 1999.

shed'. Conceptually, this 'shed' allowed a complete separation of functions between its outside and its inside; how it is to be 'read' at the urban level outside, and what it contains.

In theorising recent developments in the contemporary city, Ignasi de Solà-Morales proposes the category called 'container' to describe a certain predilection for a completely predetermined, interior space.¹ Conceptually, in the architecture of the container, there is a strong separation between the interior and the exterior. It is a hermetically enclosed building, with the residual condition on the outside for parking of cars, loading and unloading access. Inside, it is a self-sufficient, climatically-conditioned space, characterised by a safe, secure atmosphere. In this instance, the façade is no longer important and can be

BEING
GRAND NO. 1

Fullerton Square by Architects 61 Pte Ltd

text and photographs by Jacinta Neoh

The space between The Grand Fullerton and the newly completed One Fullerton, the two parts of the $165 million Fullerton Square project, offers more grounds for reflection about our (global) urban situation than the 8-lane Fullerton Road that divides them.

AMALGAMATE

SYNERGISE

MISSION

AIM

VISION

OVERHEAD BRIDGE

5

6

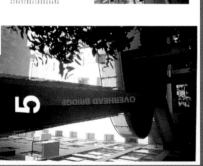

Sungei Road: a market on the margins

"Singapore is clearly not free, but at the same time it is difficult to identify what precisely is unfree, how and where the exact repression occurs, to what extent its magnetic field – the uneasy cohesion of its inhabitants – is imposed or, more ambiguously, the result of a 'deal'."

Rem Koolhaas

"Encounters with New Model Communities"

Bangkok on the Move

ACME FONTS

Designer
Christian Küsters

Archi-typographic Design
Gregory More
Nick McKenzie

Art Director
Christian Küsters

Design Company
CHK Design

Country of Origin
UK

Work Description
Poster for an Acme Fonts type foundry, in collaboration with architect-animators Gregory More and Nick McKenzie

Dimensions
21¹/₄ x 32 in
545 x 820 mm

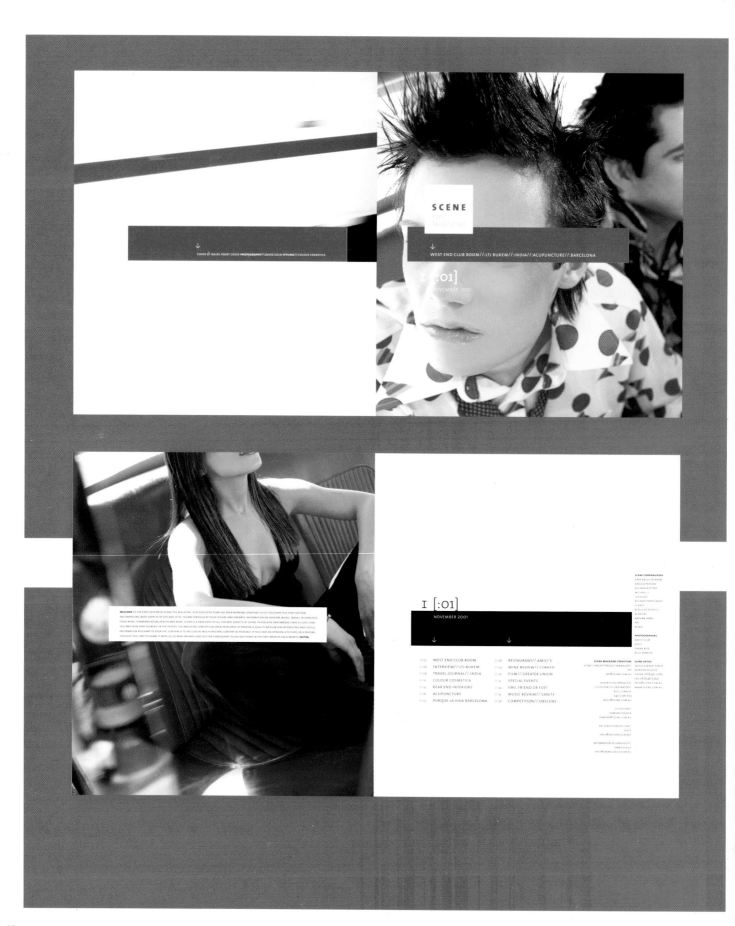











//20 //21

Designers
Anthony De Leo
Scott Carslake

Photographers
Voice
David Solm

Art Directors
Anthony De Leo
Scott Carslake

Design Company
Voice

Country of Origin
Australia

Work Description
Front and back covers
(above left) and
spreads from *Scene the
magazine,* a magazine
about lifestyle, events,
people, travel,
entertainment, food,
and wine

Dimensions
7³/₄ x 7 in
197 x 180 mm

COLOUR

TEXT//:REBECCA PASTORE//:MARKETING MANAGER

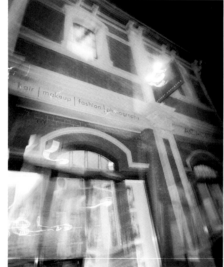

COSMETICA

COLOUR COSMETICA IS AN EXCITING AND FRESH ORGANISATION THAT HAS HIT THE MAKE UP AND COSMETIC INDUSTRY. IT IS THE FIRST ORGANISATION OF ITS KIND TO FULLY INTEGRATE ALL FACETS OF THE INDUSTRY INTO A "ONE STOP SHOP" WHERE YOU HAVE THE OPPORTUNITY TO INDULGE ALL YOUR BEAUTY REQUIREMENTS; HAIR, MAKE UP, BEAUTY AND EDUCATION ON ALL THE FACETS OF THE INDUSTRY. COLOURS' VISION IS TO CREATE AND ALLOW THE FLOW OF NEW DIRECTIONS IN STYLE, TO PROVIDE AN ALTERNATIVE SOURCE OF INSPIRATION INSIDE AN INDUSTRY BLOCKED WITH REPETITION. COLOUR COSMETICA SEEKS TO SATISFY THESE THREE PRINCIPLES VIA 4 MAIN ARMS OF OPERATION: RETAIL ARM, ACADEMY, SALON AND STUDIO. COLOURS' RETAIL SECTION IS LINED WITH A SELECTION OF TOP QUALITY PROFESSIONAL MAKE UP WHICH HAVE PROVEN COLOURS' REPUTATION TIME AND TIME AGAIN AT THE INDUSTRY'S HIGHEST LEVELS. THE MAKE UP SELECTION CURRENTLY CONSISTS OF 'ATELIER, DIEGO DALLA PALMA' PRODUCTS, AND LOCAL AUSTRALIAN BRAND 'PROOF.' THESE PRODUCTS HAVE BEEN CHOSEN FOR THE RICHNESS, INTENSITY OF THE PIGMENTATION, THE COLOUR RANGES AND THEIR TEXTURES. PLEASE EXPECT MAKE UP PRODUCTS TO LINE THE SHELVES SOME TIME AROUND FEBRUARY AND KEEP YOUR EYES PEELED TO THE INTRODUCTION OF MORE TOP INTERNATIONAL PRODUCTS. ALL OF THESE PRODUCTS ARE AVAILABLE FOR BOTH GENERAL, PUBLIC AND PROFESSIONAL INDUSTRY USE.

BUKEM'S FIRST INTRODUCTION TO MUSIC WAS, LIKE SO MANY OTHERS, THROUGH PIANO LESSONS AS A CHILD. UNLIKE SO MANY OTHERS HOWEVER, THE YOUNG PIANIST TURNED OUT TO POSSESS A NATURAL TALENT AND HE QUICKLY MOVED THROUGH THE PIANO GRADES. IN THE MID EIGHTIES, AT THE AGE OF SEVENTEEN, **LTJ BUKEM** DISCOVERED THE JOYS OF CLUBBING.

THE TEENAGER REGULARLY CHECKED OUT THE LOCAL SOUL CLUBS AND LEGENDARY RARE GROOVE ALL DAYERS.

Designers
Anthony De Leo
Scott Carslake

Photographers
Voice
David Solm

Art Directors
Anthony De Leo
Scott Carslake

Design Company
Voice

Country of Origin
Australia

Work Description
Spreads from *Scene the magazine,* a magazine about lifestyle, events, people, travel, entertainment, food, and wine

Dimensions
7³/₄ x 7 in
197 x 180 mm

Both men and woman are offered the flexibility in having: facials, day and night make up, hair cutting/designs, and availability of the Step by Step personalised workshop. The Academy is where we translate the depth of our under-standing of the products, skills and techniques, from the fiction or the surprise of someone else's hands into your own. The academy provides certificate and Diploma courses; Covering application, to refashioning the beauty of the eye, from your luscious lips to the portfolio analysis. For the curious, we provide the 12 week creative design certificate. For those with serious career intentions in the fashion industry, this is the course "La Moda", which at the end earns a diploma that is recognisable both nationally and internationally. Overall these courses are designed to cater for: Make up and hair services for fashion magazines, Advertising, Media, Freelance, Professional photograph, Editorial work, Film and art. However none of this is complete without us practising what we preach. Here is where the Salon allows us the chance to communicate and weild our understanding of our products, skills and techniques. Every service and product makes you a part of the Colour wheel, putting you amongst our loyalty club. The unique club gives 1 point for every $10 spent on hair. The accumulated points can be redeemed for any service booked on Monday, Tuesday or Wednesday. You will receive: Exclusive special offers, Colour Cosmetica reward dollars to spend on great gifts you really want, and opportunities to attend Colours' make over nights and fashion events. The salon is the area in which the talent

and experience of the Colour Cosmetica team is demonstrated, providing make up application, Lakme [the Spanish range] and further more providing hair cutting services as well as high fashion work including, long hair, hair extensions and wig designs. The salon is designed to be as therapeutic as it is aesthetically pleasing with the emphasis being on the total pampering of the consumer. Studio operations are centred around freelance work comprised of: the products sold in retail, the skills and techniques taught in the academy and the styles available through the salon. Studio operations are predominantly centred on freelance work comprising Make up artists, Educators and Photographic work. The mobility of the studio is designed to give on-site, instantaneous solutions; Colour is currently working with Insight Sports Magazine, Lakme national and international educators and Oyster magazine, on a variety of TV newsreaders and TV commercials. Considering the fact that there is no other full service operation such as this in Australia.

It is seen that Colour Cosmetica is both ambitious and ideal-istic in their undertaking. Colours' team is a selection of intelligent, talented, avant guarde decorative individuals. It is the combination of talents, experience and dexterity within the market, which will enable Colour Cosmetica to operate on the cutting edge of industry design and devel-opment, well into the future.

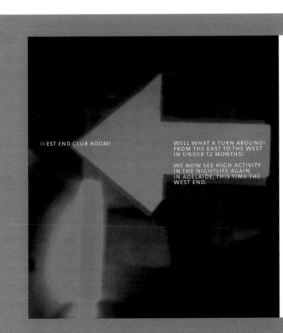

WEST END CLUB BOOM!

WELL WHAT A TURN AROUND! FROM THE EAST TO THE WEST IN UNDER 12 MONTHS!

WE NOW SEE HIGH ACTIVITY IN THE NIGHTLIFE AGAIN IN ADELAIDE, THIS TIME THE WEST END.

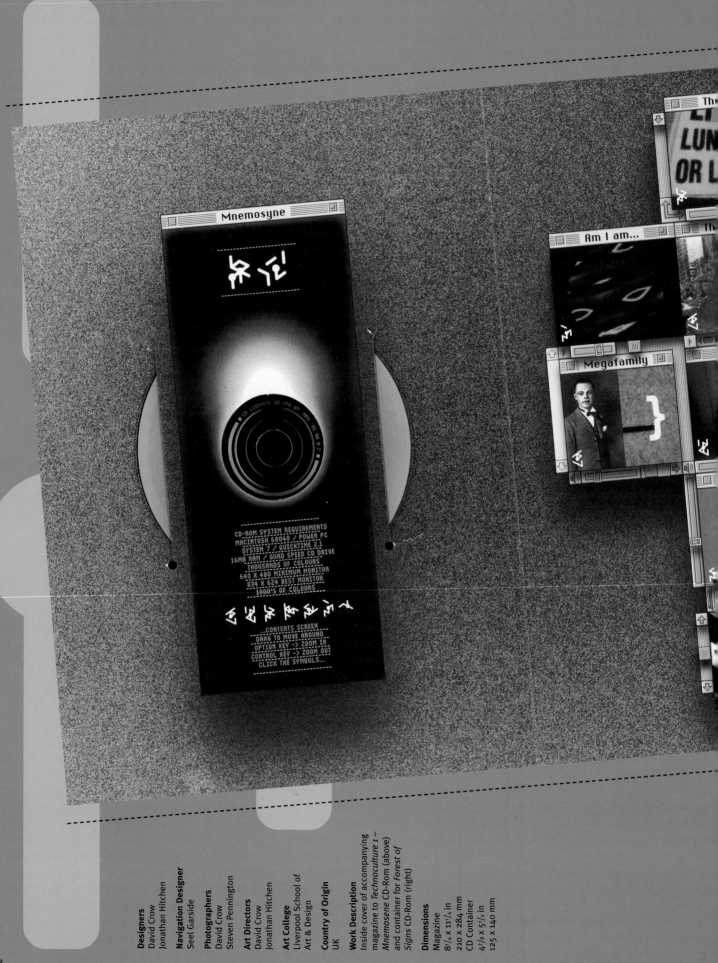

Designers
David Crow
Jonathan Hitchen

Navigation Designer
Seel Garside

Photographers
David Crow
Steven Pennington

Art Directors
David Crow
Jonathan Hitchen

Art College
Liverpool School of
Art & Design

Country of Origin
UK

Work Description
Inside cover of accompanying
magazine to *Technoculture 1 –
Mnemosene* CD-Rom (above)
and container for *Forest of
Signs* CD-Rom (right)

Dimensions
Magazine
8¹/₄ x 11¹/₄ in
210 x 284 mm
CD Container
4⁷/₈ x 5¹/₂ in
125 x 140 mm

Technoculture Nº1, Mnemosyne. CONTENTS: [PAGE 4]"Father Massissi, Meet Baron Samedi" **Declan Sheehan.** [PAGE 8]"The object(ive) of art in the age of digital revolution" **John Byrne,** "Interacting with the Divine Comedy" **Nickianne Moody.** [PAGE 25]"A Meme" **Sean Cubitt.** [PAGE 30]"Walerian Borowczyk *Jeux des Anges* / John Hejduk *Bovisa* – An inventory of confluence and representation" **Giles Lane,** "Mnemoteknics" **Lowena Faull.** [CD ROM]"Shthnd Lite™" **Beaufonts,** "The Struggle" & "Mcgafamily" **David Crow,** "Am I am therefore I am 1" **Karen F,** "Origins" **Paul Farrington,** "Theology" **Carl Hunter,** "Locus" **Michelle Wardle.**

EST OF SIGNS

CD/ROM

Beta Version Mac System 7.0. Quicktime 3.0 or later

Disk beginning to rotate, fast, becoming a sphere of paler gray. Expanding - And flowered, flowered for him, fluid origami trick, the unfolding of his distanceless home, the country, transparent 3D chessboard extending to infinity. Inner eye opening to the stepped scarlet pyramid of the Eastern Seaboard Fission Authority burning beyond the green cubes of Mitsubishi Bank of America and high and very far away he saw the spiral arms of military systems, forever beyond his reach.

[Gibson, *Neuromancer*]

with Yates account of St. Augustine's discussion of memory:

I came to the fields and spacious palaces of memory, where are the treasures of innumerable images... Behold in the plains, and caves, and caverns of my memory, innumerably full of innumerable kinds of things...over all these do I run, I fly; I dive on this side and that, as far as I can, and there is no end.

[*Confessions Book X* quoted in Yates, *The Art of Memory*]

Hyperreality

Hyperreality is a term used by various contemporary cultural critics. It refers to the excess of simulation, the endless recycling of form, content and style, most remarked upon in fashion, pop video and advertising. Imitation has superseded representation. The perfect copy has been reified by the service industries of the last quarter of the

[ix] *The Bad Lieutenant*: his eponymous nature; what does the audience demand of this figure? "Harvey Keitel is the Bad Lieutenant." His losing streak; his descent into the pit of abjection. Abel Ferrara cannot be said to "love people" and not "despise them as we do". If the Bad Lieutenant began to make winning bets, if the Bad Lieutenant lost his need for crack, if the Bad Lieutenant entered a wholesome, loving, healthy relationship... Would the audience be happy of this conversion? We will accept your abjection. We demand no less.

[*Father Matasits, Meet Baron Samedi*]

Artificial memory is prosthetic, existing outside the body, accessible at will but existing simultaneously and open to others. The implications resulting from this understanding of artificial memory-power begin to redefine the meaning of memory itself. Instead of a private resource refined for public speech it becomes visualised as a public utility occasionally reappropriated for private contemplation. Memory is a facility for a different set of survival skills required and necessitated by the popular fictional discourse of the information society

[x] In this general connection the second stanza of Poe's *Leonore* is pertinent: "Wretches, ye loved her for her wealth and hated her for her pride, And when she fell in feeble health, ye blessed her that she died! How shall the ritual, then, be read? the requiem how be sung By you - by yours, the evil eye - by yours, the slanderous tongue That did to death the innocence that died, and died so young?"

twentieth century. Memory has different objectives, one of which is the recording of trivia for the pop quiz. The contemporary memory has to emulate the machine, quick to absorb, perfect recall and always ready to update, reclassify and delete.

In *Simulations* Jean Baudrillard regards hyperreality as the predominating form of simulation. One of his main concerns with its ascendancy is the loss of imagination hyperreality engenders. Hyperreality is the external construction of similitude. The cultural product of the information society is tangible rather than mental simulation, that is the simulacra which negates the realising power of imagination.

So goes creativity. This also means the collapse of reality into hyperrealism, in the minute duplication of the real, preferably on the basis of another reproduced medium - advertisement, photograph etc. From medium to medium the real is volatilized; it becomes an allegory of death, but it is reinforced by its very destruction; it becomes the real for

the real, fetish of the last object no longer object of representation, but ecstasy of degeneration of its own ritual extermination; the hyperreality.

[*Baudrillard, Simulations*]

As a simulation the simulacra is actually untenable because it is void of meaning. As pure simulation rather than representation it exists without particular reference to the real. This existence neither reflects presence nor masks absence. The simulacra negates the energy Yates describes in her account of the agency of memory. Instead the action is located external to the individual mind and designated for mass consumption.

In the material world of late capitalist consumer society the distinction between real and the imaginary is less sustainable and begin to be effaced, as Eco phrases it, in his earlier book, *Travels in Hyperreality*, "Absolute unreality is offered as real presence". The reasons for this are ontological. In his examination of hyperreality in American culture, Eco speaks of the demand made by the American imagination for real things; to supply this need, cultural industry generates the fabrication of the absolute fake.

Interacting with the Divine Comedy

[Page 16] [Page 17]

An inventory of confluence and representation

The Record Keeper of Hallucinations

"... is given structures in which to live and work, the House of the Suicide and the House of the Mother of the Suicide. He works in the son's house and he lives in the mother's house. He reads the poems of Rilke to the point of obsession. [2]

"Angels, it seems,
 don't always know
 if they're moving among
the living or the dead.

[Rainer Maria Rilke, *The Duino Elegies*]

Shoah

Horrific allusions constantly refer me to the concentration camps. The imagery is blinding. *Jeux des Anges* - the tunnels and cell-like rooms, the ubiquitous symmetry of the pipes mouthing random execution to unknown victims. A cinematic exegesis of the dehumanised and mechanistic processes of death and killing in the twentieth century, Walter Benjamin's eponymous *Age of Mechanical Reproduction* as applied to the great leveller, Death.

Bovisa: the hospital towers connecting with the old gasworks, now converted into a cemetery, the spaces of confinement in *Bovisa - Hospital Tower: Detention Center; Hospital Tower: Prison/Normal*, Joseph Mengele, Auschwitz, Dachau, Treblinka.

Hejduk uses the iconography of the camp: its guard posts and observation towers become public institutions like the Board of Education, overseeing the indoctrination of the young. The barbed wire becomes a shroud for *The Rose Woman Captured*.

The panoptic Asylum - no asylum from surveillance.

There is an overwhelming violence in the torture, and execution of the angels, a 'veterinary implication (vivisection) in a drawing such as *Autopsy*, and the invocation of the Nazis via a subtle use of motifs from Imperial Rome. The lined victory procession of a triumph reflected in the drawing *Via of the Crucified Angels*.

I have a haunting recollection from childhood of a photograph showing victims of the Nazis hung by piano-wire. In her essay, *In Plato's Cave*, Susan Sontag memorably describes the effect on her of photographs of Bergen-Belsen and Dachau as a "negative epiphany":

"When I looked at those photographs, something broke. Some limit had been reached, and not only that of horror. I felt irrevocably grieved, wounded, but a part of my feelings started to tighten, something went dead; something is still crying.

Both *Jeux des Anges* and *Bovisa* avoid the sentimentality of a work such as Spielberg's *Schindler's List*; our sensibilities are not spared the naked brutality or trivialised by crass sentiment.

[Fig. T]

[xxiii] "My own feeling is that Welles enjoyed *The Merv Griffin Show*, and the instant ghostly amiability of Merv himself. He liked to do gentle illusions for daytime audiences – they were routines he knew inside out, but he never tired of those gasps of wonder that greet proficient conjuring, or its brief air of mastery. And he revelled in the conceit that Lear and Kermit might be elements in one piece of magic, peas under the cups, his playthings. He cherished magic because it put him in charge, so he never regarded it as a cheap trick. To make people gasp with surprise is a noble calling. Any Lear is ever dreamed of would have had that aspiration. That's why his Lears and Othellos all seemed a little bogus, like player kings in Zenda, conned into taking the Big Part. Equally, he could sometimes make *The Merv Griffin Show* feel as if the cloak and staff of Prospero had enchanted the stale air and sick light." [B]

[*Father Matasits, Meet Baron Samedi*]

[xxiv] F.Scott Fitzgerald said, "Movies have taken away our dreams. Of all betrayals, that is the worst."

[xxv] The process of melodrama's grand (emotional) conflicts can be described not as one of humanising, but rather as a process of anthropomorphising psychological themes. In much the same way as occurs within standard anthropomorphic cinema – generally cartoons or films featuring live animals (eg. *Black Beauty, Lassie*) – melodrama is removed from any attempt at achieving standard psychological realism. The psychological complexity of melodrama's characters is on a par with the essential single solitary trait of an animal star or cartoon star – Goofy is goofy, Lassie is compassionate – and the humans within melodrama generally have only one single essence – they are, for example, either good or evil, or sane or mad. In melodrama, these issues, these states similarly act out the characters.

no one was allowed to walk sideways – that is sidelong through the grain of history – going against the Flow, surfing through and across the wave rather than on it.

Tragic Magic – Prayers of passion – stay the same through changing fashion – it frees my mind like water on a winter's night.

[John Prine]

Nothing in history is better expressed than those forgotten and (then) rediscovered facts which reinvent our pasts and give us our futures.

Is there a fourth dimension? One which can provide us as a new space to play with? Abandon perspective! Abandon linear narrative structures! None other than William Blake reminds us – see with the soul – since the body by itself only sees a lie – a human delusion.

Blake believed that information gathered by the physical senses, which contain necessarily the individual's learned experience and assumptions about the world, leads only to a projection of the individual's rational selfhood. But if an individual sees with the soul, with the faith of the blind, then there are dialogues with angels, in which are revealed "the infinite in all things, the sublime, the wondrous regions of eternity." This is to attempt to represent the unrepresentable and it is the attempt, the leap of faith, which is the sublime.

Mnemotechnics

[Fig. S] [Page 37]

[xv] "[Welles] fastened upon the realization that movies are... atmospheres, seances or dreams... He saw a way in which authorial power delivered a state of wonder and emotion."[18]

[xvi] "It is then among the later immigrants that we find the belief in the Evil Eye intact, most vigorously among Italians and Jews. It is almost always true that the first generation born in this country puts no stock in the Evil Eye; the second generation never heard of it. It survives for the lifespan of the immigrant and only in urban areas where there is a large number of people from the same or similar background in Europe."[19]

Italians & Jews: Hollywood.

Father Massici, Meet Baron Samedi.

[Fig. N]

[Fig. O]

➤ tural change. Rather than a model of domination, `the end of creativity`, similitude marks the site of cultural struggle during a period of social transition. Open memory and the meaningless sign are ripe for reappropriation and spark off interactivity. The simulacra is waiting to be filled by individual and collective memory to become a point of visible contradiction. Even the perfect copy is subject to graffiti

ified worker who can ignore hunger, pain and distraction is being given the skills for work which allow her to engage with the complexities of cyberspace. However, the pleasures of simulation which are the reward for such employment will be denied to a vast number of the unemployed created by such a system. A future where all have equal access to new technology is utopian or equally dystopian but nonetheless ideal

Reality, however exists through interaction. Concern for the loss of reality, expressed through the criticism of popular culture, is one that acknowledges the anxiety of cultural and social change. Prosthetic memory systems are a symptom of the necessity for new survival strategies in the social environment. Science fiction performs modifications on the brain or the psyche, so that the worker can reach optimum efficiency and emulate the machine. In theory medieval allegory concentrated the mind upon spiritual salvation and not material reward. In practice it is part of the process which enabled secular scientific thought. A mod-

Dante's fiction is interrogative, requiring sustained contemplation, the route for which is composed of social and political comment. The mythology of interactive media is not all encompassing. At best its polysemy is governed by comedy and not tragedy, where there is still as yet unnegotiated opportunities for the human agent to dispute the adversity of simulation. ➤

Intersecting with the Divine Comedy

[Page 22] [Page 23]

Designers
David Crow
Jonathan Hitchen

Navigation Designer
Seel Garside

Photographers
David Crow
Steven Pennington

Art Directors
David Crow
Jonathan Hitchen

Art College
Liverpool School of
Art & Design

Country of Origin
UK

Work Description
Spreads from accompanying magazine to *Technoculture 1 – Mnemosene* CD-Rom

Dimensions
8¹/₄ x 11 in
210 x 284 mm

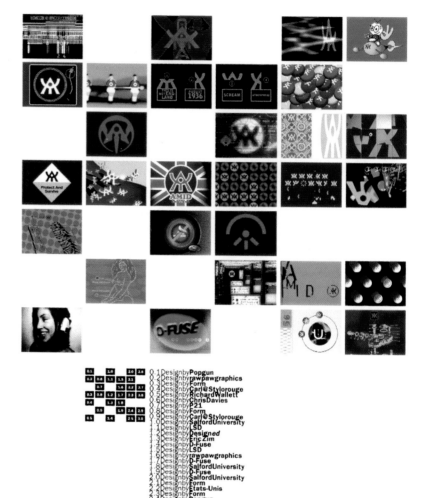

AMID

Association Of Music Industry Designers
Promotes and supports designers working in the music industry.

For more info on these designers and other members visit the website: **www.amid.co.uk**
Fax +44 (0)171 221 7195

The **Scuro'97** Event will feature projections of work shown here. Acts will include **Ignition Musik**, **Si-{cut}-dB**, **Fila Brazillia** – and more.
Dates: 5.12.97 & 12.12.97.
15 Golden Square, London W1.
Visit **www.dfuse.com** for latest info.

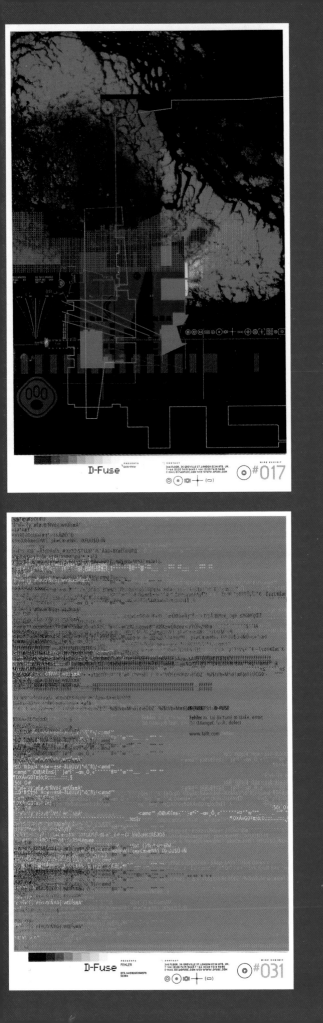

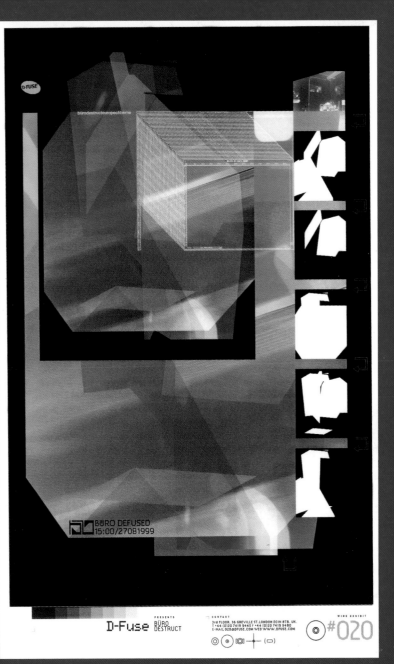

Designers
D-Fuse
Fehler
Büro Destruct
Raw-paw

Art Director
Michael Faulkner

Design Company
D-Fuse

Country of Origin
Various

Work Description
Spreads from "Wire space": graphic art
designed by D-Fuse and other artists for
The Wire, a modern music magazine

Dimensions
9 x 10³/₄ in
230 x 278 mm

D-Fuse PRESENTS RICHARD FENWICK TITLE RND#47

CONTACT: 3rd FLOOR, 36 GREVILLE ST, LONDON EC1N 8TB, UK. TEL: +44 (0)20 7419 9460 E-MAIL: INFO@DFUSE.COM WEB: WWW.DFUSE.COM

D-Fuse

#042

D-Fuse

#045

54

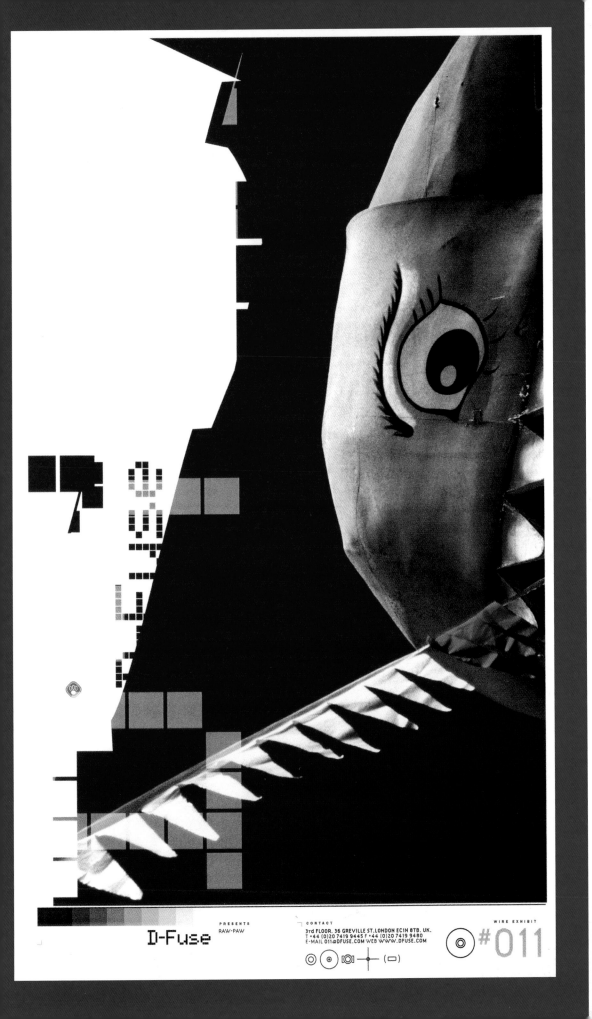

Designers
D-Fuse
Raw-paw
Sarah Wootton
Richard Fenwick

Art Director
Michael Faulkner

Design Company
D-Fuse

Country of Origin
Various

Work Description
Spreads from "Wire space": graphic art designed by D-Fuse and other artists for *The Wire*, a modern music magazine

Dimensions
9 x 10³/₄ in
230 x 278 mm

D-Fuse

PRESENTS
RAW-PAW

CONTACT
3rd FLOOR. 36 GREVILLE ST. LONDON EC1N 8TB. UK.
T +44 (0)20 7419 9445 F +44 (0)20 7419 9480
E-MAIL 011@DFUSE.COM WEB WWW.DFUSE.COM

WIRE EXHIBIT
#011

arcCA

architecture california
the journal of the american institute of architects
california council

architect and society issue | 00.2

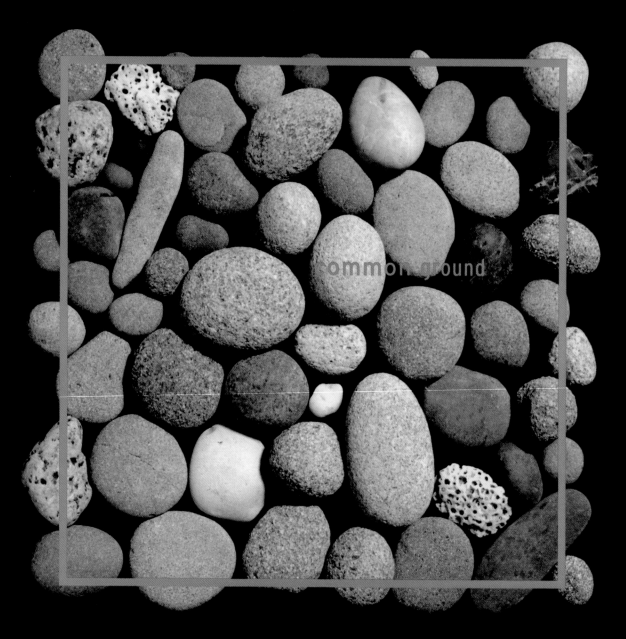

ommon ground

:: **you have to pay for the public life**
:: **lessons from burning man**
:: **coda: the delta primer**

Designers
Bob Aufuldish
Supreeya Pongkasem

Illustrators
Various

Photographers
Richard Barnes
Various

Art Director
Bob Aufuldish

Design Company
Aufuldish & Warinner

Country of Origin
USA

Work Description
Front covers from four
issues of the redesign
and relaunch of
Architecture California,
the journal of the
American Institute of
Architects California
Council

Dimensions
7 x 10 in
178 x 254 mm

Designers
Bob Aufuldish
Supreeya Pongkasem

Illustrators
Various

Photographers
Richard Barnes (cover)
Various

Art Director
Bob Aufuldish

Design Company
Aufuldish & Warinner

Country of Origin
USA

Work Description
Spreads from four
issues of the redesign
and relaunch of
Architecture California,
the journal of the
American Institute of
Architects California
Council

Dimensions
7 x 10 in
178 x 254 mm

The Fluid Agora

Since the summer of 1975, spent
in LA while attending architec-
ture school at the University of
Michigan, the author has pho-
tographed public spaces in Los
Angeles, amassing a collection
of images that celebrate a kind
of outdoor living only dreamed
of in other parts of the country.

Anne Zimmerman, AIA

Getting
Engaged
The New Context

Bruce Mau

To call the 20th century an era of change is to under-
state the obvious. The past century has seen the world
swept along by an extraordinary tide. We have been
exposed to instances of invention, discovery, growth and
rupture that have transformed our lives in ways that we
cannot yet fully comprehend. The effects of global
modernization continue to shape and connect us.

To better understand the work we produce,
and the work we ought to produce, I have attempted a
preliminary inventory of the "background" conditions
that increasingly constitute the substance of our
work. The inventory touches on a range of phenome-
na currently shaping and constituting our global
image context and includes surveillance, celebrity,
violence and communication. Explored here are circu-
lation, infrastructure, tourism and freeway condition.

What becomes apparent in studying the
inventory is that things are now more connected than
ever. The attempt to find the boundary of any prac-
tice—where one ends and another begins—is in-
creasingly artificial. We live in a 24-hour-market
world where there is less and less "unregulated"
terrain. Events, cultural styles, technologies, memes,

29

The Problem of Architecture in Public

and the Public in Architecture

Bryan Shiles, AIA

Inside the universal "outside" that surrounds us, there is an inferred and imaginary consciousness: inferred because we believe in it the way we believe in Other Minds (surface, after all, means "on the face"); imaginary because it is purely projected – not without excuse – but projected beyond the simple smile lines which say smile, or the brow's wriggles which write puzzlement or anxiety, to create the emotional state we regularly assume would draw them. These conditions of consciousness, which live metaphorically "behind" the configurations of the city's face, can dampen or liberate our feelings almost by osmosis, the way any friend's or lover's gestures can, through the frank show of this state of mind. —William H. Gass, "The Face of the City"

Because architecture defines the human landscape, it is the most public of art forms. No matter what the use or context, a work of architecture—or, more accurately, the aggregate of architecture—dominates the visual field in which we live our lives. Architecture's visual prominence drives the contentious debate over public values in architecture. What makes a building good or bad, worthwhile or wasted, progressive or conservative, is often what makes us the same. Thus it follows that good architecture is critical, that it searches to define us but does not stop there. The best architecture carries us forward by appealing to vision, not nostalgia, and aspirations, not fears. Doing so requires a challenge to, and not the mere confirmation of, our assumptions.

In "The Face of the City," William Gass illustrates the reflexive relationship we have with architecture. Our consciousness affects the way we read the city and our consciousness is affected by the signs that the city's surfaces project back to us. Implicit in this relationship is the importance of the language of architecture. How the surfaces are articulated, what they allude to or disregard, is as important a component in urban design as the scale and arrangement of the pieces. The surfaces of the city have the power not only to shock, but more significantly to quietly shape our everyday lives. They are the most visible murals of the inspiration or the complacency of the public will. This is the context, both physical and spiritual, that anticipates architecture and demands rigor in its appraisal.

Yet if criticism of context is so vital to public architecture, who provides the criticism? Traditionally, of course, criticism has been part of the authorial purview of the artist. For the architect, that most public of artists, this purview creates a special conundrum. On one hand, authorship is a private undertaking, part of the creative process that is at its heart very personal (even if undertaken as part of a professional collaboration). On the other hand, an integral component of the best design is specificity to its site, and the architect is in most cases a citizen of a metropolitan world, not a representative of a particular locale. As an interpreter of context, a provocateur who translates the known into the unfolding, the architect requires assistance in making a complete assessment of what best informs the design.

25

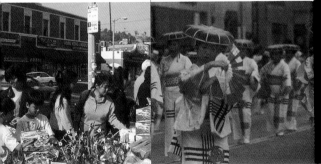

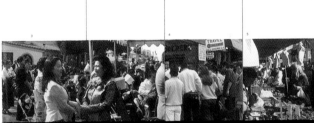

Made up of gathering places for communities of people, the fluid agora includes streets, parks, festivals, markets and demonstrations—venues ever changing in time and location. Much of America has forgotten, or grown fearful of, the life of public spaces. The ethnic communities of Los Angeles (and elsewhere) remind us of the pleasures of the public life.

Previous spread—Strolling an oceanfront walk (aka "the Boardwalk").

Venice Beach; August, 1986

1 Street vending, Los Angeles' Chinatown; January, 2000

2 Nisei Day Parade; Little Tokyo; October, 1991

3 Dedication of Thai Town; January, 29, 2000

4 Three Card Monty on Broadway, Downtown Los Angeles; January, 2000

5 Santa Monica Farmer's Market; January, 2000

6 Pro-Choice Demonstration, Rancho Park, West Los Angeles; November, 12, 1989

7 Third Street Promenade, Santa Monica; June, 1996

8 Santa Monica Farmer's Market; January, 2000

32

33

Designer
Tnop

Illustrator
Tnop

Photographer
David Raccuglia

Art Directors
Carlos Segura
Tnop

Design company
Segura Inc.

Country of Origin
USA

Work Description
Front cover (left)
and spreads from
Mixed medium, a
book about Folk
Art featuring 18
artists for
American Crew

Dimensions
10 x 12 in
254 x 305 mm

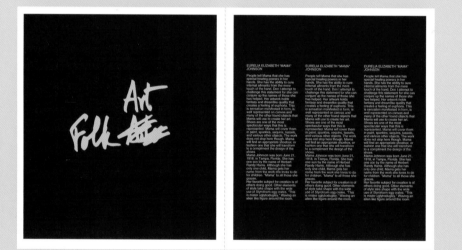

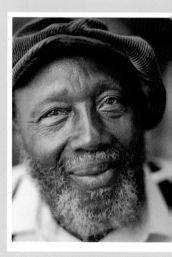

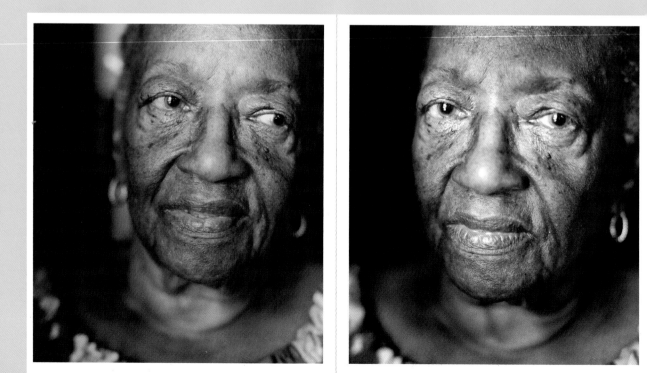

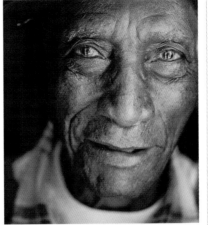

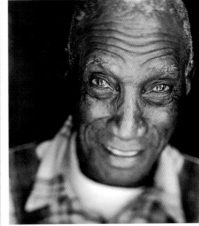

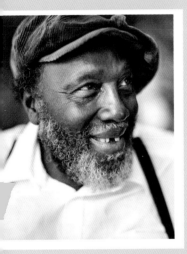

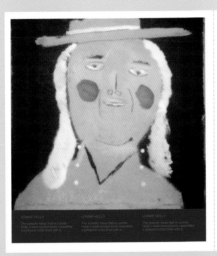

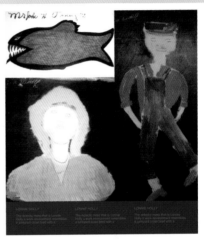

JIMMIE LEE SUDDUTH

Born March 10, 1910 in Cains Ridge Alabama. Jimmie Lee Sudduth has been painting all his life. Jimmie paints with a sweet mud mixture that he discovered when he was a child. This mixture is a brew of sugar honey or molasses, paint or natural pigment, and mud, of which there are at least 30 types in Alabama.

The story about Jimmie is that he created his mixture of sweet mud when he was a child. His mother was a Native American tribal medicine woman. She would take Jimmie into the woods to gather the natural herbs and berries that she used to create her tinctures and medicine. After traveling for some time into the thick of the woods she felt that it would be too dangerous for Jimmie to continue on with her. She left the young Jimmie on a log with a small pot of honey to pacify him until her return. Some time passed and his mother returned to find Jimmie painting in mud that he created by softening the earth with the honey. Although she scolded the boy for his obvious waste of scarce honey she could not help but to be delighted by the imagery her young boy created in the earth. A few weeks had passed and once again it was time to return to the thick and forage out more herbs and berries. The path was always the same and would return them to the log where Jimmie would sit. This time, without honey. Astonishment swept over her face as Jimmies mother saw the images previously painted by Jimmie unscathed in the dirt in the very same spot they were weeks ago despite the fact that it had rained on several occasions since. At that moment it was predicted that Jimmie would be a wonderful artist, which is exactly what he is.

In Jimmies youth, supplies would often run low so he would have to mix in berries as well as other colorful objects found in nature to create the desired color tones.

Jimmie Lee has regained his childhood. He takes in information as if it were a wonderful new experience. Ever smiling, perpetually pleasant, Jimmie stomps his feet to the smooth draw he pulls from his harmonica. Inside his shed of a workspace, Jimmie is covered in paint spattered overalls and the trucking cap of the day. Ninety years old and still turning out work.

As the pain of age creeps in there is one appeasement. Seebo is Jimmies younger cousin, at age 72. Seebo handles all of Jimmies affairs of the estate. Takes care of the house and gets Jimmie moving, although Jimmie can stomp like a child.

Jimmie is a favorite at art festivals and Museums alike. Kentuck Festival of the Arts is the Mecca for all folk artists as well as lovers thereof. Jimmie has attended every one since its inception 30 years ago, with the exception of 1999 for health reasons. Jimmie will be amongst the world until the mud crumbles.

Jimmi Lee Sudduth

ANOTHER MA GAZINE

PREMIERE ISSUE, BI-ANNUAL AUTUMN/WINTER 2001 UK£ 4.99

COVER PHOTOGRAPHY BY NICK KNIGHT

ANOTHER MA GAZINE
FOR MEN AND WOMEN

CONTENT 1/2

ISSUE 1

ANOTHER MAGAZINE FOR MEN AND WOMEN AUTUMN/WINTER 2001

FASHION
One PHOTOGRAPHY MARIO SORRENTI FASHION DIRECTION CAMILLA NICKERSON PAGE 184-197
Two PHOTOGRAPHY TERRY RICHARDSON FASHION DIRECTION SABINA SCHREDER PAGE 198-207
Three PHOTOGRAPHY NICK KNIGHT FASHION DIRECTION KATY ENGLAND PAGE 208-209
Four PHOTOGRAPHY GREG KADEL FASHION DIRECTION TABITHA SIMMONS PAGE 210-217
Five PHOTOGRAPHY RICHARD BURBRIDGE FASHION DIRECTION SABINA SCHREDER PAGE 218-229

PERFORMANCE PHOTOGRAPHY PHIL POYNTER FASHION DIRECTION KATY ENGLAND/TABITHA SIMMONS ... PAGE 150-175

SOUL WINDOWS PHOTOGRAPHY DAVID SIMS FASHION DIRECTION KATY ENGLAND PAGE 232-241

CENTREFOLD
KATE HUDSON & CHRIS ROBINSON
GUEST ART DIRECTOR STELLA MCCARTNEY PHOTOGRAPHY MATTHIAS VRIENS PAGE 176-177

INTERVIEWS
JUDE LAW INTERVIEW BRUCE ROBINSON PHOTOGRAPHY HELMUT NEWTON PAGE 98-107
MARIANNE FAITHFULL INTERVIEW BARNEY HOSKYNS PHOTOGRAPHY HORST DIEKGERDES PAGE 108-117

ANOTHER MAGAZINE 15

108 ANOTHER MAGAZINE

"WE WANTED TO MAKE A REALLY FUCKED-UP CLUB TRACK THAT WASN'T TRYING TOO HARD, AND DIDN'T SOUND TOO READY FOR THE RAVE CHAMBER." Beck

Designer
Nobi Kashiwagi

Junior Art Director
Thomas Hofer

Design Company
Buero NY

Photographers
Nick Knight
Gered Mankowitz
Horst Diekgerdes
Terence Spencer

Country of Origin
UK/USA

Work Description
Front cover (above far left), page and spreads from *Another Magazine*

Dimensions
9³/₄ x 12⁵/₈ in
250 x 320 mm

1980 TERENCE SPENCER CAMERA PRESS

MARIANNE

ANOTHER GAZINE

TEXT SUSANNAH FRANKEL CATWALK PHOTOGRAPHY CHRIS MOORE

COLLECTIONS REPORT

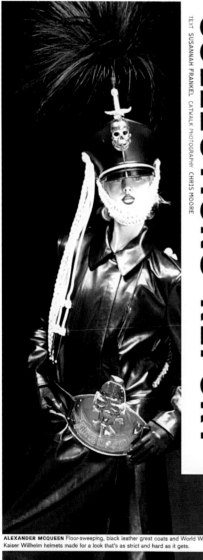

ALEXANDER MCQUEEN Floor-sweeping, black leather great coats and World War I, Kaiser Willhelm helmets made for a look that's as strict and hard as it gets.

Fashion mayhem ...

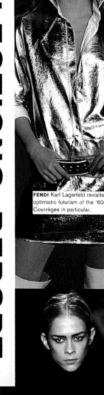

FENDI Karl Lagerfeld revisited the optimistic futurism of the '60s and Courrèges in particular.

YVES SAINT LAURENT Tom Ford preferred to plunder the wasp-waisted, full-skirted silhouette of the Victorian era for this show.

The autumn/winter 2001 season will go down in fashion history as being about as contrary as a petulant child. The battle will be a ferocious one - there's nothing much like a fashion spat after all - between the vampish and the plain pretty, the masculine and the overtly feminine, the sophisticated and the sweetly naive.

At Gucci, there was skin-tight black tailoring gleaming with zips that snaked from throat to waistline and from waist-line to hem one minute, a parade of what can only be described as baby doll dresses the next. At Alexander McQueen, where a Victorian toyshop formed the backdrop and an art deco merri-go-round took centre stage, models stalked out in everything from frilly lace ra-ra skirts to World War I, Kaiser Willhelm helmets and floor-sweeping black leather greatcoats.

"I wanted to explore the sinister side of childhood as well as the fun," McQueen said after his show - the soundtrack sampled the eerie voiceover of the Chitty Chitty Bang Bang childcatcher and many of the looks were inspired by the film but this was infant fantasy at its most twisted. "They show children clowns as if they're funny. They're not, they're really scary."

Christian Dior, too, encapsulated extreme contrasts in mood: mannish tailoring was juxtaposed with quite the prettiest floral-print, bias-cut sheath dresses in a show that was pure Galliano at his most insanely eclectic. At Comme des Garçons, meanwhile, winsome lace-trimmed dresses, layered one over the other, were cinched at the waist with glossy black weightlifters' belts. Suffice it to say that a petticoat has never looked so, well, so hard. With the typical reticence to expand on her vision that belies her stature as perhaps the world's greatest designer, Rei Kawakubo said that her collection was about "freedom beyond the taboo, expressed in the Comme des Garçons way". Trousers slashed at the crotch - for easy access, perhaps? - certainly put the wind up the more politically correct in attendance. But, then, this is fashion, those who take offence easily might do well to look away.

As if to drive fashion's current, disparate nature home, even the requisite revivals came, this season, from opposing corners: the dark, repressed sexuality of the Victorian era on the one hand and the happy optimism of the free-loving '60s youthquake on the other. It seems strange to some, incidentally, that in our proud to be modern times, there are always revivals. At Christian Dior, John Galliano went out on a limb and revisited the Acid House movement of the early '90s - and this not even a decade after the original was laid to rest. This made for uncomfortable viewing for those old enough to have lived through "smiley culture" the first time round - memories of drug-fuelled escapades in muddy fields, located around the none-too-glamorous M25, continue to make the thirtysomething generation wince in pain. It is interesting, however, that for younger members of Galliano's privileged audience, this was a blithe and brightly coloured sight for fashion eyes. The fact that the great names in fashion seem, for the time being at least, to have agreed to disagree is, of course, just as it should be. it almost goes without saying that the days when girls will be girls are long gone, and among the greatest things about being a woman at the turn of the 21st century is that fashion can be dictatorial only at its own expense. In the end women wear what they want to wear and are quite empowered enough to step out in corsets and stilettos should they so wish - let anyone tell them they can't wear them to the office at their peril. Equally, should they prefer a more androgynous low-profile dress solution, that's fine too. The cleverly post-modern, meanwhile, will really put the cat among the pigeons by mixing the two. This - alongside the requisite jeans-and-t-shirt combination that no modern woman, or indeed man, should ever be without - is, perhaps, the most contemporary way of them all to dress.

In a world where the mega-corporation reigns supreme - news of The Gucci Group snapping up one name after another in lethal competition with France's giant LVMH breaks almost daily - individuality shone like the brightest of lights at the collections. There are certain designers who, quite refreshingly, remain true to their own particular vision whether this fits neatly into any prevailing trend or not.

In New York Miguel Adrover sent out floor-length caftans, harem pants and layered printed tunics, all of which went to prove that there is more to looking lovely than a mini-skirt and high heels. ►

CHRISTIAN L
maximal design

MA

Designer
Nobi Kashiwagi

Junior Art Director
Thomas Hofer

Design Company
Buero NY

Photographers
Chris Moore
Richard Avedon

Country of Origin
UK/USA

Work Description
Spreads and pages from
Another Magazine

Dimensions
9³/₄ x 12⁵/₈ in
250 x 320 mm

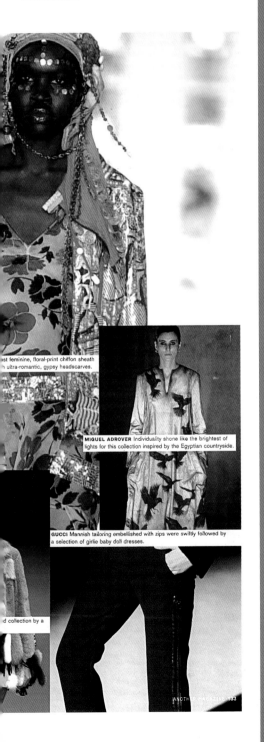

st feminine, floral-print chiffon sheath
h ultra-romantic, gypsy headscarves.

MIGUEL ADROVER Individuality shone like the brightest of
lights for this collection inspired by the Egyptian countryside.

GUCCI Mannish tailoring embellished with zips were swiftly followed by
a selection of girlie baby doll dresses.

d collection by a

ANOTHER MAGAZINE 133

ANOTHER THING I Wanted To Tell You

by Hal Wilner, Music Producer

Ernie Kovacs, the innovative 50s American TV comedian.

"Ernie Kovacs seems to be virtually unknown outside America, and even there he's no longer a household name. He was an innovator and one of the great genius artists at a time when TV was still relatively young. Beyond just being an intellectual comic able to do almost anything, he was a great actor, a pioneer of television, an improviser of talk and variety shows, and a supreme surrealist. On TV in the '50s, he'd do video vignettes of apes dancing ballet to Swan Lake, people eating spaghetti to Stravinsky, and kitchens coming to life choreographed to Prokofiev. He thought up strange recurring characters such as Wolfgang von Sauerbrauten, German disk jockey, "schpinning der dischks"; Miklos Molnar, irascible Hungarian chef; Motzah Hepplewhite, drunken magician; Percy Dovetonsils, poet and Martini lover. Kovacs wasn't subversive in the political sense except that he wasn't politically correct and did everything with amazing sophistication. No one has ever bettered him."

Hal Wilner is an esteemed producer best known for his work with Lou Reed, Marianne Faithfull, William Burroughs and Allen Ginsberg. He famously produced tribute records to Charlie Mingus "Weird Nightmare", Kurt Weill "Lost In The Stars" and Edgar Allan Poe "Closed On Account Of Rabies" as well as the soundtracks for Robert Altman's *Shortcuts* and *Kansas City*, Gus Van Sant's *Finding Forrester* and Wim Wenders' *The Million Dollar Hotel*. Last year, Wilner organised a benefit concert featuring Nick Cave, Van Dyke Parks and David Johansen in aid of the archive of Harry Smith and the Anthology of American Folk Music.

ARCHIVE PHOTOGRAPH OF ERNIE KOVACS COURTESY OF EDIE ADAMS TEXT BY EDWARD HELMORE

60 ANOTHER MAGAZINE

ANOTHER THING I wanted to tell you

ANOTHER MAGAZINE ASKS TWELVE VISIONARIES TO GET PERSONAL AND SHARE A PASSION WITH US.
WHAT ARE THEY THINKING ABOUT, LISTENING TO, READING ABOUT OR SEARCHING FOR RIGHT NOW?

AIMEE MULLINS VITALITY
CHRISTINE VACHON DOLLS
NOEL GODIN ANARCHY
CHAN MARSHAL EARTH
HAL WILNER LAUGHTER
ROMAN COPPOLA FUTURISM
KIM GORDON VOICES
BRUCE MAU AMERICA
BENEDIKT TASCHEN DIRECTION
CHRIS OFILI BEATS
SIMON DOONAN TASTE
TERRY GILLIAM TIME
KARYN KUSAMA WAR

ANOTHER MAGAZINE 29

ANOTHER THING I Wanted To Tell You

by Bruce Mau, Designer

Nothing Personal, by photographer Richard Avedon and writer James Baldwin.

"Larry, an essayist on the future's capacity of the image and *Nothing Personal* is a model held hits the hip spot. Ostensibly a book about late in America in the early '60s, it is also an incredibly powerful indictment of images combined with sexually fraction text. It is a kind of *Anatomy of America*, that plays in two modes, a text and an image essay. James Baldwin is completed the text, an essay about the separation between rhetoric and reality in America. Avedon then completed a set of images picturing that rhetoric. Working together, they both expose the reality of modern America by weaving in and out of each other so that you begin to read images in the same way that you read text. It is an beautifully powerful piece of work and points in different ways in which we are able to view the world around us."

Canadian Bruce Mau is a multi-disciplined designer in full-direction. Since founding his Toronto-based studio in '85 he has maintained long-standing relationships with architects Frank Gehry and Rem Koolhaas both whom he designed and contained the book *S, M, L, XL* over the years, as well as producing installations work for many international institutions, from the Getty Research Institute to the Whitney Guggenheim. Although committed to broadening the role of the designer, Mau is most well-known for his books and his content with the relationship between image, text and page. Last year, he published the 640-page *Life Style*, a collection of essays, criticism and images questioning and discussing the importance of the aesthetic in our time.

88 ANOTHER MAGAZINE

65

RECORDINGS WERE NOT SEEN AS OBJECTS BUT AS TOOLS

musical forms and conventions by recontextualising and abstracting them within the highbrow realm of "New Music." This working method is similar to that employed by the LAFMS members, one which utilizes an aspect of known musical and cultural currency as a literal tool for sonic transmogrification. In the case of LAFMS, this approach winds up all over the place: L-44's flouting of "high" electronic music culture, Tom Recchion's montage-style reconfiguration of old exotica records into something altogether different and repetitive; Fredrik Nilsen's sampling common "how to speak a foreign language" recordings in some of his live performances — and this is just the tip of the iceberg.

This pre-sampling approach to recontextualising extant recordings is an important part of the LAFMS modus. Most listeners use music as some form of social lubricant or as a mnemonic key to unlock certain nostalgic memories in themselves. It remains true to this day that music is rarely conceived as material for any further use. To LAFMS members, however, recordings are not seen as monoliths to stand back from and worship, but as tools in the world — tools which stimulate one to action, asking to be altered or wholly transformed by the listener. They understand listening to music as an active process, even when it involves a passive object like a record LP or CD. Consciously or not, they consistently refuse to be addressed as passive "recipients." In this way the LAFMS can make a commercially available record "theirs" without allowing it to dominate them, thereby showing that they understand recordings for what they are: objective tools for making sound. For instance, the group Monique Et Aviv use old exotica recordings and superimpose their own words, singing on them in a kind of unsettling personal karaoke. Their tracks provide a good example of the LAFMS appropriation strategies.

Although this box-set might well promote a sense of retrospective closure, the LAFMS are not a thing of the past. Just last September, the groups Extended Organ (including Joe Potts, Tom Recchion, Fredrik Nilsen, and artists Paul McCarthy and Mike Kelley) and Solid Eye (including Rick Potts and Joseph Hammer) performed their brew of densely layered found-sounds at The MAK Center's Schindler House in LA to a capacity crowd. What they are doing may still be unnamed, but there seem to be more of us out there in the field of experimental and improvised music who are willing to begin the process of deciphering it.

Even in all their unruliness and strangeness the LAFMS may claim a secure place in the musical continuum, and the very existence of this box-set belies this fact. There, LAFMS "members" acknowledge the sonic debt they owe to many musics through quotation and parody. No doubt Cage, in his openness to new musical forms and sounds, enabled them to come to grips with music while at the same time allowing them the freedom to negotiate their own relationships to music through improvising. And at the very end of the entire CD set, after approximately two minutes of silence at the end of disc ten, the immediately familiar, distinctly feminine and jovial voice of John Cage chimes in through the lo-fi haze of a home tape recorder. The LAFMS know where they come from and they give Cage the last word on it, literally.

Desi-Dosefus

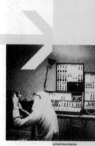

La Forte Foot at Cal Arts

WHITE ALBUM

what immediately
them. It is a strai
point-of-blunt ge
offers virtually n
ties for analysis a
this instance, their
of assembling te
band names and s
duction strategy
indexical relations
tice as a curator.

those from a rang
and institutions.
institutional hold
or less randomly
a process the ar
sample drilling, r
retrieve represer
an informationa
accrued over time
tary increments
disparate source:

WHITE

...pines — to some extent ...then reproduced "as is" — ...o Muller's particular filing ...act that there are, in fact, ...of the "White Album" ...ertain trainspotterishness ...ist impulse to "back up" ...ms) although it is just as ...t would actually use both ...is DJ sets. Indeed, the ...this double album alludes

...k, and this was in turn ...with related material on ...rom LA. As the light and ...s 1960s counterculture ...emerging from a dismal, ...climate, and the second ...and of perpetual sun — ...g up here would seem to ...in contrasts. However, ...riginally hoped to exhibit ...multaneously in Liverpool

directly to the DJ's dual turntable rig, to the possibility of cutting up and reconfiguring extant recordings, which is precisely what The Beatles themselves began to do on the "White Album." David Bunn also examines the archive in an ongoing multimedia project that entails a process of connecting, or as he puts it, "twinning," the obsolete card catalogue of the LA Central Library with

and Los Angeles, thereby highlighting the connection between these two "port-towns" — i.e. the sea, which, according to the title of a book that Bunn has included in his installation, "is a magic carpet." As it happens, the untimely closing of Bunn's local gallery, Burnett Miller, in the summer of 1997 would drastically alter this plan. It is therefore the first time that this work, entitled "DB

(an excerpt from Here, There and Everywhere, 1997)," will be seen on these shores, as a matter of just, just one door down from its initially proposed location. In the context of any other project, this sort of anecdote might seem superfluous, yet here every slight shift in the economic fortunes of the town in relation to the other is potentially grist for the mill. Brian Tucker is also concerned

Frances Stark, "Tiger Dead a Week, The Gromer Heroin" 1996 (detail)

ultimately served only to reveal the idiosyncrasies of the collector himself — which was, of course, the point. Here, Tucker has reproduced some of that material to fit into a standard jewel-box CD case. The cover of his limited-edition sound work, like the first batch of The Beatles' "White Albums," plain white, with only a hand-stamped edition number to identify it. Titled "The Smart One, The

with archival themes, but within the particular context of fandom. As with many or most of the works included in "White Album," this one discloses a specifically historical dimension since it is related to an earlier work that was shown in an exhibition entitled "Inheritance" at LACE in the Spring of 1992. That show proposed to examine the artistic potential of genealogical method and procedure

claim that a successful pop song is one that can be identified from the very first moment. Despite the brutal and alienating hatchet job that Tucker has performed on The Beatles' discography, one tends nevertheless to surrender, in stops and starts, to the surging nostalgic emotionalism on offer. The immense compression of a towering vinyl archive onto a single "faceless" digital disc no doubt plays

within a decidedly Post-Conceptual, identity-based framework. Tucker's contribution took the form of several conventional museum vitrines stuffed with Beatles memorabilia. Upon examination, however, one found that the actual contents of this collection were by no means exhaustive, nor were they systematically arranged to further any particular knowledge of their subject. This arbitrary accumulation

Good-Looking One, The Quiet One, The Clown," it consists of the first few bars of every Beatles song ever released, played in consecutive order and followed by a brief moment of silence. This gap or space between is just long enough to "cleanse the palate," as it were, so that each new tune can claim our undivided attention. From start to finish, the experience amply confirms Brian Eno's

a part in this as well. Frances Stark also works from the singular perspective of the artist as fan. It is a position that she has explored throughout her career in relation to a wide range of theories of authorship, both Modern and Post. The two works on view here are almost emblematic in this respect, as The Beatles mark a limit-point of superstardom beside which the affairs of the art world

Designers
Brad Bartlett
Danielle Foushee

Illustrators
Brad Bartlett
Danielle Foushee

Art Directors
Brad Bartlett
Danielle Foushee

Design Company
Turnstyle Design

Country of Origin
USA

Work Description
Front covers (above and bottom far left) and spreads from *X-Tra*, a two-color art journal

Dimensions
8 3/8 x 10 7/8 in
215 x 275 mm

ing. How many artists can you say have done that? Now that we're coming back to some of these ideas, we find Fend has been making progress on his own all this time. I think he's a great resource and am curious as to why he isn't better known."

I take Fend's talk as a performance, much like those of the late artist Joseph Beuys, in which complex ideas were discussed within a mix of disciplinary concepts punctuated by visual symbols, technical drawings and blurry metaphysical pictorials. Fend, however, focused on the pragmatic activities of the artist without any detours into the metaphysical. His role is that of a social entrepreneur who works to change systems and provide solutions.

It is easy to dismiss Peter Fend as a dreamer or a kook, but I think he's a type of dreamer the world needs, the kind who can dip their hands into various disciplines and pull together something that can benefit all forms of life. Artists like Fend are, to use Beuys' analogy, sources of energy or links to a type of multi-dimensional thinking that exists outside the academy.

After travelling through the Southwestern deserts with little money, foolishly drinking water directly from the Colorado River, and sitting through two days of presentations, Fend is back in New York, where he recently unveiled his new work, "Big Deal: Revival of the Americas." Nicolai Fine Art's press release states that Fend aims "to tackle the ominous and growing threats of global warming, non-renewable resource depletion, and the widespread degradation of renewable soil/water resources." In conjunction with that show, Fend is trying to raise funds for his underwater Rigs by selling shares of stock in Ocean Earth's subsidiary corporation, Giant Algae Systems. Once again, Fend has a lot on his plate.

Last night I had a dream. Not about Fend disappearing in the desert, but about his Soil Rigs floating in the Pacific ocean, turning biomass into energy, as all the moth-balled fossil-fuel generators were scavenged for their metal parts. The lights never flickered.

1. The activities of OEDC are reminiscent of the Dutch artist group Superflex, whose methane-producing manure-biogas-digester balloons are used to provide electricity in some small third-world villages.

2. After the event, I contacted a few experts on ocean flow patterns to see if Fend's claim that the rainfall in California would be directly affected by the Three Gorges Dam construction was correct. I was told that "screwed" was a little extreme. One of my contacts said that "the dam will exert some significant influence on the overall flow pattern as far the discharge into the sea is concerned. As far as changes in the SoCal rainfall patterns are concerned, much uncertainty still exists."

Peter Fend, "Rooftop of Death Hole and Dry Wells," 1978.

Peter Fend, "Instead of Dams, High Land Meanders and Water-wheels"

BUM

14-15

ARCHITECTURE OF THE 21ST CENTURY: OCEAN EARTH
By Peter Fend

how far can art go?

Building on phenomena like Architecture Without Architects and global digital flow, Ocean Earth functions as an architecture firm without precedent: a firm producing only, as its NY State corporate charter of 1980 describes, "architectural components" and "media services." That is, it produces hardware for architecture without architects, and then the information on how to make it work.

The idea base is the art of the past century, the 20th. What has originated as art, like structuralist film, or field-theory painting, or salt-lake earthworks, or counter-weighted arcs, gets combined with scientific research into nature-suited programs of construction and development - on the scale of current technological impact, the planet. Since, of course, the planet is chiefly saltwater, recalling Duchamp, this firm set up for global-scale architecture was founded as "Ocean Earth Construction and Development Corporation." To avoid some acronym confusion with the supra-governmental Paris-based Organization for Economic Cooperation and Development, or OECD, we shortened the name in 1994 to "Ocean Earth Development Corporation," or "OEDC." Our phrase: How far can art go?

The track record says, Pretty far. Certainly beyond anything like art-world stardom. [...]

To date, even after over a decade on the world-art circuit, more press and more official action, even more money and more contracts, has been generated by Ocean Earth outside the art world — its source — than inside. The question now, like that faced by the Russian Constructivists, the Italian Futurists and the French/British Situationists, and like that successfully solved by the artists who worked for Louis XIV in the 17th century to become chief architects of the French State and its fortifications, is to break out of the box of culture onto the stage of history. Onto the stage where art, like all the other professions, belongs. In the front pages, not the leisure ones.

This can happen if one uses what John D. Rockefeller, Bill Gates and Japan's present-day samurai have practiced to cause pan-global change: business organization.

Architecture, Ocean Earth says, can be Big Business. It can also be, as history shows repeatedly, the Manifestation of State. All our media and architectural-component offerings are produced under brand names, each one being managed and financed differently, some quite independent, all in their own competitive markets. All brand groups, while separate, enjoy the unique combination of geographical, engineering, and ecological knowledge gathered by Ocean Earth.

Reprinted, with permission, from the "Ocean Earth" brochure. The original punctuation has been retained.

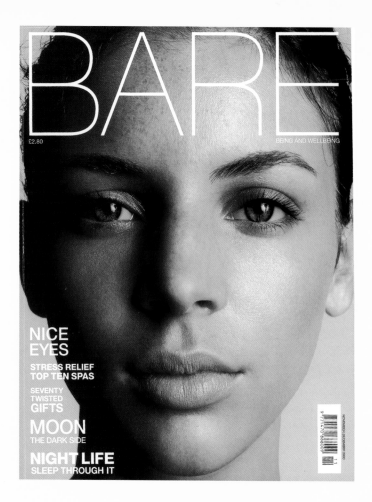

Designer
Annie Gleadow

Senior Designer
Daniel Biasatti

Photographers
Todd Barry (cover)
Magnus Mårding
Nato Welton

Art Director
Kirsten Willey

Design Company
John Brown Publishing

Country of Origin
UK

Work Description
Front cover (left),
pages and spreads
from *Bare* magazine

Dimensions
9 x 11³/₄ in
230 x 300 mm

From cover:

£2.80

BARE
BEING AND WELLBEING

NICE EYES

STRESS RELIEF
TOP TEN SPAS

SEVENTY TWISTED GIFTS

MOON
THE DARK SIDE

NIGHT LIFE
SLEEP THROUGH IT

20 02

PERFECT VISION. WHAT YOU NEED TO SEE
YOU THROUGH: LIPSTICK PSYCHOLOGY,
GLASSES THAT MAKE WINE TASTE BETTER,
KNICKERS TO PANT FOR… AND, SEVEN PAGES
OF TWISTED CHRISTMAS PRESENTS FOR THE
CHICK WHO LIKES TO GET IT LICKED EARLY

THE NEXT THING YOU TO

THREE HAIL MARYS – AND A TREE

THE TREES MOST PEOPLE WILL SOON BE thinking about are those acres of pines and firs: grown by the million, slashed, sprayed, shipped, then slung with bits of coloured glass. But, this year, if you fancy buying a tree that might make it to 2001, you could do worse than follow the lead of Stella McCartney, Yasmin Le Bon and Damien Hirst and sign up with Future Forests. The organisation rather alarmingly promises to make you 'a carbon neutral citizen, household or corporation' by planting the number of trees to counteract your carbon emissions. The Woodland Trust, meanwhile, will dedicate a tree for you, your partner, your mum – or your pet iguana.

If you've bought a tree for everyone you've ever met and still have cash spare, you could take the example of Doug Tompkins, ecologist and founder of Esprit clothing. Over the last decade, he's snapped up 1,000 square miles of temperate rainforest in the south of Chile to protect it from loggers. I guess he's what you'd call a carbon negative citizen. CHRISTOPHER STOCKS

DID YOU KNOW?
● It takes two tonnes of fuel to fly one person across the Atlantic.
● 0.21kg of carbon is produced when making a CD.

WHAT YOU CAN DO
● Planting one tree can offset the CO_2 produced by one long-haul flight
● Become a carbon neutral driver by planting five trees per year
● If you live in the UK, you can offset your carbon emissions by planting 15 trees per year

WHO TO TURN TO
● Future Forests, Hill House, Castle Cary, Somerset BA7 7JL; 01963 350 465; www.futureforests.com
● The Woodland Trust, Autumn Park, Grantham, Lincolnshire NG31 6LL; 01476 581111; www.woodland-trust.org.uk
● Trees for London: 020 7587 1320

CARBON NEUTRAL CHRISTMAS
The average family Christmas involves: ten shopping trips (eight miles each); five ten-mile taxi rides, three times the normal household waste; Christmas tree, packaging and extra food waste: an increase in the use of gas and electricity; and four 100-mile round-trips to relatives. This means each family produces 195kg of carbon over the holiday.

WHAT YOU CAN DO
Plant one tree and over time it will absorb all the CO_2 from your Christmas this year.

ALTERNATIVE PRESENTS
If you buy a tree through Future Forests, they will e-mail back a certificate and map of the forest in which your tree has been planted. These can be printed off and given as Christmas presents.

'Do you want to dance?' If these words start a drumbeat pounding in your chest, it shouldn't be through fear

DANCE

THE BEST PARTIES ARE ALWAYS THOSE WE DANCE AT. When, loosened either by a touch too much alcohol, or simply the right track playing, we get up and dance. We will ache the next day, we will form short, intense relationships on the dancefloor with people who were strangers five minutes ago, but we just can't help ourselves.

When asked to choose the 'best thing in life' the writer Richard Williams chose not staying in one of the world's best hotels, or having a fast car, but dancing in his ski-boots. He described it thus: 'On an afternoon in early spring, the Dolomites turn pink.. You've spent the day skiing the Sella Ronda. Now it's teatime, and the light is starting to go. You arrive at Corvara. There's a hotel, with a large bar. A band is playing. You order a gluhwein and, still with your ski-boots on, you dance the rest of your energy away.' Makes you want to do it, doesn't it? This is because dancing, like yawning, is contagious.

Dancing resonates deep within us for the simple reason that, after breathing, it was the second thing we learnt how to do. Babies don't know they're dancing, of course, but then expressing ourselves through movement is so primal, it comes before conjecture. Dancing makes us feel powerful, and when we feel powerful, we feel good.

When we dance, three things happen: we connect with nature because we are responding to a beat that reminds us (however unconsciously) of

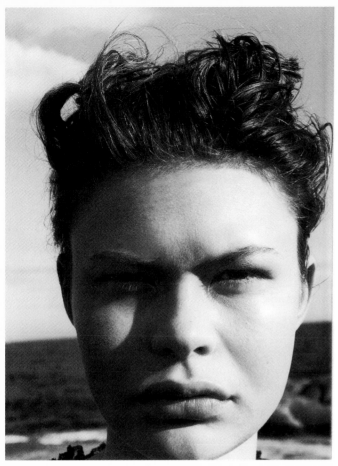

WORDS JUSTINE PICARDIE
PHOTOGRAPHS MAGNUS MÅRDING
ART DIRECTION STEF BAKKER
CONCEPT CLAUDIA NELLA
MODEL SAIMA @ STORM
PHOTOGRAPHER'S ASSISTANT ERIK FREDERIKSSON

MOON

RAINS, FLOODS, HARVEST, FERTILITY... THE MOON'S PRIMORDIAL POWER IS SO OBVIOUS, BUT SO LITTLE UNDERSTOOD. WE'VE SPENT BILLIONS GETTING THERE, BUT WE'RE STILL IN THE DARK

THE WAXING AND WANING MOON LINKS US WITH DEATH, REBIRTH – AND ETERNITY – SYMBOLISING LIFE TO DEATH AND DEATH TO LIFE

BARESPIRIT 057

BARE 27

cubism

The world's most expensive ice

In 19th-century Europe, you weren't anyone unless you had an ice house in your mansion. These igloo-shaped enclosures guaranteed ice cream right through the summer. And without ice cream, you might as well have been in Antarctica. At the Great Exhibition of 1851, French inventors proudly unveiled their *frigorique*, the world's first fridge. And in 1929, American inventor Clarence Birdseye perfected the fast-freeze technique that's kept the world in fish fingers ever since.

Today, most commercial ice cubes are machine-made, sliced from tubes or pellets of UV-treated water. Greenland Ice Cap Rocks, however, are something else altogether – the purest, most expensive ice cubes in the world, extracted by Inuit miners from giant inland glaciers. Ssshhhh. The Greenland rocks you're dropping into your pink gin are breaking up, releasing 60,000-year-old oxygen into your glass. Take a sip and listen to the song of the glaciers. KEVIN GOULD

Greenland Ice Cap Rocks are available at £7.50 per kg from Ice Box, Unit A, 35/36, New Covent Garden Market, Nine Elms, London SW8; 020 7498 0800. A mail order service is available

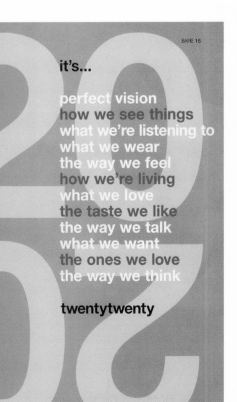

BARE 15

it's...

perfect vision
how we see things
what we're listening to
what we wear
the way we feel
how we're living
what we love
the taste we like
the way we talk
what we want
the ones we love
the way we think

twentytwenty

2020

Designer
Annie Gleadow

Senior Designer
Daniel Biasatti

Photographers
Martyn Thompson
PSC
James Burns

Art Director
Kirsten Willey

Design Company
John Brown Publishing

Country of Origin
UK

Work Description
Spreads from
Bare magazine

Dimensions
9 x 11³/₄ in
230 x 300 mm

WORDS LISA ARMSTRONG
PHOTOGRAPHS MARTYN THOMPSON
STYLING CARIN SCHEVE
STYLIST'S ASSISTANT LYNSEY MARSDEN
STILL-LIFE STYLING JANE LARKIN
CASTING SIAN @ESP

sleep

MIDNIGHT IS NO LONGER THE MIDDLE OF THE NIGHT, WITH ALL THE MYSTERY IT IMPLIES. THANKS TO THE LIGHT BULB, WE'VE OVERRIDDEN OUR BIOLOGICAL CLOCKS TO STEAL EXTRA TIME. BUT AT WHAT COST TO OUR HEALTH, IQ – AND LIFE-EXPECTANCY? EIGHT HOURS' SLEEP ISN'T A LUXURY. WHY YOU REALLY NEED TO SPEND MORE TIME IN BED

FOR MOST OF HISTORY, PEOPLE HAVE GONE TO BED WHEN IT GREW TOO DARK TO DO ANYTHING ELSE. They woke gradually and naturally with the dawn, eight or nine hours later. They were in tune with their internal clocks to an extent that seems almost Utopian. Today, we live in a 24-hour society where progress means being able to bank on-line, do the Tesco's shop or surf into a chat room at 3am. Our happiness is measured against the perfect homes, perfect jobs, perfect wardrobes and perfect gardens we're supposed to want. Oh, and that's before you factor in the perfect (ie frantic) social life. The only way to achieve any of this is to borrow time from what should be sleeping hours.

On average, we sleep one-and-a-half hours a night less than our great grandparents did. At the start of the 20th century, a normal night's sleep was nine hours. Then in 1910, the first tungsten light bulb was switched on. We'd had light bulbs for a while, but this was a brighter prototype in which soot was no longer deposited round the bulb's filaments, causing it to grow dim with use. Brilliant scientific advance – but the inexorable slide towards sleeplessness had begun. Not having to fuss around with messy candles or smelly gas lamps, or jeopardise our eyesight by reading in the semi-dark meant we could push the boundaries of wakefulness. By 1975, that figure of nine hours a night had fallen to seven-and-a-half. Bedtime shifted to 10, 11 or later, instead of 8 or 9.

This would be fine if it also gave us licence to start work at a commensurate hour, but most of us are still locked into the daily nine-to-five routine. No wonder nearly half the adult population is said to suffer from some form of sleep disorder. The results of this can be serious: more than 20

ECRU FELTED PILLOW, £99, FROM NICOLE FARHI HOME. PETROL BLUE BEDSPREAD, £89, FROM THE CONRAN SHOP. SHIRT, MODEL'S OWN. TATAMI MATTRESS, £90, FROM GANESHA. TEA CUP, PLATE, KNIFE, PHOTOGRAPHER'S OWN.

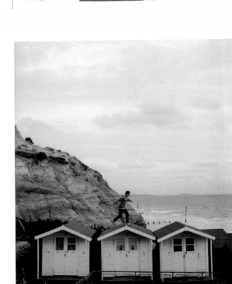

bonding

070 DATE BALANCE

46 BARE VOICE

WORDS ELSBETH THOMPSON
PICTURES JAMES BURKE

sea

It's powerful, mysterious and beautiful, but is the tide finally turning?

LAST YEAR, I FULFILLED A LIFETIME'S DREAM and moved to a house by the sea. Quite apart from its beauty, which changes daily with the weather and the seasons and the tides, there is something compelling about the mystery of the ocean. The twice-daily rhythm of the tides becomes the backdrop to one's life. Like sunrise and sunset, the ebb and flow is both incredible and inevitable – an everyday miracle. Many sea creatures, such as turtles and terrapins, time their breeding and egg-laying to coincide with certain tides. It has even been claimed that old people and animals who are ready to die often do so at the turn of the tide. Yet these phenomena are still mysteries to us. We may know more about Mars than about life on the ocean bed. Perhaps the sea, rather than space, is the final frontier. In the beginning, the sea's unknowns were listed. And long after we'd stopped thinking we'd sail over the edge of the Earth, the ocean

was a vast distance to be crossed and conquered. The sea was dreamed of some of us might as it because us in a series of myth stories, a bottomless larder, a playground for water sports and holidays and a giant dustbin.

Sometime in the last century we began to take this beautiful resource for granted. We thought the ocean were big enough to take anything and everything we threw at them. They're not. These days it is impossible to cross an ocean without encountering signs of human intrusion. Surfers Against Sewage reports finding sewage, tampons and syringes among the waves, out far offshore. Pesticides and chemicals are carried out to sea by rivers and into the marine food chain, with dire consequences. And goodness knows what percentage of the nuclear waste dumped at sea may have leaked or ruptured.

THE SEA IS ALWAYS IN A STATE OF FLUX, but recent climatic changes – again due to pollution of the environment – are wreaking far-reaching changes. Global warming has pushed up sea temperatures to record levels, attracting exotic fish and marine creatures from Britain's once-cold seas and forcing cod and haddock (again, already at risk from pollution and overfishing) further north. According to the World Wide Fund for Nature, a two-face temperature increase of just one more degree could lead to a mass northern migration of British marine species of between 200 and 450 miles. Changing weather patterns have also led to higher waves, which are accelerating coastal erosion. Oceanographers claim the mean height of Atlantic winter waves later →

PROJECT YOUR MIND THREE OR FOUR YEARS HENCE AND IT'S BEEN A LONG DAY. YOUR IMMUNE SYSTEM FEELS A NEED TO CONCENTRATE. YOU LOOK DOWN THE MENU AND ECHINACEA AND PROPOLIS, GARLIC BREAD WITH SYSTEM AND THROAT. CHICKEN IN THE BASKET WITH BRAIN AND HELP YOU CONCENTRATE. MAYBE A LITTLE IMPREGNATED WITH TIME-RELEASE VALERIAN – THAT WILL HELP YOU SLEEP WHEN YOU GET HOME. LASTLY, SOME KEEP YOU ALERT IN CASE THEY'VE OVERDONE IT AGAIN WITH OVERDID IT WITH THE GOTU KOLA INSTEAD AND YOU CAN'T NOW UNTIL THE MORNING'S MULTI-VITAMIN-AND-MINERAL-RELEASE VIAGRA TOAST – YOU'VE GOT A HOT DATE LATER.

PICTURE THIS: YOU'RE AT AN IMPORTANT DINNER MEETING BIT PUMMELLED. YOUR THROAT'S SLIGHTLY SORE AND YOU CHOOSE CAREFULLY. AVOCADO VINAIGRETTE WITH ANTIBIOTICS – THAT SHOULD TAKE CARE OF YOUR IMMUNE GINGKO. GOTU KOLA AND VASOPRESSIN TO WAKE UP YOUR GREEN SALAD WITH COS LETTUCE AND ITALIAN DRESSING STOP YOU GETTING TOO STRUNG OUT AT THE MEETING AND CONCENTRATED GUARANA WINE SHOULD JOLLY YOU UP AND THE OLD VALERIAN. WHEN YOU GET HOME, YOU FIND THEY SLEEP, SO YOU... ALL IS SORTED WITH-GINSENG MUESLI FOLLOWED BY CATUABA AND TIME-WHY NOT? IT SAVES TIME AND LETS YOU STAY ON THE CASE.

VITAMINS + FOOD = NUTRACEUTICALS

WORDS STEPHEN RUSSELL

THE SUPPLEMENTS THAT ARE BEING slipped into our food – nutraceuticals – are the latest food-improving, timesaving device. At some point in the near future, you may no longer need to visit your overworked GP to be dished out your various medication, or the chemist to buy your various pharma-patches. Instead, you'll be able to get it all controlled into the inside of your choice at the supermarket. The rationale is simple: we already supplements better with food and, with the ever-accelerating pace of life, once we won't even have time to remove the top from a bottle and swallow a pill. We'll be far too busy.

The nutraceutical industry is growing rapidly in America, and it has its marketing eye fixed firmly on Europe. The US, which tends to follow American trends just to free press later, is a particular target.

Front-line developers in the field include all the usual suspects – Monsanto, Procter & Gamble, DuPont – along with a host of lesser known names: Ohseki Nutraceuticals, Cyanotech, Flaxnil, Body Amino and Indiger Nutraceuticals. Many, like Indiger, are involved in a range of fields, including pharmaceuticals, nutraceuticals and the commercial applications of cloning technologies, or cattle breeding. Draw your own conclusions.

So just as the spectre of GM foods appears

to be receding, and it seems organic produce could finally rule the supermarket shelf, it now looks as if our stomachs – and quite probably our health and sanity – are about to be toyed with a whole new Frankenstein nutritional wheeze.

In all probability, the nutraceutical movement started out with some mixed, well-meaning lies and lorry types in northern California or New Mexico adding echinacea and golden seal to their wheatgerm juice – as you do – and soon the idea found its way into the hearts of the mind of folk who knew how to raise proper finance.

But it hasn't all been plain sailing. In September last year, Dr Steven Zeisel of the University of North Carolina School of Public Health – and obviously on old hippy – warned that the health of the public is at stake and urged the US Food and Drug Administration (FDA) to step up regulation of dietary supplements and nutraceuticals. 'Until a few years ago, most companies in the field were relatively small,' he said. 'But now multi-billion-dollar companies commit major resources to discovering health-enhancing activities within the foods we eat, and to changing traditional foods as they contain never-before ingredients.

Certainly, the companies involved are not

motivated by altruism. I mean, are you? If you'd been sitting at that business-raising session at lunchtime given the current unpopularity of GM, wouldn't you have seen a pay-rise coming if you'd suggested nutraceuticals as the way forward?

Cyanotech achieved close on $1.7 billion in worldwide sales last year with its top-three products alone. Incidentally, the company intends to boost profits for 2001 by introducing high-value products sourced from microalgae. These include genetically engineered pharmaceuticals (did you get that?), nutraceuticals and polyunsaturated fatty acids for which I'm sure you can hardly wait.

It's a silly move by the guys in concept and marketing, and will also provide a short-term turnover boost for supermarkets, and profitably chemists, too – assuming they stick enough food. It will increase the trend for oneway-stopping and ultimately enable all the large retail groups to morph into one universal big brother of an outfit and tally over not only the high-street, but the entire known world.

Who says you need all these supplements anyway? If you eat a fairly balanced diet most of the time, sleep seven hours a night and get some kind of intelligent exercise every day, neither your body nor mind needs them. In

fact, without access to body-food or hair-sorting accelerants, it's impossible to determine exactly which minerals and vitamins you need to increase or. In some cases, unless if you don't incite regular visits to a herbalist, you can't tell which herbs will heal you and which will do damage, and there's no way of knowing how various herbs will react with any unconsidered medications you might be taking. This can occasionally prove fatal.

That said, though it might seem unwise to experiment with our bodies in this way, it's never stopped us ingesting nutritional drugs, alcohol or any other substances that engender altered states. The fount of nutraceuticals is their potential to alter your state of mind and body, altering things is what we like to do. This applies to non-nutraceutical food as well. All food is a drug. Everything you eat changes your state of mind as well as body. Not just sugar, tea and coffee, but also carrots, beef and corn celery.

But what if nutraceuticals, like GM products, before these, are being added to food without our knowledge? What if your Frosties are already popped with Prozac? Do you really want your system – at fancy the Tiger's – perfect around by substances whose long-term safety – we haven't had time to prove?

still proceed notwithstanding, there is no doubt that nutraceuticals could be a no-care social. We all want to be healthy and feel on top form without having to do too much about it. We have less and less time to do anything other than sleep, eat, work and network. We are all hooked on convenience. So what will it do for you? Well, it could turn you into a superman or woman within three ways to male, or into an overlanked, our exhausted gut-measurement. We'll just have to wait and see.

Personally, apart from the old Bioelixir every morning I drop one or two heavyduty, multi-vitamin-and-mineral-cell-glowing capsules – as favoured by pumps and packers. Mostly I do it for the psychological effect, as I am sure they don't actually do anything. And I don't know about you, but I instinctively avoid milk with added vitamin D – added anything other than value many raw oil – and although I tried guarana chewing gum once, I didn't like my mind being gripped with.

Don't get me wrong. I'm no substance prude. My guru is that nutraceuticals could just be a direct transformation hit and our mouth sensible people getting in a tizz over the other hand... Pass the horseshoe honeous, will you? I'm just out of winds.

118 BARE BODY

BARE BODY 119

71

SECTION

Columns

Designer
Daniel Towers

Illustrator
Daniel Towers

Photographer
Daniel Towers

Art Directors
Sandy Ward
Rhiannon Robinson

Art College
Cumbria Institute of the Arts

Country of Origin
UK

Work Description
Spreads from *Art & Science*,
an experimental magazine

Dimensions
8¹/₄ x 11¹/₂ in
209 x 296 mm

GOING FOR IT!

Everyone begins life somewhere, as soon as they say their head out and draw their first breath. They reach out for the day they were born and eventually they get there.

discourse constructs colonized subjects as Others suitable for domination while at the same time collating data useful for the management of those Others. In reaction to this production of knowledge in the service of colonialist management, many of us have seized on multiculturalism as a means of wresting control of that knowledge in order to fight racism and promote post-colonial interests. We see multiculturalism as the logical local extension and application of the projects of political and cultural 'decolonization' taking place since the 1950s in the so called Third World.

Given such divergent histories and goals, one would expect multiculturalism to stand in stark contrast to area studies programs, which were after all the products of and reactions to the end of the colonial era. But how different are area studies and multicultural ism, and how well has the latter been able to overcome and correct the abuses of colonial knowledge? Has multiculturalism's focus on issues of textual representation been at the expense of exploring the contexts in which representation takes place? By focusing on the similarities that link colonial era ideas and institutions with their post-colonial reactions and readjustments, we hope to flesh out what we see as dangerous blindnesses in the multicultural proj Aftfly area studies programs we mean those programs which came to maturity during the main period of historical decolonization (the 1950s and 1960s) and provided the

fter the turn of the the last fifteen years, critiques of 'area studies' programs have become commonplace among 'enlightened' circles, thanks in part to exposés of the uses and abuses of the kinds of specialized knowledge these programs produce. These critiques have typically focused on the ways in which colonial

framework for U.S. studies of non-European cultures. Although neither real independence nor actual decolonization took any place in the contest there was a winner of the contest.

THE VISITATION

place during this period, imperialism did become a more complicated matter: these former colonies were given some semblance of autonomy and independence while their colonizers were compelled to carry on their work in less obvious ways. Neo-colonialism necessitated a more efficient, more informed management. Enter area studies programs, intended to provide interdisciplinary approaches to studying the cultures of the newly independent nation states. 'Culture' promised to be a useful tool that would better implement and sell development projects: You see, their society is based on kinship relations and therefore we doomed from the start: You see, their society is based on kinship relations and so they can't be related . After this occurence the people never went back so nothing further happened whatsoever. In fact nothing seemed to take place prior to this happening because there was nothing to do. But how interdisciplinary did these programs become? While some area studies programs

did emerge spontaneously to fit the new needs, many others were formed as extensions of previously existing language studies departments. In the social sciences, we find disciplines based in understandings of culture (anthropology), micro-political relations (sociology), or macro-political relations (political science); and in the humanities, disciplines are divided by language group or artistic medium. Contrastingly, in area studies the only explanation for the areas' under study is the First World's geopolitical order

ing of the globe; it's only when we hold the programs (Middle Eastern Studies, African Studies, East Asian Studies, etc.) up to the light of geopolitics and foreign policy that we become able to see the logic that brings together the likes of Iran, Turkey and Egypt in a monolithic 'Middle East', despite their many linguistic, religious, ethnic and cultural differences. Such a conception of the world would seem to demand an interdisciplinary approach. Instead what we see is a proliferation of a-disciplinary area studies programs which are deficient in the theoretical underpinnings that characterize other departments, and yet qualify as disciplines in the worst possible sense of the term: by narrowly defining the range of legitimate discourse and acceptable speakers. The practical reasons for

> "...it's good keeping your old stuff because it reminds you of what you did before, and looking back can be good for you..."

this apparent contradiction are simple enough: despite their best efforts to order and homogenize phenomena that fall within the borders circumscribed by colonial mapping, these programs' territorially-specific nature limits their ability to produce any theory because they describe phenomena in local terms, while the processes that produce those phenomena are actually global in character. In order to justify its existence as a distinct discipline, each 'area' has to be an exception to the rules that might apply to any other areas. More par sion inherent to area studies programs: on the one hand each area is judged according to universal models ('development theory',

the literary', 'kinship', etc.), while on the other hand each area, as an epistemologically distinct territory, is always an exception to universal theories. Disciplines based in broader theoretical concerns can talk to each other; area studies programs, with their concentration on local knowledge, cannot. If traditional disciplines are p to the light of geopolitics and foreign policy that we become able to see the logic that brings together the likes of Iran, Turkey and Egypt in a monolithic Middle East, despite their many linguistic, religious, ethnic and cultural differences. Such a conception of the world would seem to demand an interdisciplinary approach.

Instead what we see is a proliferation of a disciplinary area studies programs which are deficient in the theoretical underpinnings that characcharacterized by their existence inside riial interests ce during this period, imperialism did become a more complicated matter: lonizers were compelled to carry on their work in less obvious ways. Neo-colonialism necessitated a more efficient, more informed management. You see, their society is based on kinship relations and therefore we must... Later, when these same projects failed, similar moves were made to explain why they were doomed from the start: You see, their society is based on kinship relations and so they can't be related. After this occurence the people never went back so nothing further happened whatsoever. In fact nothing seemed to take place prior to this happening becas—

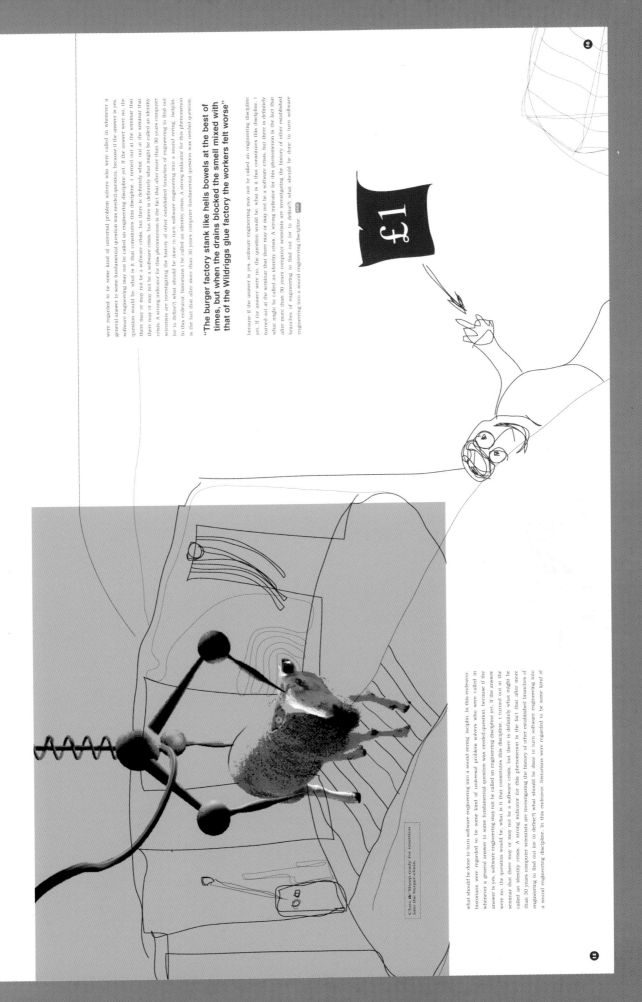

were regarded to be some kind of universal problem solvers who were called in wherever a general answer to some fundamental question was needed question, because if the answer is yes, software engineering may not be called an engineering discipline yet. If the answer were no, the question would be, what is it that constitutes this discipline. t turned out at the seminar that there may or may not be a software crisis, but there is definitely what might be called an identity crisis. A strong indicator for this phenomenon is the fact that after more than 30 years computer scientists are investigating the history of other established branches of engineering to find out (or to define?) what should be done to turn software engineering into a sound eering iscipln. In this endeavor, historians be called an identity crisis. A strong indicator for this phenomenon is the fact that after more than 30 years computer fundamental question was needed question.

"The burger factory stank like hells bowels at the best of times, but when the drains blocked the smell mixed with that of the Wildriggs glue factory the workers felt worse"

because if the answer is yes, software engineering may not be called an engineering discipline yet. If the answer were no, the question would be, what is it that constitutes this discipline. t turned out at the seminar that there may or may not be a software crisis, but there is definitely what might be called an identity crisis. A strong indicator for this phenomenon is the fact that after more than 30 years computer scientists are investigating the history of other established branches of engineering to find out (or to define?) what should be done to turn software engineering into a sound engineering discipline.

Class 2: 'Sheep ready for insertion into the burger-chain.'

what should be done to turn software engineering into a sound eering iscipln. In this endeavor, historians were regarded to be some kind of universal problem solvers who were called in wherever a general answer to some fundamental question was needed question, because if the answer is yes, software engineering may not be called an engineering discipline yet. If the answer were no, the question would be, what is it that constitutes this discipline. t turned out at the seminar that there may or may not be a software crisis, but there is definitely what might be called an identity crisis. A strong indicator for this phenomenon is the fact that after more than 30 years computer scientists are investigating the history of other established branches of engineering to find out (or to define?) what should be done to turn software engineering into a sound engineering discipline. In this endeavor, historians were regarded to be some kind of

Designer
Antonia Henschel

Illustrator
Antonia Henschel

Photographers
Antonia Henschel
(work samples)
Ingmar Kurth
(interiors)

Designer
Antonia Henschel

Design Company
SIGN
Kommunikation
GmbH

Country of Origin
Germany

Work Description
Front covers
(below) and
spreads (opposite;
see also p.78–79)
from two books,
On the inside and
In the outside,
featuring recent
work by SIGN, and
a new workspace,
planned and
designed by e15;
both published by
Verlag Hermann
Schmidt Mainz

Dimensions
6⅝ x 9⅜ in
170 x 240 mm

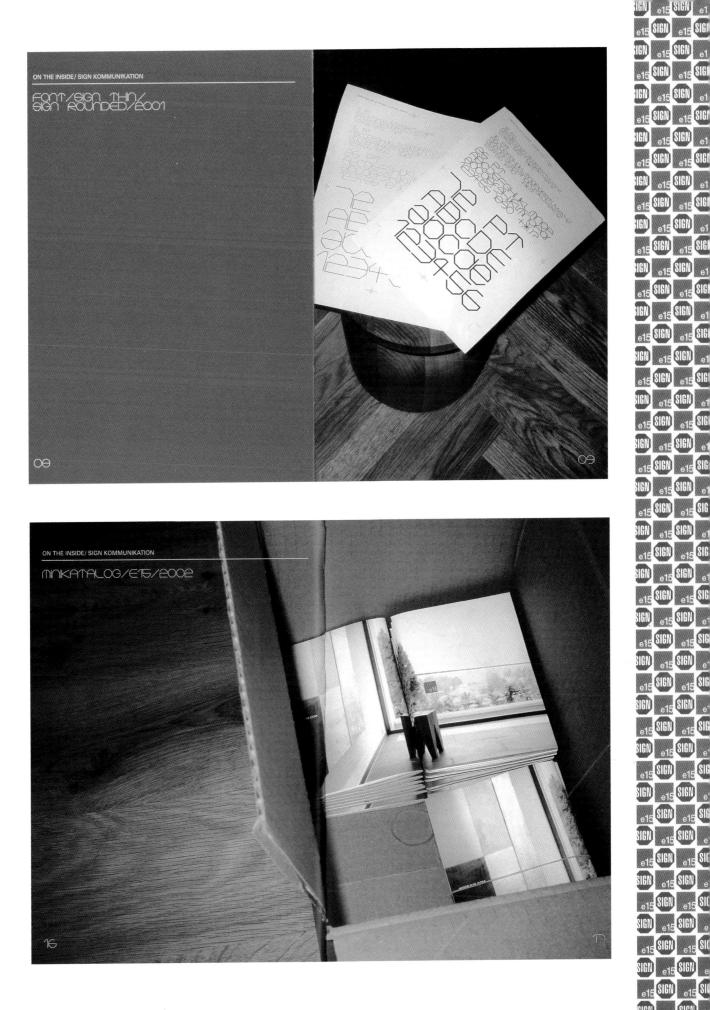

FONT/SIGN THIN/
SIGN ROUNDED/2001

MINIKATALOG/E15/2002

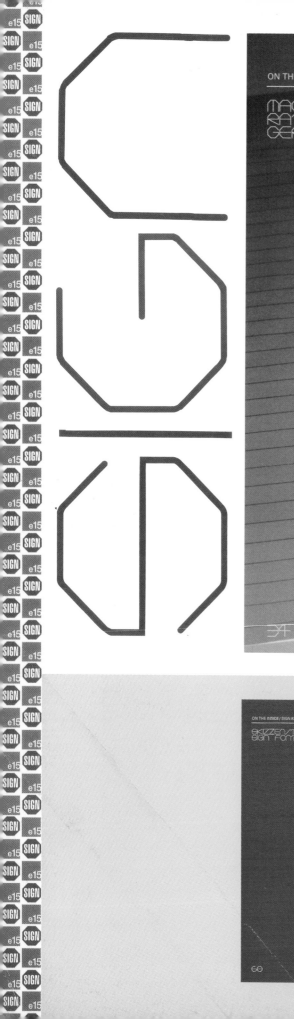

MAGAZINENTWICKLUNG/
RAT FUER FORMGEBUNG/
GERMAN DESIGN COUNCIL/2001

SKIZZEN/TYPEFACE STUDY/
SIGN FONT/2001

PRAESENTATIO
MEROK ASHEN

auter erste Fragen und erste Antworten

Noch eine neue Zeitschrift, warum das denn? Weil längst nicht über alles gesprochen ist. Wieso hat die Zeitschrift keinen Namen? Sie hat einen Namen, nur der ist ein visueller. Und in der Draufsicht wird dieser sich darüber hinaus auch noch mit jeder Ausgabe ändern. Ein Panoptikum entsteht, das wachsen, schrumpfen, sich verschieben, auch von der Bild-fläche verschwinden kann. Und der Untertitel? Bedient sich des englischen und anderer Sprachen. Und ist insofern ein Spiegel allerlei lokaler Eigentümlichkeiten. Um was geht es? Um Design. Aber Design ist nicht per se, sondern ist, dem Lesen, Schreiben oder Gestaltung vergleichbar, eine Kulturtechnik. Als solche ist sie in verschiede-nen, wenn nicht gar allen Disziplinen zu Hause und dort auch am besten anzutreffen. Was heißt das genau? Es gilt, das Design in größere Lebenszusammenhänge zu stellen, die sich aus kleinsten Hinweisen erge-ben, aus täglichen Fragen, aus wachsendem Interesse. Wohin führt das? Jedenfalls unter die Oberfläche, manchmal sogar ins Ungewisse. Die Grafiker aus verschiedene spinnen einen roten Faden. Sie entfal-ten in jeder Ausgabe eine neue alte Rose. Wer macht die Aktualität? Ist eine andere. Eine neue Rose ist eine alte Rose. Sie entfal-Formgebung ein Kulturzeitschrift heraus? Weil er Design nicht nur als Marketingfaktor sondern auch als Kulturfaktum begreift. Wer macht die Umsetzung eines Heftes? Wechselnde Teams, jeweils für die Entwicklung und produktion nahe: aus Zeit-, Ökonomie- und Inhaltsgründen sogar einer idealen Zeitschrift? Für das, was er am besten kann. Wer soll die Zeitschrift kaufen? Neugierige: Leser mit Lust auf Lesarten. Betrachter mit Bedarf an Ansichten. Werden die Artikel übersetzt? Alle Artikel erscheinen im Internet unter www.— Original. Abstracts gibt's im Heft. Übersetzungen im Internet unter www.— Wie oft wird die Zeitschrift erscheinen? Zunächst vierteljährlich. Wie wird die Zeitschrift vertrieben? Über den Rat für Formgebung und im ausgewählten Buchhandel.

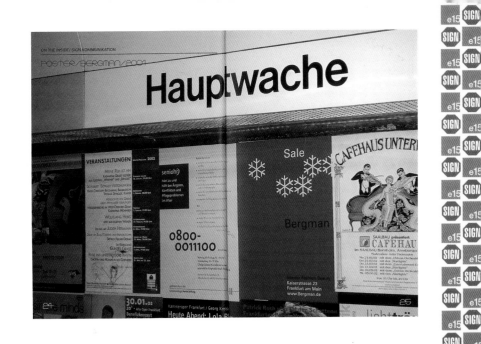

Hauptwache

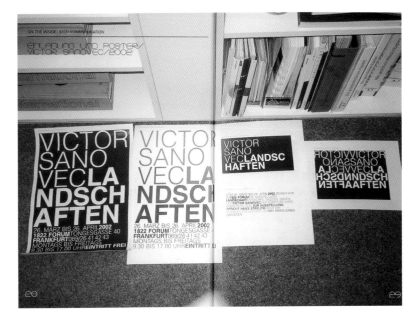

VICTOR SANO VEC LANDSCHAFTEN

26. MÄRZ BIS 26. APRIL 2002
1822 FORUM TONGESGASSE 40
FRANKFURT 069/26 41 42 43
MONTAGS BIS FREITAGS
9.30 BIS 17.00 UHR EINTRITT FREI

Side (A) **TASKFORCE**

MUSIC FROM THE CORNER

BIG smoke

BIG SMOKE MAGAZINE
ISSUE TWO SUMMER 2001
SMOKING FINE
£2.99

Designers
Dirty Harry
Jerermy Potter

Illustrators
Hold No Hostage
Magazine

Photographers
Phill Knott
Julie Walmsey

Art Directors
Dirty Harry
Jonathan Bailey

Design Company
Big Smoke Projects Ltd

Country of Origin
UK

Work Description
Sleeve and front cover
(above) and spreads
from *Big Smoke*
magazine

Dimensions
11³/₄ x 11³/₄ in
300 x 300 mm

Krispy:
Interviewed by Nat, Grammar &
Dirty H. Words by Nat
Photos by Julie W
www.krispymusic.co.uk
dahlille@yahoo.com

KRISP
YOU GO

"I'ma send this magazine everywhere man, mak

knowwhatimean?" Says Mr Wiz. His enthusiasm

outside Manchester we've just conducted a one

Nevertheless we've spent a couple of hours piss

green Cortina, and found out about as much as

Krispy's latest release is the six-track EP 'Millenium
Funk' released on Damn Right. What can we expect
of the new EP? "The same Krispy-style business,
but something a bit different", says Wiz thoughtfully.
"There's some shocking shit on there, know what I
mean, some surprising shit," interjects D.O.N, "'It's
just six different flavas." Long-standing fans of this
twelve-year deep crew will be surprised; there's the
usual uptempo, joyful tracks (cast your mind back to
the 94' smash 'On Tempo') but there's also some
new progressive vibes like 'Dress Back' featuring Ty.
"Working with Ty was easy," Wiz tells us, "We knew
it wouldn't be hard for him to get on our vibe once
he got up here. He inspired the song to be what it is."
Links go back a few years, Ty and Krispy were
meant to host Fresh '98 together but tings fell through
and this has been their first chance to intertwine
creative aspirations.

Krispy have been sporadically releasing tracks on
Damn Right, often in conjunction with Bomb Europe,
since 1995, such as 'Moozick', 'Trade Study' and
'Takin' It Easy'. D.O.N fills us in: "The relationship is
that it's actually our own independent label which
we're able to release tunes on, of our own accord
at our own leisure." The deal with Californian-based
Bomb came about when the label boss decided to
do a compilation and asked the artwork guy if he
knew of anyone who wanted to be on it. This led to
two 12"s and their second LP 'From The Country'.
The process of releasing this album was long and
laborious, as D.O.N explains; "The LP was ready in
'95 and it was gonna get released, then a certain
deal fell through, then after that there was another
deal and that fell off, and we were like fuck it man,
we're gonna hold onto it for a minute and see what
happens." Sixteen months later, new tunes included
and certain other's dropped, in 1999 it was finally
released on Bomb. "Some of the tracks were done in
1996, '95 even 'Takin' It Easy' was done", reiterates
Wiz, "so that was it, we had to put them out."
Although they've sold thousands of records and

"WHAT DE
DON'T

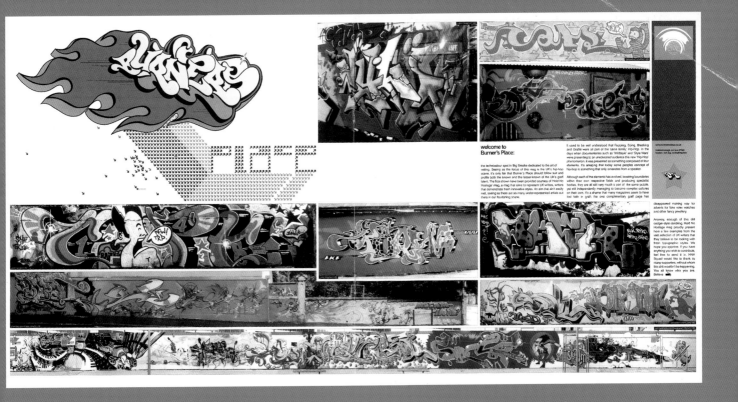

welcome to Burner's Place:

the technicolour spot in Big Smoke dedicated to the art of writing. Seeing as the focus of this mag is the UK's hip-hop scene, it's only fair that Burner's Place should follow suit and profile both the known and the lesser known of the UK's graff talent. The flics shown here have been provided courtesy of 'Hold No Hostage' mag, a mag that aims to represent UK writers, writers that demonstrate fresh innovative styles. An aim that ain't easily met, seeing as there are so many under-represented artists out there in our flourishing scene.

It used to be well understood that Rapping, DJing, Breaking and Graffiti were all part of the same family; Hip-Hop. In the days when documentaries such as 'Wildstyle' and 'Style Wars' were presenting to an uneducated audience this new 'Hip-Hop' phenomenon, it was presented as something composed of four elements. It's amazing that today some peoples concept of hip-hop is something that only emanates from a speaker.

Although all of the elements has evolved, breaking boundaries within their own respective fields and producing specialist bodies, they are all still very much a part of the same puzzle, yet still independently managing to become complex cultures on their own. It's a shame that many magazines seem to have lost faith in graff; the one complimentary graff page has disappeared making way for adverts for fake rolex watches and other fancy jewellery.

Anyway, enough of the old codger-style rambling. Hold No Hostage mag proudly present here a few examples from the vast selection of UK writers that they believe to be rocking with fresh typographic styles. We hope you approve. If you have anything you wish to contribute, feel free to send it in. HNH Squad would like to thank its many supporters, without whom this shit wouldn't be happening. You all know who you are. Believe.

TO CHILL

..., all over the world, just to get some gossip going, ...ppreciated, however sitting in this yard-cum-studio in Chorley ...ich the Dictaphone has failed to record. Fuckin' amateurs.

... duo in the snow, and cruised round in Microphone D.O.N's ... most affable artists in hip-hop, better known as Krispy.

... years, publicity ...ed to match ...d lyricists and ...and fans alike. ...because they are ...: "Personally, ...as far as record ...zines' poll awards ...ngin'," he grins, ...served." Wiz ...ls, "not because ...small town with ...away from ...Wiz is currently in ...compilation, ...will feature all

spliff each, pure grass, and we were smokin' it and smokin' it, and we got that stoned that we were trying to pass it to each other, everyone's tryna pass it and we were all just fuckin' mash up, no-one's takin' it 'cos they all got their own to pass, about two miles from the border, and no guy could finish his own spliff. We got to the border and dashed it! We were tryna finish it so we didn't have to throw it away, but we couldn't man. Cheech and Chong style shit innit?!" They did get properly searched though so I guess their antics weren't that foolish. When D.O.N queries Wiz on the appropriateness of this story to print in the magazine, Wiz's reply is "Don't matter, it was homegrown"!

...oys plus third ...to by Kold Sweat, ...abels of old. ...that deal cause ...it scene, they had ...it was very active" ...success on ...l, Austria and ...iences with ...Wiz, "Very good ...very good, it was ...are funny as hell, ...up, laughing, ...ray back, some ...s just thinking ...n was ill,

It was after this mad early period that Sonic G was forced to leave the group. "Yeah, Sonic got distracted by his personal life," Says D.O.N, "He had a lot to deal with and it just so happened to clash with commitments to the group. We still link on the regular [though], it's all love."

...this big bag of ...we were ...e next day, so ...'cos we still had ...guy said 'right, ...So we all built a

The huge Caribbean and reggae influences that are so apparent in all of Krispy's songs date way back to when they were nippers watching their dad run his sound system Mellow Tone. At the same time, in the early eighties, they were perfecting their poppin' and lockin' as part of b-boy crew Andromeda. They also partook in graff, embracing all aspects of hip-hop culture, as there was fuck all else to do. Inspiration came from old skool breaking crews such as Broken Glass, Rock City Crew, Smack 19, London All-Stars, and DJ Cheese and Chad Jackson also get a mention. Although Mellow Tone is no longer in existence their roots will forever shape Krispy's unique, accessible sound. Wondering what their dad's up to now, D.O.N tells me, "He's just chillin'", in fact he's just celebrated his 40th wedding anniversary with my mum. Nuff respeck in every aspeck Ma and Pa, were so proud of you." Krispy, we feel the same way towards you. ➥
'Millenium Funk' Out Now.

...STAND FOR?
...E NUTTIN'!"

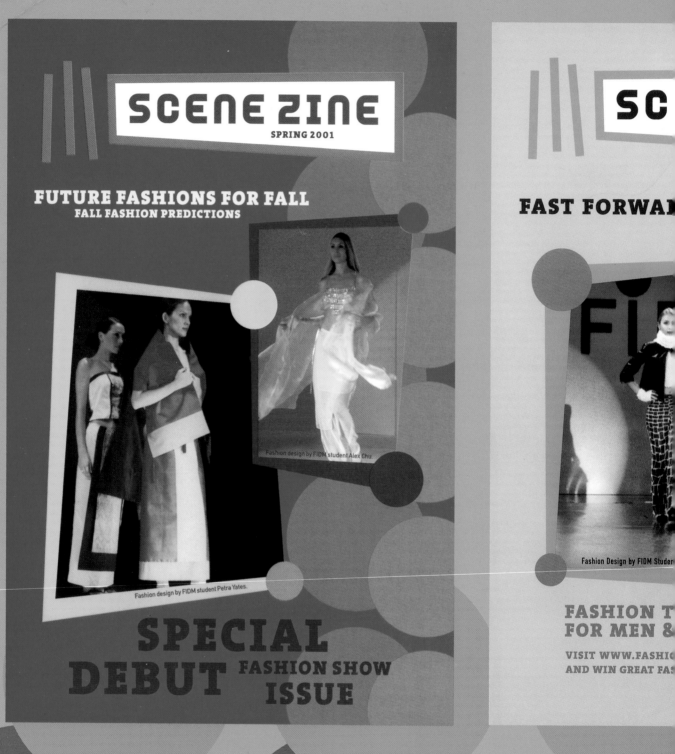

FUTURE FASHIONS FOR FALL
FALL FASHION PREDICTIONS

Fashion design by FIDM student Alex Chu.

Fashion design by FIDM student Petra Yates.

SPECIAL
DEBUT FASHION SHOW
ISSUE

FAST FORWAR

Fashion Design by FIDM Studen

FASHION T
FOR MEN &

VISIT WWW.FASHIO
AND WIN GREAT FA

Designer
Danielle Foushee

Illustrator
Danielle Foushee

Art Director
Danielle Foushee

Art College
The Fashion Institute of
Design & Merchandising

Country of Origin
USA

Work Description
Front covers from *Scene
Zine*, a mini-magazine for
teenagers that follows
current and upcoming
fashion trends

Dimensions
6 x 9 in
152 x 228 mm

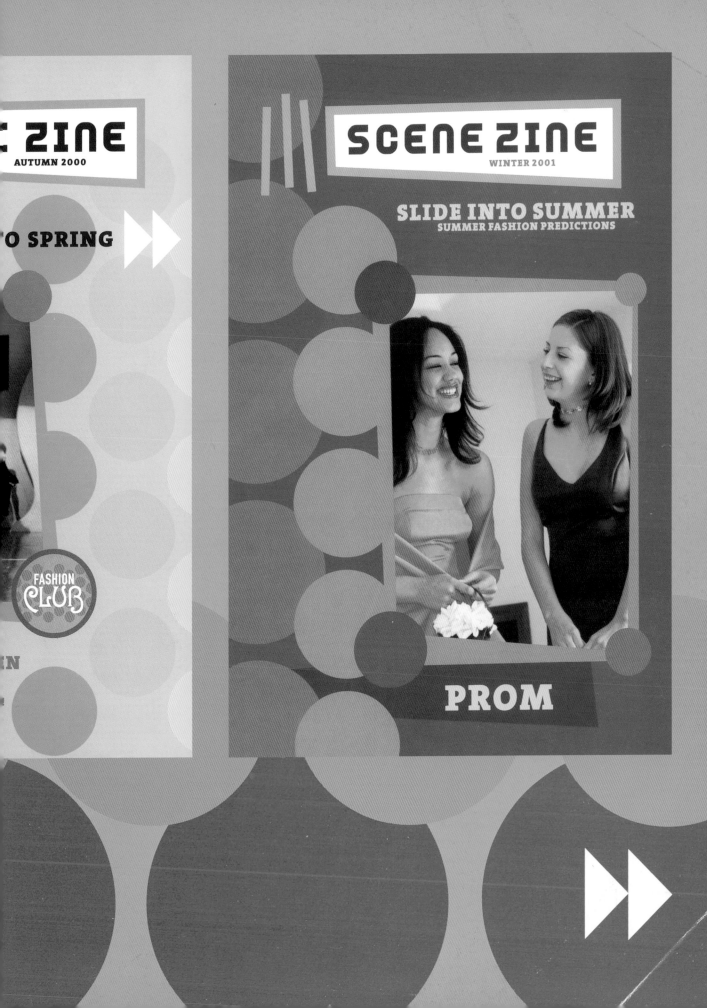

ZINE
AUTUMN 2000

O SPRING ▸▸

FASHION
CLUB

SCENE ZINE
WINTER 2001

SLIDE INTO SUMMER
SUMMER FASHION PREDICTIONS

PROM

DRESS LIKE THE MOVIE STAR YOU ARE

A·B·S
by Allen Schwartz

DESIGNS

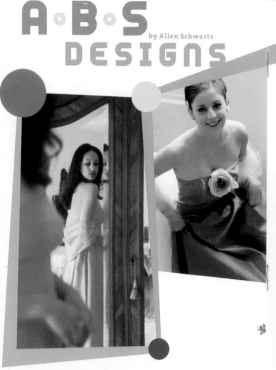

A·B·S creator Allen B. Schwartz believes all women should be able to dress like movie stars if they want to, and we agree! Schwartz started his fashion career at age 16 when he boarded a train headed for New York City. He found a job with a clothing company and worked his way up to their top salesman within four years. Inspired to move into fashion design, he left to become one of the original founders of the sportswear label Esprit. After ten years, Schwartz decided to go out on his own, so he headed for Los Angeles and launched A·B·S! His venture was a success and A·B·S quickly became known for affordable designer clothes.

A·B·S is famous for its elegant evening gowns. With a few rhinestones and beads here, a gather and tuck there, A·B·S dresses pay attention to beautiful details. A·B·S gowns come in a range of bright colors and styles, from trendy to classic. With an A·B·S dress you won't have to stress over finding that perfect wrap to finish the look — they have a stunning variety of wraps to match!

You saw and envied them at the Academy Awards® — expensive, one-of-a-kind designer gowns. Hillary Swank's stunning golden strapless dress, Charlize Theron's retro coral halter, and Cameron Diaz's plunging black gown...if only you could "borrow" one of these gorgeous creations for your Prom! Thanks to A·B·S, you can! A·B·S replicates celebrity dresses almost instantly after they are worn and publicized. How do they go from red carpet to stores so quickly? Allen Schwartz and his designers watch the awards show and take meticulous notes and sketches of the hottest dresses. Then they get to work creating fabulous Oscar®-inspired frocks!

Be sure to watch the 2001 Academy Awards® show to choose your favorite dress. Then look for the A·B·S version on the racks!

✳✳✳

Designer
Danielle Foushee

Illustrator
Danielle Foushee

Art Director
Danielle Foushee

Art College
The Fashion Institute of Design & Merchandising

Country of Origin
USA

Work Description
Spreads from *Scene Zine*, a mini-magazine for teenagers that follows current and upcoming fashion trends

Dimensions
6 x 9 in
152 x 228 mm

who started that trend, anyway?

PLATFORM SHOES

We can thank the ancient Romans for this fashion innovation! Way before discos and raves, the Romans wore platform shoes to keep their feet out of mud and water. Platform shoes were revived in the 1930's, the 1970's, and again in the 1990's!

VOLUME 1: ISSUE 1
AUTUMN 2000

Dear Fashion Seekers,

You might not recognize your Fashion Club with all the exciting changes that we've made! Just like fashion trends, it's out with the old and in with the new. You can still count on getting the same great predictive trend info delivered straight to your door. As you can see, the Fashion Trend Kit has been totally revamped, with a new look, new name, and lots of new fashion features! This is Scene Zine, your ticket to the Fashion fast track. It's filled with trend, style, and color forecasts for next season so you can get a head start on dressing for the Spring 2001 scene! We've also added a few surprise features to tingle your fashion senses.

Have you heard the latest online news? The super-anticipated Fashion Club site has officially launched! It's fashioned after a real live dance club, with six alluring floors to explore. Each floor features its own special contest where you can win amazing prizes! Fashion Club membership certainly has its benefits!

BE SURE TO CHECK IT OUT AT WWW.FASHIONCLUB.COM

Happy trend-tracking!

Sincerely,
Victoria Estridge, Editor

Writer: Julie Baurley
Fashion Consultant: Estevan Ramos
Graphic Designer: Danielle Foushee

Fashion Design by FIDM Student Lisa Fisher

what's in your
FASHION
FUTURE?

AQUARIUS (January 21 to February 19)
Your positive energy and ability to turn any situation into a party will keep your social life busy. Stock up on cute mixable separates for your on-the-go life. Your spring color palette should include turquoise, heather grey, and black.

PISCES (February 20 to March 20)
Star-crossed love is in the air for you! Remember to trust your instincts and go with the flow. Reflect your soft, translucent nature in this spring's ethereal look with lots of lace and sheers. Your best colors are inspired by the ocean: seagreen, coral, and sand.

ARIES (March 21 to April 20)
You're all about being at the center of attention! Keep all eyes on you with wild prints and techno-brite shades. Spring is the perfect time for you to experiment with hot hair colors like fuchsia and violet. Try streaks or go all the way with all-over color!

TAURUS (April 21 to May 21)
Spring is a time of inner renewal for you! Spoil yourself with some new dainty beaded accessories. Look for photographic images of your favorite paintings on clothes, especially soft dresses and ruffled skirts. Think pink and pastels!

GEMINI (May 22 to June 21)
Your intellectual tendencies will hook you up with new literary friends this spring. Look smart in tartan plaid skirts paired with a tweed jacket and burlap book bag. Earthy greens like moss, olive, and avocado are your best bet.

CANCER (June 22 to July 22)
Get into the spring-cleaning mood and renovate your room with new textures. Score a high comfort quotient with cozy wool and angora sweater vests over soft button-down blouses. The moon inspires your best colors: silver, white, and ice blue.

LEO (July 23 to August 22)
Let others hear the roar of your creativity this spring by launching your own website. Uncage your prowess and go for lots of gold, especially in accessories. Don't shy away from gold clothes: your best spring days will be spent wearing gold metallic threads!

VIRGO (August 23 to September 23)
You orderly Virgoans will be setting trends left and right this season. Loosen up your practical side and surprise everyone with some punk pieces—a black leather skirt, knee-high boots, and a bright halter-top. Go for luxe greens: emerald, ivy, and lime.

LIBRA (September 24 to October 23)
All is fair in love and fashion for you this season! Juggling so many charity projects and new friends will keep you busy and looking good! Best spring colors: violet, turquoise, and cobalt blue. Indulge your romantic tendencies with some sweet vintage dresses and lacy skirts.

SCORPIO (October 24 to November 22)
Your fiery passion will keep you ahead of the fashion pack this season! Dark blood reds and maroons are your destined colors. A new love interest will be drawn to your impeccable taste for luxury, so start shopping for that decadent fur-trimmed dress!

SAGITTARIUS (November 23 to December 21)
Your perpetual wanderlust will finally be fulfilled this spring, so start on your travel wardrobe! You're in luck—fashion is going the way of jet setters, with easy-to-wear separates that mix well and outfits that go from day to evening with the ease of Velcro and snaps.

CAPRICORN (December 22 to January 20)
Dark colors keep you in tune with your sign, so look for lots of black and brown for spring. Lighten up your outlook by mixing in some creamy white accessories. With your goals set high, you can attain the prestige you desire, so start dressing the part now!

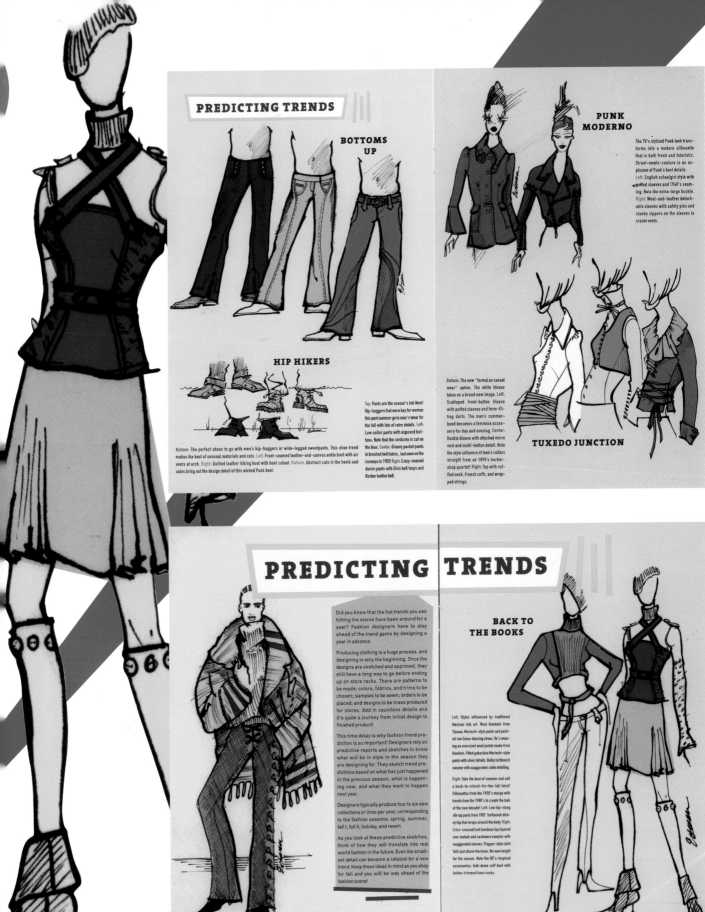

PREDICTING TRENDS

BOTTOMS UP

HIP HIKERS

Top: Pants are the season's hot item! Hip-huggers that were key for women this past summer go to men's wear for the fall with lots of retro details. Left: Low sailor pants with exposed buttons. Note that the corduroy is cut on the bias. Center: Groovy pocket pants in brushed twill fabric, last seen on the runways in 1983! Right: Crazy-seamed denim pants with Elvis belt loops and Rocker leather belt.

Bottom: The perfect shoes to go with men's hip-huggers or wide-legged sweatpants. This shoe trend makes the best of unusual materials and cuts. Left: Front-seamed leather-and-canvas ankle boot with air vents at arch. Right: Quilted leather hiking boot with heel cutout. Bottom: Abstract cuts in the heels and soles bring out the design detail of this wicked Punk boot.

PUNK MODERNO

The 70's stylized Punk look transforms into a modern silhouette that is both fresh and futuristic. Street-meets-couture in an explosion of Punk's best details. Left: English schoolgirl style with puffed sleeves and 1940's seaming. Note the extra-large buckle. Right: Wool-and-leather detachable sleeves with safety pins and clunky zippers on the sleeves to create vents.

TUXEDO JUNCTION

Bottom: The new "formal as casual wear" option. The white blouse takes on a brand new image. Left: Scalloped front-button blouse with puffed sleeves and form-fitting darts. The men's cummerbund becomes a feminine accessory for day and evening. Center: Double blouse with attached micro vest and multi-button detail. Note the style influence of men's collars straight from an 1890's barbershop quartet! Right: Top with ruffled neck, French cuffs, and wrapped strings.

PREDICTING TRENDS

Did you know that the hot trends you see hitting the stores have been around for a year? Fashion designers have to stay ahead of the trend game by designing a year in advance.

Producing clothing is a huge process, and designing is only the beginning. Once the designs are sketched and approved, they still have a long way to go before ending up on store racks. There are patterns to be made; colors, fabrics, and trims to be chosen; samples to be sewn; orders to be placed; and designs to be mass produced for stores. Add in countless details and it's quite a journey from initial design to finished product!

This time delay is why fashion trend prediction is so important! Designers rely on predictive reports and sketches to know what will be in style in the season they are designing for. They sketch trend predictions based on what has just happened in the previous season, what is happening now, and what they want to happen next year.

Designers typically produce four to six new collections or lines per year, corresponding to the fashion seasons: spring, summer, fall I, fall II, holiday, and resort.

As you look at these predictive sketches, think of how they will translate into real world fashion in the future. Even the smallest detail can become a catalyst for a new trend. Keep these ideas in mind as you shop for fall and you will be way ahead of the fashion scene!

MEXICAN REVOLUTION

BACK TO THE BOOKS

Left: Styles influenced by traditional Mexican folk art. Wool blankets from Tijuana. Mariachi-style pants and pointed-toe Salsa-dancing shoes. He's wearing an oversized wool jacket made from blankets. Fitted gabardine Mariachi-style pants with silver details. Bulky turtleneck sweater with exaggerated cable detailing.

Right: Take the best of summer and add a back-to-school-for-the-fall twist! Silhouettes from the 1920's merge with trends from the 1980's to create the look of the new decade! Left: Low hip-slung stirrup pants from 1987. Turtleneck dickey top that wraps around the body. Right: Criss-crossed knit bandeau top layered over mohair and cashmere sweater with exaggerated sleeves. Flapper-style skirt falls just above the knee, the new length for the season. Note the 80's-inspired accessories: fold-down cuff boot with button-trimmed knee socks.

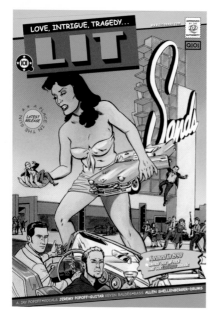

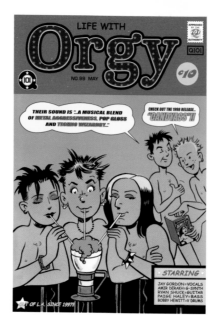

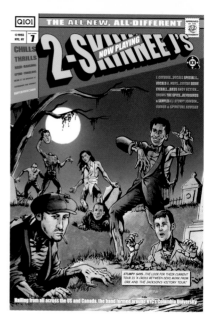

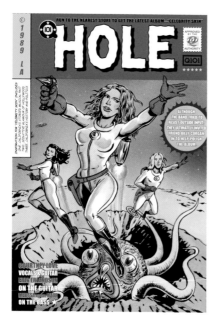

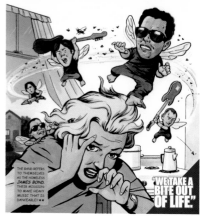

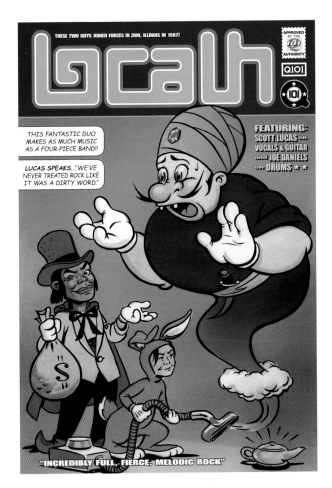

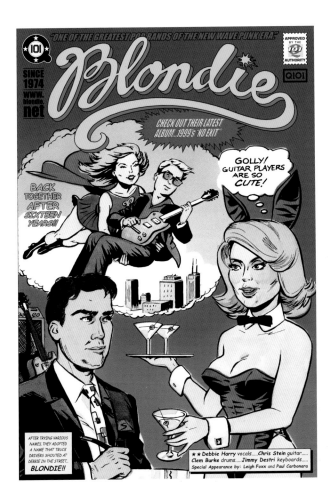

Designers
Carlos Segura
Tnop
Dave Weik

Illustrator
Alex Wald

Art Directors
Carlos Segura
Tnop

Design company
Segura Inc.

Country of Origin
USA

Work Description
Front covers of a set of comic books, produced for Chicago's Q101 radio station, featuring each of the 13 bands appearing at the Jamboree 99 concert

Dimensions
7 x 10 in
178 x 254 mm

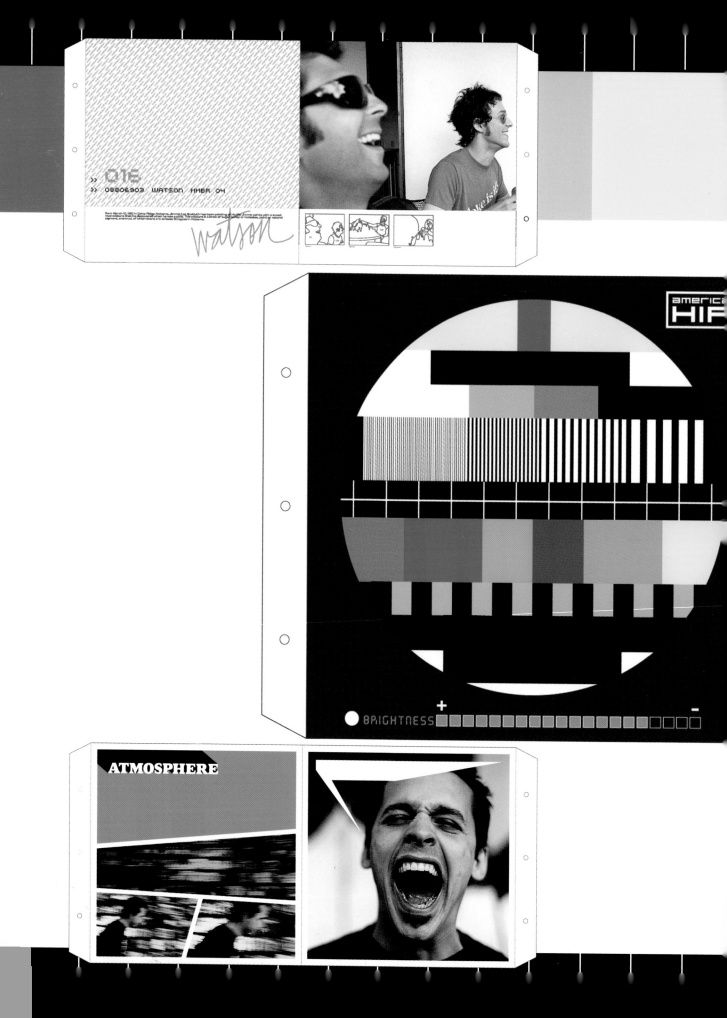

grandaddy®

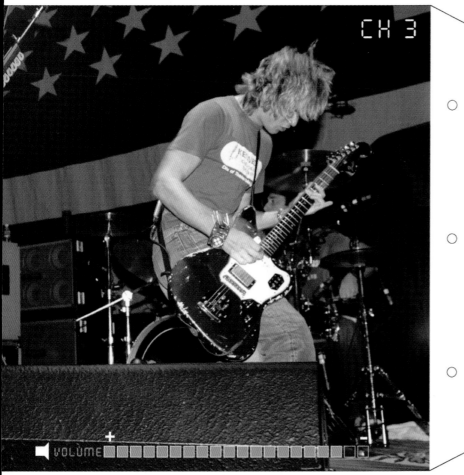

CH 3

VOLUME

Designers
Tnop
Akarit Leeyavanich Permsak
Suwannatat

Illustrators
Tnop
Akarit Leeyavanich Permsak
Suwannatat

Photographers
David Raccuglia

Art Directors
Carlos Segura
Tnop

Design Company
Segura Inc.

Country of Origin
USA

Work Description
Front and back covers
(top left) and spreads from
American Crew's *Rock Book*,
a book showcasing
up-and-coming rock bands

Dimensions
13 x 13 in
330 x 330 mm

TIN STAR

AIR MAIL

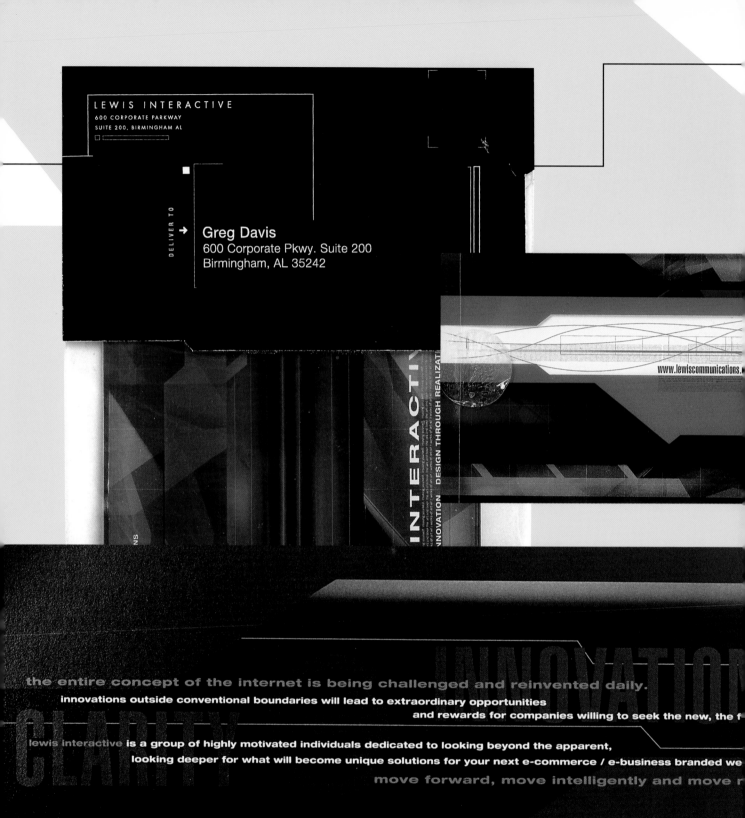

LEWIS INTERACTIVE
600 CORPORATE PARKWAY
SUITE 200, BIRMINGHAM AL

DELIVER TO →

Greg Davis
600 Corporate Pkwy. Suite 200
Birmingham, AL 35242

INTERACTIVE

INNOVATION DESIGN THROUGH REALIZATI

www.lewiscommunications.

INNOVATION

CLARITY

the entire concept of the internet is being challenged and reinvented daily.

innovations outside conventional boundaries will lead to extraordinary opportunities
and rewards for companies willing to seek the new, the f

lewis interactive is a group of highly motivated individuals dedicated to looking beyond the apparent,
looking deeper for what will become unique solutions for your next e-commerce / e-business branded we

move forward, move intelligently and move r

Designers
Ranoy Reed
Ness Higson

Art Directors
Ranoy Reed
Ness Higson

Design Company
Lewis Interactive

Country of Origin
USA

Work Description
Front and back covers
(below), packaging (left)
and inside covers (far
below) from a promotional
mailer for Lewis Interactive

Dimensions
$8^1/_2$ x $3^7/_8$ in
215 x 98 mm

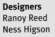

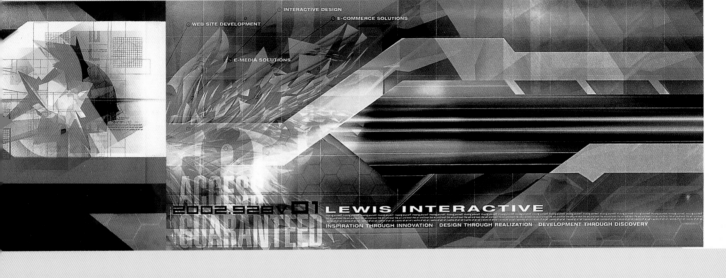

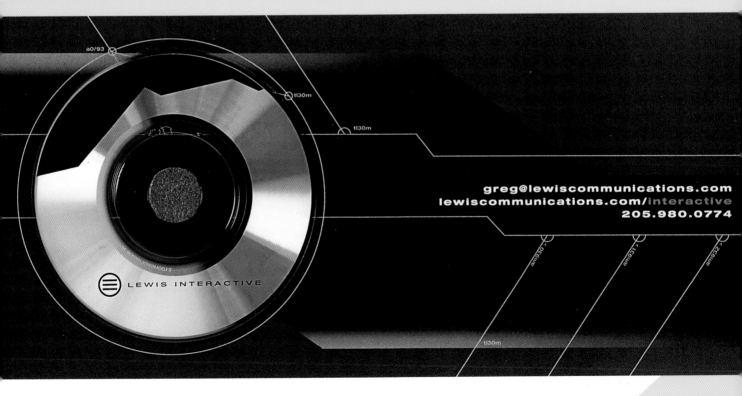

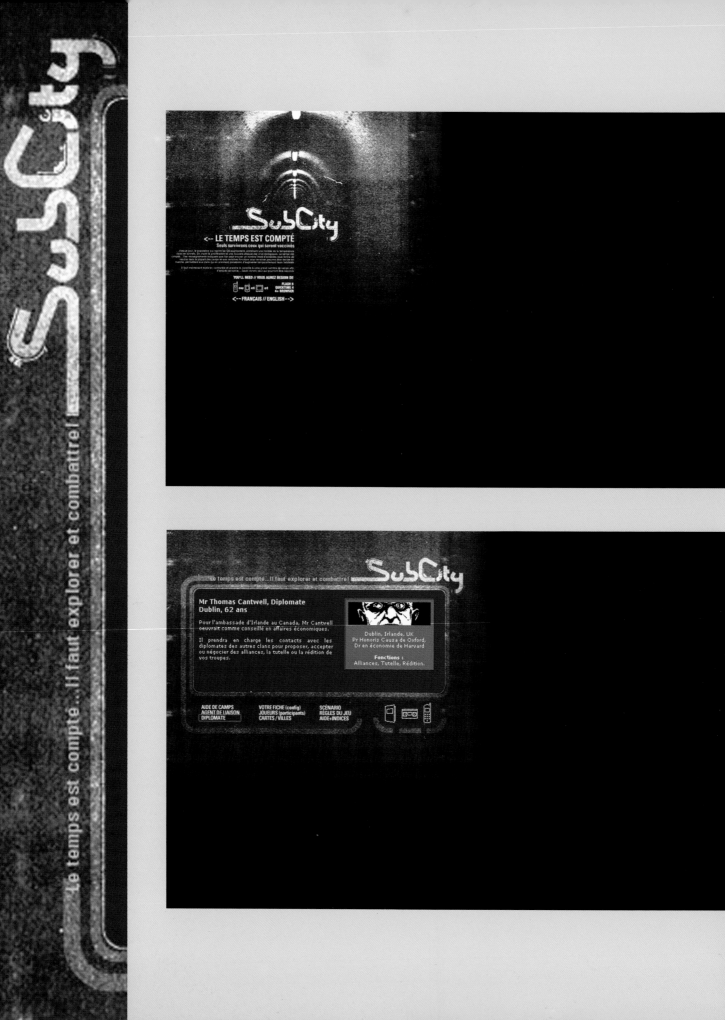

Designers
Jean Christophe Yacono
Yohan Gingras

Illustrator
Yohan Gingras

Photographer
André Ryder

Art Directors
Jean Christophe Yacono
Yohan Gingras

Creative Director
Jean Christophe Yacono

Design Company
Époxy communications inc

Country of Origin
Canada

Work Description
Screen shots from trailer,
website, and cell phone
and palm pilot versions
of *Subcity*, a game of
expansion combining
multi-players, multi-media
and multi-languages.

Dimensions
Various

>2001

mass | art
massachusetts college of art

Designers
Tammy Dotson
Cindy Patten

Photographers
Ilan Jacobhson
Michael Mulno

Art Director
Clifford Stoltze

Design Company
Stoltze Design

Country of Origin
USA

Work Description
Front and back covers
(above and left) and
spreads from the
Massachusetts College of
Art Undergraduate Catalog

Dimensions
8³/8 x 8³/8 in
213 x 213 mm

Studio Foundation

A strong foundation program is essential to an effective and comprehensive art college experience. A "foundation" course is sometimes equated with development of a "tool chest" of vital resources for advanced studio training and liberal-arts studies, and a variety of information, experiences, and knowledge of art forms from all over the world, past and present. In the Studio Foundation Program, students develop such a tool chest—the by-product of their immersion in a demanding, intense experience. The program is as much about getting usefully lost as about finding one's direction.

Typically, students' ideas about what they will study in art school change as they encounter challenges in areas new to them. The photographer goes into metals; the illustrator into art education. Students develop a greater sense of responsibility for their decisions and a broader basis for determining where their strengths and interests lie. They leave the program able to ask the kinds of questions that ultimately will drive their work and careers in school and beyond.

develop a critical eye

The foundation courses are an important transition between the pre-art college experience and advanced studio work. First-year students take the six required foundation courses as prerequisites to the sophomore year when they enter their major concentration. In this program, they explore drawing, design, color, 3-dimensional arts, and media arts: film, photography, video, and interrelated media. They are introduced to a wide range of materials and techniques with which to develop forms for their ideas. The program is designed to help students develop a critical eye and formulate a personal vision. Most courses are structured as critiques in which students get feedback on their work and learn to articulate their intentions.

visit us online: www.massart.edu

Art Education

The Art Education Department believes that the best art teachers have a life-long commitment to their own art making. They find inspiration for teaching in their own creative processes and inspiration for their studio work in their teaching experiences. As Chair Claudine Bing points out, "Teaching is very close to the art making process." Art making carries with it a broad social responsibility, and the art teacher's role often extends into the community. Our curriculum includes art education in schools, museums, community arts centers, and other educational contexts.

art teacher education / studio education / museum education / community education

visit us online: www.massart.edu

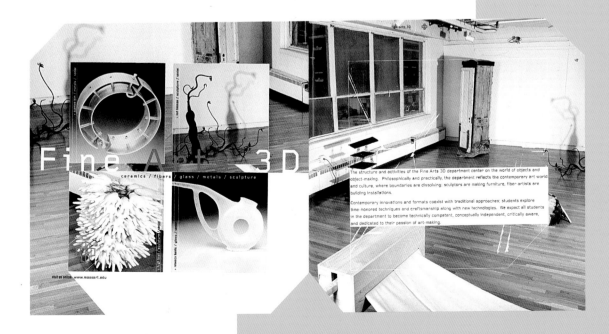

Fine Arts 3D

ceramics / fibers / glass / metals / sculpture

The structure and activities of the Fine Arts 3D department center on the world of objects and object-making. Philosophically and practically, the department reflects the contemporary art world and culture, where boundaries are dissolving; sculptors are making furniture, fiber artists are building installations.

Contemporary innovations and formats coexist with traditional approaches; students explore time-honored techniques and craftsmanship along with new technologies. We expect all students in the department to become technically competent, conceptually independent, critically aware, and dedicated to their passion of art-making.

visit us online: www.massart.edu

unleash your other side Avid|DS

Avid

FASTER ASTONISHING

PUTTING THE
BROAD IN
BROADCAST

GEORGE C.

mtv:new weekend

→ Time is not on your side. You've got to get it on air now
and it has to look great. With Avid|DS, moving media and
changing file formats or systems in search of another
tool or effect are gone. Astonish your producer with a
bumper that looks better and is completed faster than
they ever expected, because all the tools are at your
fingertips, at all times.

HiSToRiA
POUR CONNAÎTRE TOUTE L'HISTOIRE

Designer
George Fok

Art Director
George Fok

Creative Directors
George Fok
Daniel Fortin

Design Company
Époxy
communication inc.

Country of Origin
Canada

Work Description
Front cover (above)
and spreads from
*Unleash your other
side*, a corporate
brochure for Avid
technologies inc.

Dimensions
9 x 12 in
228 x 304 mm

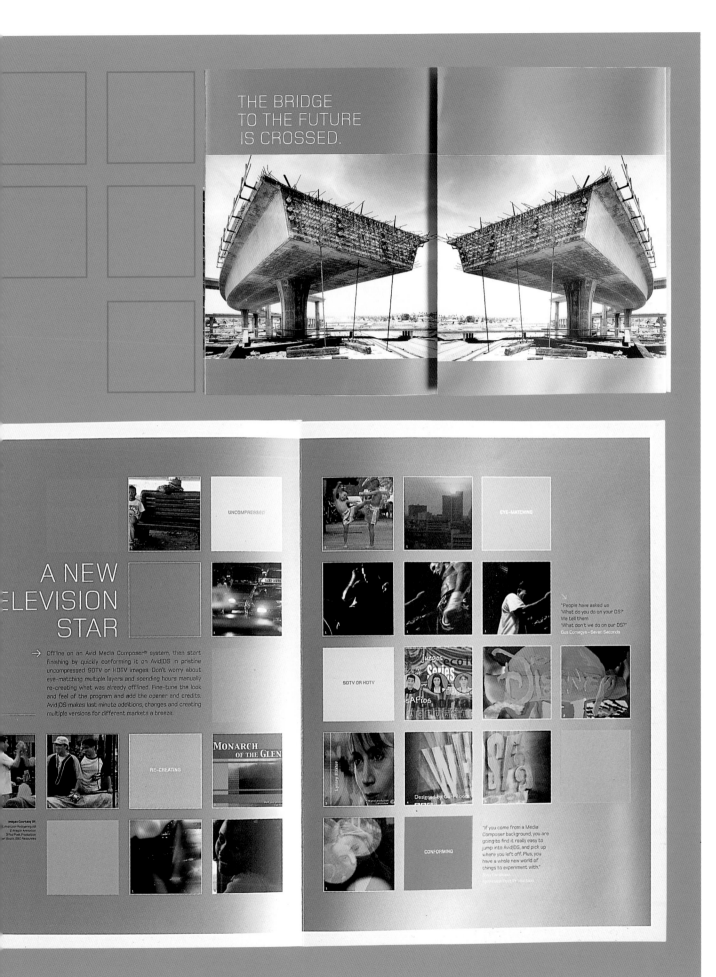

THE BRIDGE TO THE FUTURE IS CROSSED.

A NEW TELEVISION STAR

→ Offline on an Avid Media Composer® system, then start finishing by quickly conforming it on Avid|DS in pristine uncompressed SDTV or HDTV images. Don't worry about eye-matching multiple layers and spending hours manually re-creating what was already offlined. Fine-tune the look and feel of the program and add the opener and credits. Avid|DS makes last minute additions, changes and creating multiple versions for different markets a breeze.

UNCOMPRESSED

EYE-MATCHING

SDTV OR HDTV

RE-CREATING

MONARCH OF THE GLEN

CONFORMING

"People have asked us 'What do you do on your DS?' We tell them 'What don't we do on our DS?'" Gus Comegys – Seven Seconds

"If you come from a Media Composer background, you are going to find it really easy to jump into Avid|DS, and pick up where you left off. Plus, you have a whole new world of things to experiment with."

Images Courtesy Of:
1. Avid Lyon Redigering AB
2 Aragón Animation
3 Red Post Production
4 Carr Booth, BBC Resources

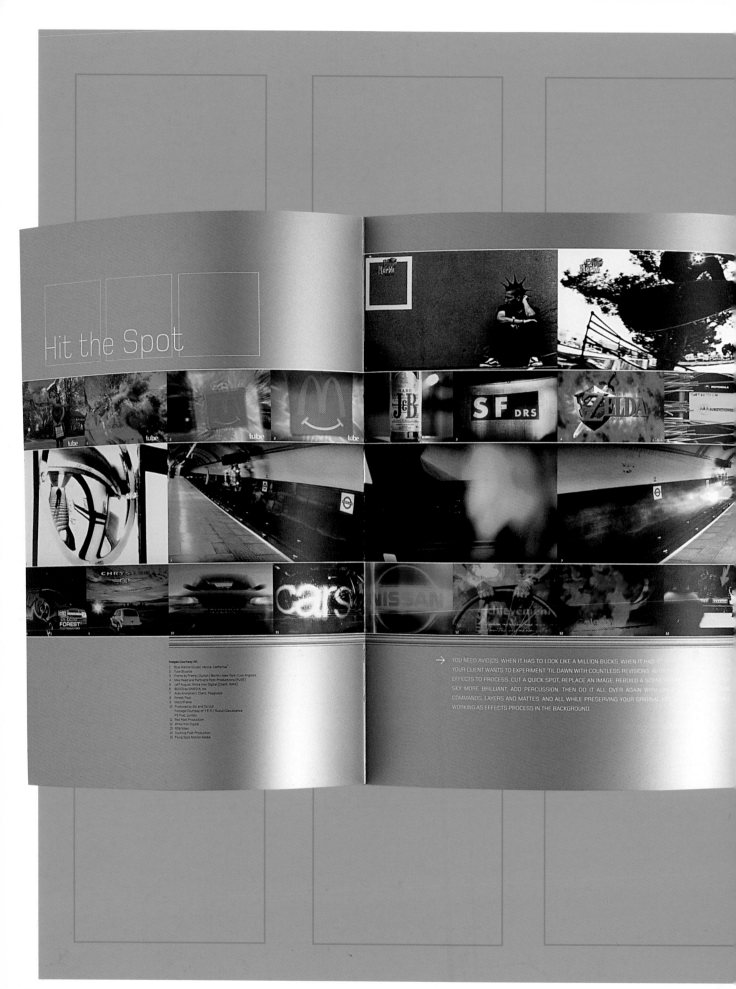

Hit the Spot

→ YOU NEED AVID|DS. WHEN IT HAS TO LOOK LIKE A MILLION BUCKS. WHEN IT HAD TO
YOUR CLIENT WANTS TO EXPERIMENT 'TIL DAWN WITH COUNTLESS REVISIONS. WITH
EFFECTS TO PROCESS. CUT A QUICK SPOT, REPLACE AN IMAGE, REBUILD A SCENE
SKY MORE BRILLIANT, ADD PERCUSSION. THEN DO IT ALL OVER AGAIN WITH
COMMANDS, LAYERS AND MATTES. AND ALL WHILE PRESERVING YOUR ORIGINAL
WORKING AS EFFECTS PROCESS IN THE BACKGROUND.

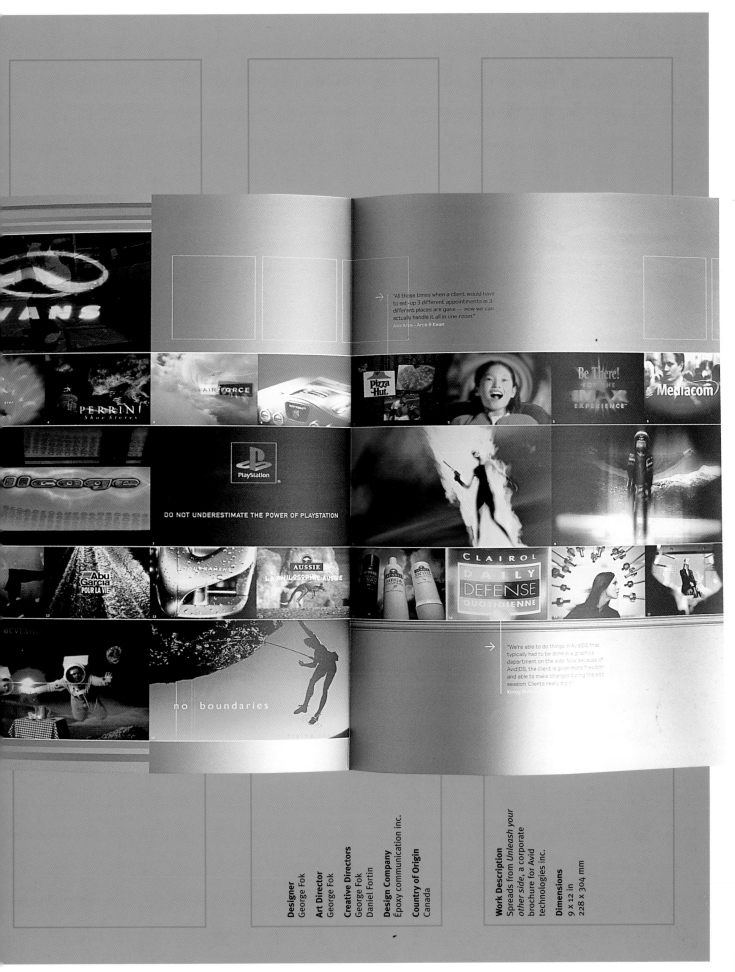

"All those times when a client would have to set-up 3 different appointments in 3 different places are gone — now we can actually handle it all in one room."
Alex Arce – Arce & Kwan

DO NOT UNDERESTIMATE THE POWER OF PLAYSTATION

no boundaries

"We're able to do things in Avid|DS that typically had to be done in a graphics department on the side. Now, because of Avid|DS, the client is given more freedom and able to make changes during the edit session. Clients really dig it."

Designer
George Fok

Art Director
George Fok

Creative Directors
George Fok
Daniel Fortin

Design Company
Époxy communication inc.

Country of Origin
Canada

Work Description
Spreads from *Unleash your other side*, a corporate brochure for Avid technologies inc.

Dimensions
9 x 12 in
228 x 304 mm

Surf Skate Snow Sustain

adre-
nalin

adrenalin magazine
Number Eight
U.K £3.50

9 771369 806022 06>

Designers
Mickey Boy G
Danny Miller

Photographers
Matthias Fennetaux
Bertrand Trichet
Aaron Chang

Art Director
Mickey Boy G

Design Company
Mediacell Ltd

Country of Origin
UK

Work Description
Cover (left) and spreads
from *Adrenalin* magazine

Dimensions
8^1/$_2$ x 10^3/$_4$ in
220 x 275 mm

UPFRONT SKATE_ **Skate & (Don't) Destroy.**
Text **RICH BEACH** Imagery **BERTRAND TRICHET & DANNY MILLER**

Corporation, a part of the Surfrider Foundation - an organisation renowned for its eco-ethos. Skate One have been recognised by a number of environmental bodies for their efforts in going above and beyond their commercial duty to lessen their factories' emissions and waste - any collected excess glues, varnishes and urethanes are recycled and re-used.

Even ramps and skateparks can actually contribute to the environment. A Seattle based engineering company called Ravensforge manufacture modular skatepark components from reclaimed plastic milk bottles. Always said drinking milk was good for you.

Ironically, however, Ravensforge got into the skate world by way of preventing skaters from attacking their favourite public spots by producing cast-iron nobbles designed to fit planters, benches, walls and rails, which were sold to city halls and state councils around the states. Now whether or not their motives for designing skate ramps and fun-boxes came about through the moral reasoning of needing to provide the now banished skaters with an alternative, less public 'playground', or simply the upper-cut of their sales pitch to city hall, securing themselves a second contract to keep those wretched hoodlums out of sight. I can only guess...

"You see Mayor, Sir, if I may make a suggestion. With all the expensive street furniture now safe from those wheeled vandals and their destructive activities, you may want to ask yourself Mr Mayor, Sir, where will these thugs go now that we've put paid to their devil-worshipping fun? **Perhaps they'll start seeking new spots, maybe near the Marina. Perhaps they'll move on to murder and rape instead. Isn't your beautiful house on the Marina Mr Mayor, my Lord? How is your lovely daughter?** Now we have a new product line of skateboard ramps and sacrificial altars and other dastardly units in a safe, recycled plastic, modular construction..." etc.

Skateboarding is environmentally friendly by its very nature. Choosing to get from one place to another by way of a self-propelled skate device rather than an unsustainable fossil-fuel powered vehicle, has got to be one of the single greatest contributions to the planet's welfare that anyone can make. But how many trees do we go through as skaters, trashing decks every few weeks? Well, quite a few I'd imagine, but most Canadian ply comes from sustainable forests where a tree is replanted after every lumber. But how about the glue and bonding process, surely there's some harmful emissions somewhere in the process? Yes granted, but it's nominal, and there are companies that have taken steps to reduce or even eliminate any damaging by-products of any of their manufacturing processes. One such company is the Skate One

Well, whichever way it worked, this company provide skaters with places and paraphernalia to skate and perform their wicked deeds away from nice, shiny public marble furniture. And this is reducing plastic waste (although nothing can ever be removed unless jettisoned into space, but it's moved from one place and turned into something useful rather than sitting in a landfill site to wait and choke the life from something or other).

I just wonder if the skaters in these places are having more fun penned in their recycled plastic playgrounds where they can be accounted for when a mail box gets knocked over or white-picket fence broken.

The moral of the story? Drink more milk. Skate where you like. Shag the Mayor's daughter.

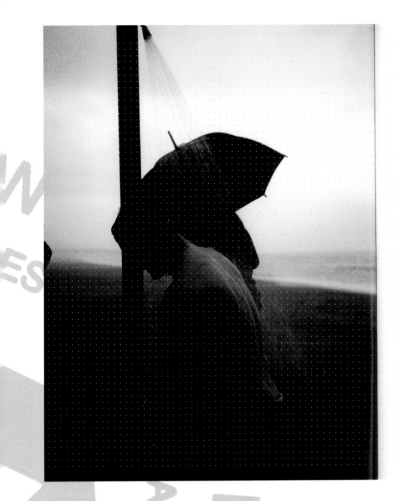

A Quik Cuppa Ch-

Text & photography **MATTHIAS FENNETAUX** / adrenalin / 008 /

a.

I have personally spent the last eleven years getting to know the myriad facets of complicated big wave spot in Galicia, northern Spain. I have moved to a foreign shore, learned to speak a new language and - the most ironic thing of all - decided to remain relatively poor, in pursuit of one thing - the big drop. But sometimes you can't help thinking, is it fame, glory and money that drive the big wave elite?

Sponsors invested a lot of money in the Cortes Bank project. Now they are happy, the photographer is rich, Mike Parsons is king cojones as well as considerably richer, and everybody and his little brother knows that Mike Parsons is the biggest big wave rider in the world. This aspect of big wave riding was elucidated in the lead-up to the famous K2 Challenge, where the rider to be photographed on the biggest wave during the winter of 1997-98 would be given $50,000. It was a paddle-in only event, with no wave-runners allowed. Although the prize was given to Taylor Knox at Todos Santos in Mexico, the whole world's attention was focused on Mavericks as being the obvious arena of destiny. That winter, the Northern Californian water-mountain was apparently more crowded than ever. All sorts of unknown faces were out there in onshore twenty foot surf, with one thing on their mind: the prize. They may have been scared out of their wits, but the lure of that $50,000 cheque drew them out there. It's been said that things became more aggressive in the water, surfers started showing signs of that vulture-like ruthlessness more suited to the bump and grind world of beachbreak mush of which big wave riding is supposed to be the antithesis.

Most Mavericks regulars were sceptical about the K2 challenge. Jay Moriarty thought it absurd that people should be out there not enjoying themselves. "I couldn't imagine what it would be like if you were scared all the time", he asserted, "It wouldn't even be fun." Jeff Clark also had his doubts: "Excuse me", he told a surf journalist, "this is not what this is about. Big wave riding is about just that...big wave riding. It's not about how much money you can make out of a wave."

This year things went beyond the K2 challenge. Swell.com and Surfline.com offered $60,000 for the biggest wave photographed, but this time allowed tow-in surfing. Needless to say, Mike Parsons was the winner of the Swell-Surfline XXL Challenge with his sixty-six foot wave at the Cortes Bank.

We have to realise that tow-in surfing and 'traditional' big wave riding are different. One is not simply an extension of the other. With one you can ride the biggest waves on the planet, get into previously unimaginable positions on the wave, and get as many waves as you want with no crowd problems. But you miss what some people maintain is the essence of big wave riding: the take-off. Paddling in on a gun you are 'naked', at the whim of a monster whose habits you have spent years getting to know, but which can still unexpectedly swat you with the merest twitch of its tail. You take off not knowing whether you are going to make the drop or will be launched into oblivion. It

54

55

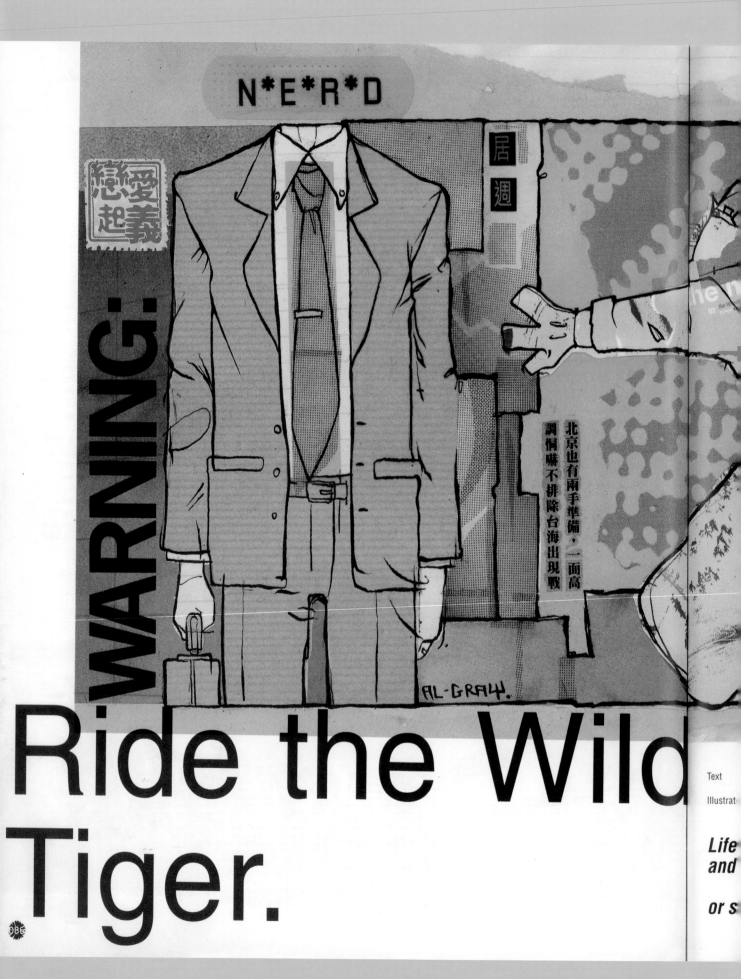

N*E*R*D

WARNING:

Ride the Wild Tiger.

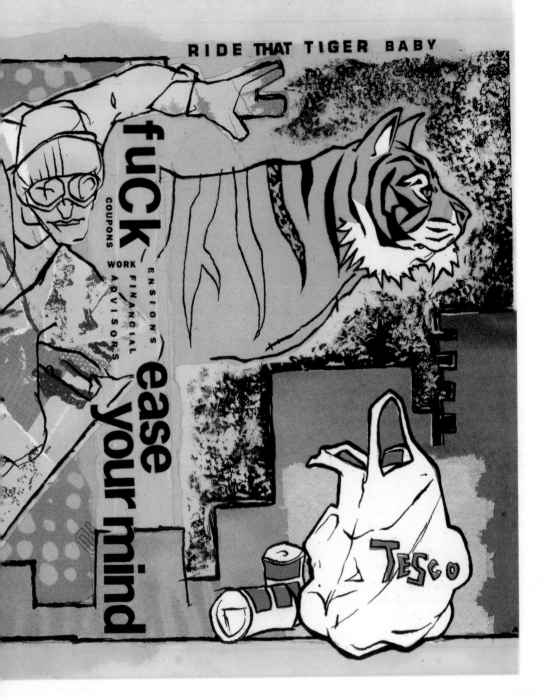

RIDE THAT TIGER BABY

fuCk

PENSIONS
COUPONS
WORK FINANCIAL ADVISORS

ease your mind

TESCO

Designer
Mickey Boy G

Illustrator
Al Gray

Art Director
Mickey Boy G

Design Company
Mediacell Ltd

Country of Origin
UK

Work Description
Spread from
Adrenalin magazine

Dimensions
8¹/₂ x 10³/₄ in
220 x 275 mm

by ANDY IVES

by AL GRAY

a wild tiger. You can either lie down
y its paw on your head

back and RIDE IT. I find myself being kept awake for nights on end >>

087

Deep funk thread.

Whilst record shopping in New York State in '96, I found some classic funk like 'Amen Brother' by The Winstons and James Brown-related classics on King, Polydor and People. A couple of months later I was back in the UK with a trolley overloaded with badly packed boxes of LPs, thinking I was beginning to get somewhere with records. Not long afterwards, I heard Keb Darge smoulders a club dancefloor with two hours of incredibly heavy funk singles I'd mostly never heard before. Dancing to Keb's big records of the time like Ernie and the Top Notes 'Dap Walk', and the Majestics' 'Funky Chick', I was sweating like a madman but my vinyl ego was smashed, as I realised that funk ran a lot deeper than I thought. It was time to put in some detective work!

The club night 'Legendary Deep Funk', started by Keb along with DJ Snowboy and others at London's Ormond's back in the mid-nineties (now at home in Soho's Madame Jo Jo's), was an important breeding ground for the UK's fascination with this music. The event's name later went on to be used as the title of Keb's highly influential series of compilations. But long before the days of selecting albums with industry heavyweights like Kenny Dope and Pete Rock, Keb and his co-compilators devised a plan. Realising they had been playing similarly rare and heavy 45s, they decided to try and forge what they had into a 'movement'. Sick to death of the same old handful of boring 'classic' funky records that had been getting played on the Rare Groove and Acid Jazz scenes for years, they decided to try and make their rarityies the dance classics of the future. They've been pretty successful as there are now various funk

THE HIGHEST COMMON DENOMINATOR

TEXT GEORGE MAHOOD PHOTOGRAPHY GRUBBY

events around the world, and a never-ending stream of compilations hits record shops almost weekly. Luckily for the country's dancers, some of the slightly lesser-known (though equally heavy) DJs like Ian Wright and The Rustler are starting to get out and about a little more.

Thanks to the Soul dealers who supplied the Northern Soul scene and other Soul scenes, there has been plenty of black music to dig through in the UK for the past thirty years or more, and alongside the veterans mentioned above there's now a generation of younger jocks like Adam Leaver & Mister Boney from Manchester, Andrew Symington from Glasgow, Dave Nicholes from Southend, and James Trouble and Jason Stirland from London. Of course, there are other veteran funk lovers in Europe who've been playing this music since the early '90s, like the Swiss collector and dealer Peter Wermellinger (and, indeed, East End diamond The Rustler for that matter). But now that the compilations and reissued 45s are coming out at a faster rate, the number of DJs playing the heavy stuff, whether from original pressings or bootlegs & genuine second issues, is increasing exponentially. And that's been pushed along by the appearance of many 'new' funk records over the last few years. Some, like the Snowboy-plugged 'Brand New Girl' by Billy Garner, or the Soul Seven's 'Southside Funk' are unreleased gems from record labels' vaults, while others are totally new recordings.

Bands have also now begun to make their impression felt, thanks to the rise in popularity of their current release 45s. Just as in the Northern Soul scene, there are **>>**

Designers
Mickey Boy G
Lucus Krull

Photographers
Grubby
Lucus Krull

Art Director
Mickey Boy G

Design Company
Mediacell Ltd

Country of Origin
UK

Work Description
Spreads from
Adrenalin magazine

Dimensions
8¹/₂ x 10³/₄ in
220 x 275 mm

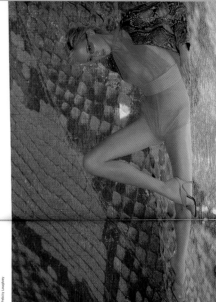

Gigi Edgley

← FULL QUOTE

"I'VE SKIDDED ON THE ICE WITH TORVILL AND DEAN, WE'VE GONE TO ALL THE CIRCUSES, PLAYED ON THE TRAPEZE. IT'S BEEN A BEAUTIFUL, EXCITING LIFE, BUT AT THE SAME TIME THERE HAS BEEN A LOT OF DISH THROWING."

MARKUS KLINKO + INDRANI

IF YOU'RE GOING TO GO GLOSSY, YOU MAY AS WELL GO ALL THE WAY. MARKUS KLINKO AND INDRANI OFFER AIRBRUSHED DREAMS OF FEMININE PERFECTION.

Text Felicity Loughrey

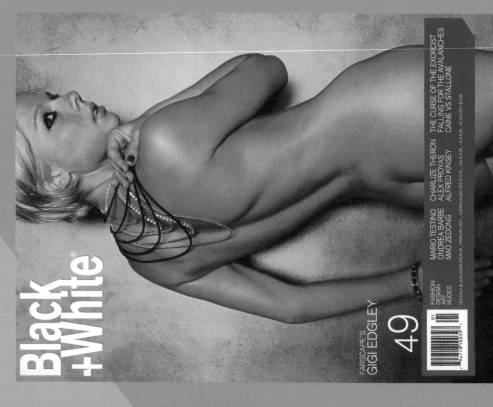

Black+White

49

01

FARSCAPE'S
GIGI EDGLEY

FASHION
DESIGN
ART
NUDES

MARIO TESTINO
ONDREA BARBE
MAO ZEDONG

CHARLIZE THERON
ALEX PROYAS
ALFRED KINSEY

THE CURSE OF THE EXORCIST
FALLING FOR THE AVALANCHES
CAINE VS STALLONE

NOT ONLY BLACK+WHITE ISSUE 49, FEBRUARY 2005, AUSTRALIA (INC 0011) $13.00, USA $14.95, UK $9.95, NZ (INC 0011) $19.95

Designers
Andrew Godfrey
Khan Van Grecken

Illustrator
Khan Van Grecken

Photographers
Carlotta Moye
Markus Klinko
Ben Saunders
Ondrea Barbe
Various

Art Directors
Andrew Godfrey
Khan Van Grecken

Design Company
DankRealms

Country of Origin
Australia

Work Description
Front cover (below) and spreads (right and opposite; see also p.108–109) from *Black+White* magazine

Dimensions
9³⁄₈ x 12⁵⁄₈ in
240 x 325 mm

THE GREAT RUSH

SPEEDING THROUGH CHAIRMAN MAO'S TOMB IN TIANANMEN SQUARE, MARK MORDUE GLIMPSES A COUNTRY RUSHING UNCERTAINLY TOWARDS A NEW DICTATOR — THE FREE MARKET.

ILLUSTRATION KHAN VAN GRECKEN

Running. That is how one visits the mausoleum of Chairman Mao in Tiananmen Square. Running here, running there, running till it hardly feels as if you have been there at all. Quickly, quickly, to the sound of organisers' loudhailers, on through the dark interior and its heavy solemnity, out into a world of souvenirs and trinkets. "Take off your hat. Please be quiet," says a sign just inside the door. You do as you are told. Hardly breathing, head bowed, shuffling forth to greet the dead Red Emperor.

From Monday through to Saturday, 8.30am till 11.30am, visits are free. Mao lies in state, mummified for the Chinese public's delectation. Entry is via the north gate, which means you'll stumble around the entire building, or the full breadth of Tiananmen Square, the largest square in the world, figuring out just where the hell north is. If the mausoleum is open — sometimes it can be closed for 'renovations' — look for a crowd and a long enthusiastic line.

I was a little less aware. Walking through a deserted gate towards what I mistook for a ticket box, I had a guard freeze me with a single gesture. "You!" he roared. Probably the only English he knew, but enough for me. I smartly interpreted it as stop, knowing full well the regime's crack troops still work Tiananmen Square, some of the same troops who took part in what locals refer to as '4-6' (the date of the June 4 massacre in 1989). Troops here are discipline personified, the kind who march in ruthless formation. That is, 108 paces per minute, 75 centimetres per pace. Every step.

Out in Tiananmen Square its all happy families and holiday snaps. The tourists are mostly Chinese from all over the country, come to see Mao in repose, along with the Forbidden City nearby and some time spent flying kites with the kids in the square. is one of this country's climate experiences. At the entrance to the Forbidden City, a large portrait of Mao looks back over the holiday bliss. During the student protest, angry farmers splattered his picture with black paint, a gesture so shocking that the students turned them over to the police. Despite criticism of the Communist regime, Mao still had a divine place in the minds of most people, including the students. It is hard to shake reverent ideas about him, even now. Thus the popularity of visits to his mausoleum, a pilgrimage to bask in the aura of the so-called 'Great Helmsman', as he was known in popular song. A quest, perhaps, to also find the lost soul of the People's Republic Of China now that rampant capitalism has seized the day.

In the revisionist atmosphere surfacing around Deng Xiaoping (deceased February 19, 1997), the post-Tiananmen monster is now softly praised for his refusal to engage in a personality cult — something Mao constantly indulged in — and the general absence of his image from public life today. Not for Deng the indulgent aspirations towards godhead that marked Mao Zedong's rule. And so Deng is getting an historical facelift: economic visionary and personally modest, a "peppery man" who gave his people hard love and tough medicine because that was what was needed. With the re-paved surface of Tiananmen, and the bull markets of the Chinese New Year stock exchange, Deng's darker heritage is almost wiped clean. Ironically, in the wake of this 'modest' and contemporary memorial universe, Maoist nostalgia is on takin' care of business. Maoist nostalgia in China is running wild as people look back to the days when leadership and the country's destiny seemed far more absolute.

I've had a bit of a laugh before I arrive at the Chairman Mao Memorial Hall, thanks to a story told to me by a Tiananmen Square refugee. Apparently a ⌐>

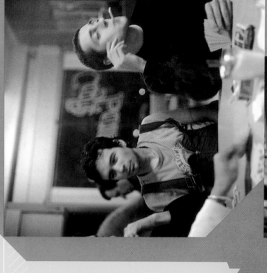

Those boys need therapy.... The Avalanches (clockwise from top left): Chater, McQuillen, Seltmann, Fabay, Diblas, and Dela Cruz.

TITLE

MEET THE NEW MOBY.
HE'S AUSTRALIAN, AND THERE ARE SIX OF HIM.
BLACK+WHITE LEARNS WHY THE AVALANCHES
ARE ABOUT TO SWEEP ALL IN THEIR PATH.

TEXT MICHELLE MARGHERITA
PHOTOGRAPHY BEN SAUNDERS

The rain tumbles down while

I wait for The Avalanches at the foyer of a seedy Kings Cross hotel. A shiny white Tarago pulls up and six young lads tumble out, damp and weary. They shuffle lazily into the foyer and introduce themselves before we all cram into the steamy, rickety lift that takes us to their hotel suite.

Once inside, the band disperses. Dexter Fabay looks from his room to his bed, rubs his eyes sleepily and drifts off into his room. James Dela Cruz scratches his head through his thick, woolly afro, and follows Fabay. Tony Diblas simply disappears. I'm left with Darren Seltmann, Gordy McQuillen and Robbie Chater (who drop heavily onto two slightly soiled couches and proceed to light up.

Young, muscular and good looking, these boys from Melbourne and central Victoria chat easily to one another, often finish each other's sentences, have a lexicon of in-jokes and act like regular guys. Which The Avalanches are, right now, though it may not last for long. The word is out. Madonna loves them. Beastie Boys producer Mario C does too. Britain's style bible, The Face flew in to do a five-page feature on the lads after a bootlegged copy of their debut album found its way onto the editor's desk.

Legendary producer/composer Van Dyke Parks (Beach Boys, Arlo Guthrie) warmed up his vocal chords to sing on a revised version of the album's title track for the single release. The band recently remixed 'Is Jennifer Gentle' for Siouxsie and the Banshees. Diwan Boy. They've signed a UK deal with dance label XL Recordings, which has Basement Jaxx and The Prodigy on their roster, and are now managed outside Australia by The Chemical Brothers' minders.

When they contacted Madonna's people about using the vocals on album track "Stay Another Season", they were told no problem – the iconic one already had their EPs and was a fan. Thus they became the first act ever to receive permission to sample Madonna.

All of which points towards The Avalanches being the next Australian group to go global.

It all began in 1997. Melbourne was freaking out to The Swinging Monkey Cocks – four guys in full samurai costume playing orchestral punk rock and acting like total lunatics on stage. It was an awesome sight and the genesis of The Avalanches in all their unhinged glory.

A wonky-sounding Japanese demonstration record for a '70s organ called Yamaha Superstar! inspired the band to change their musical direction. "It was really out of tune and just a spastic record with crazy production, and we thought, 'We could do this pretty easily,'" says Chater, 25.

So they ditched punk rock for samples, beats, turntables and frenzied noises, recorded a demo and changed their name. They sent their tape to Steve Pavlovic, one of Australia's hippest promoters. Pavlovic immediately awarded them scorching gigs supporting Beck and The Jon Spencer Blues Explosion. He also funded the recording of The Avalanches' first EPs and signed them to his own newly formed label, Modular.

You've probably already heard the high-rotation single "Frontier Psychiatrist", with its infectious that boy needs therapy chorus borrowed from Canadian comedic greats Wayne & Shuster. Now the album's out, Since I Left You, and it's as puzzling and brilliant as an Escher drawing. Mixing up samples from soul, disco, spoken word, easy listening and even opera, it sounds like a party hosted by six duelling djs.

Comparisons with Moby are inevitable, but the album makes Moby's range of musical references seem hopelessly narrow. And all it took to create this glorious mess was two years, 10,000 vinyl records and an octagonal leatherette waterbed affectionately known as The Control Pad.

"It started in our bedrooms," says Seltmann, 27. "We had a studio that was built around the waterbed and it was just fantastic. It was padded fake leather with lights and a stereo on the headboard." They recorded most of Since I Left You sitting on this superb '70s artefact (the rest was recorded at McQuillen's grandma's beachhouse in Sorrento).

"Tony broke the waterbed by jumping on it," continues Seltmann. "So I traded a few things together and sold it to a bikie. He said the work was good and sold it to a bikie, she goes [adopts a broad Australian accent] 'It's not bad and he goes 'Why?' and she says, 'There's no drink holders. Where am I gonna put... Jim Beam?' So I said, 'Why don't you put a table next to it?' and she goes, 'Oh yeah, alright.'"

Through the guys laugh at this recollection, it's easy to see that The Avalanches are exhausted. "We just did two shows, we were tired and... we went crazy... after the show the beer came out, the girls, it sucks heavily on a cigarette. "He's got eight balloons up his arms," says McQuillen, 23. "It's probably from sharing them every day," clarifies Seltmann. The guys crack up at this. "I don't know.... we just feel tired and stupid and.. not... talk... properly."

Chater explains that this diverse reaction to being so hyped up on stage is the emotional come-down. "It's why we're fucked today," says McQuillen.

With shows involving constant instrument swapping, mad theremin playing, running on and off stage to "milk and huff", jumping around and group hugs, I'm not surprised they're drained. [A few days after this interview, Seltmann broke his leg on stage in Brisbane – Ed.] It's also their fourth interview for the day. Mine is the last vertical one they're doing, they say. After the one just preceding mine they rushed to a hotel room, this morning. "That's why you're in this room", giggles Chater. "We had another room down the hall that got wrecked in a photo session. We can show it to you if you want."

"We smashed everything," says Seltmann. "Yeah, Jimmy smashed heaps of things. He ran out of a cupboard with a cupboard on his head and then he smashed them, and a chest of drawers, and then we threw a mattress out the window." He laughs. "Nah, we didn't really do that – we sat spat on everything."

"It was his therapy," says McQuillen.

Hoteliers of Europe, be warned: The Avalanches are about to come to your town. Then it's Australia's turn again, before they start work on their next album. "I think we're going to do a comedy record next, a sort of off-the-cuff thing like Derek & Clive," says Seltmann, "or maybe some kind of stand-up thing. But I'm not that funny yet."

Since I Left You is out now on Modular/EMI. The Avalanches are touring Australia in March–April.

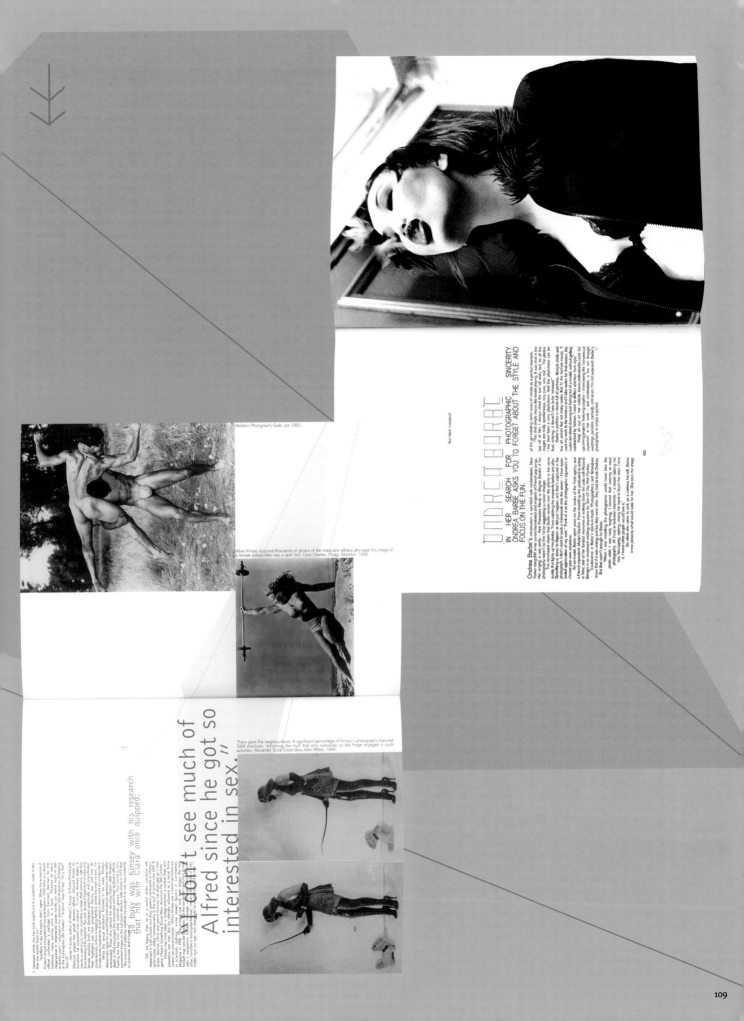

Western Photography Guild, pre-1950.

While Kinsey acquired thousands of photos of the masculine athletic physique this image of a female bodybuilder was a rarer find. Cecil Charles, *Pudgy Stockton*, 1946.

There goes the neighbourhood. A significant percentage of Kinsey's photographs featured S&M practices, debunking the myth that only individuals on the fringe engaged in such activities. Alexander Scott Couts (aka John Willie), 1944.

"...don't see much of Alfred since he got so interested in sex."

ONDREA BARBE

IN HER SEARCH FOR PHOTOGRAPHIC SINCERITY ONDREA BARBE ASKS YOU TO FORGET ABOUT THE STYLE AND FOCUS ON THE FUN.

Text Mark Campbell

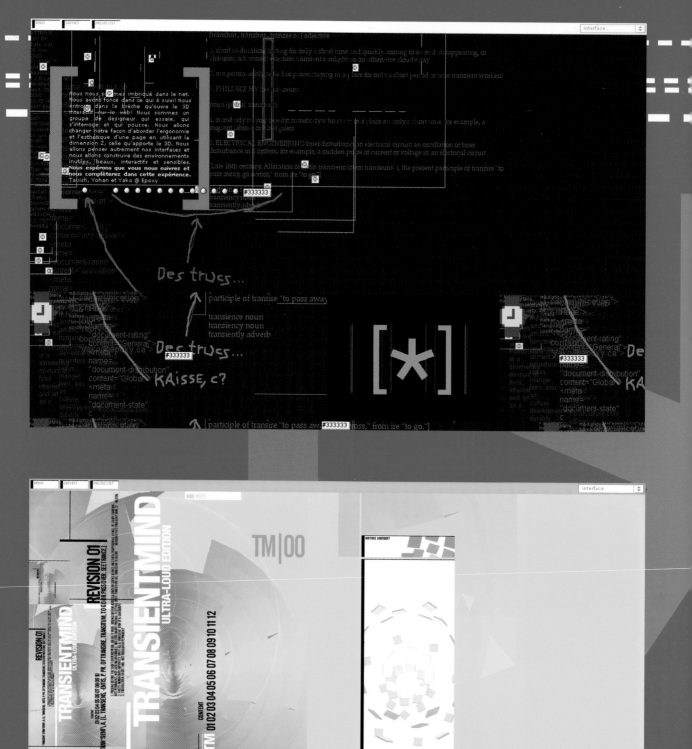

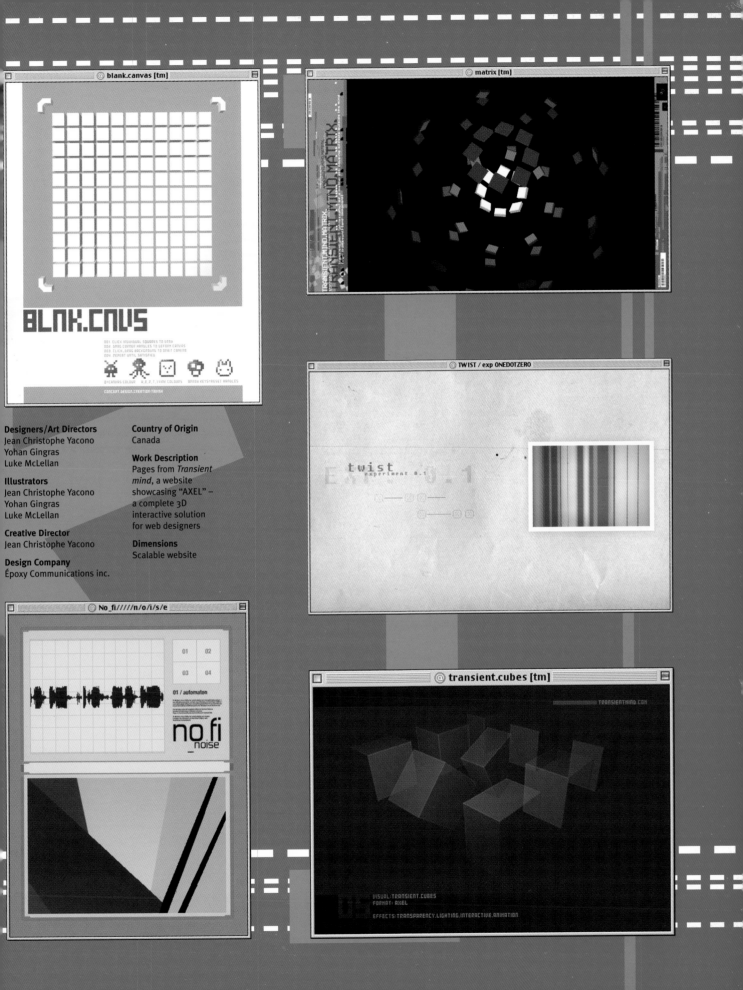

@ blank.canvas [tm]

BLNK.CNVS

@ matrix [tm]

@ TWIST / exp ONEDOTZERO

twist
experiment 0.1

@ No_fi/////n/o/i/s/e

01 / automaton

no_fi
_noise

@ transient.cubes [tm]

TRANSIENTMIND.COM

VISUAL:TRANSIENT.CUBES
FORMAT: AXEL

EFFECTS:TRANSPARENCY.LIGHTING.INTERACTIVE.ANIMATION

Designers/Art Directors
Jean Christophe Yacono
Yohan Gingras
Luke McLellan

Illustrators
Jean Christophe Yacono
Yohan Gingras
Luke McLellan

Creative Director
Jean Christophe Yacono

Design Company
Époxy Communications inc.

Country of Origin
Canada

Work Description
Pages from *Transient mind*, a website showcasing "AXEL" – a complete 3D interactive solution for web designers

Dimensions
Scalable website

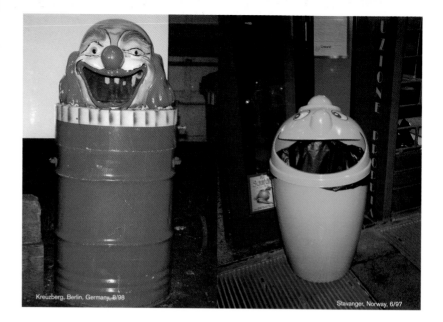

Kreuzberg, Berlin, Germany, 8/98

Stavanger, Norway, 6/97

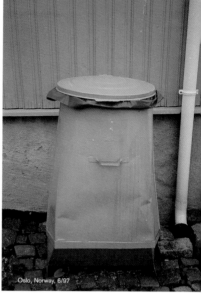

Oslo, Norway, 6/97

Litter only

Oslo, Norway, 6/97

Tooting Bec Lido, London, UK, 8/99

Designer
Alexandra Martini

Photographer
Alexandra Martini

Design Company
Alexandra Martini

Country of Origin
Germany

Work Description
Cover (left) and spreads from *Litter only*, a 300-page book showing the variety of litter bins

Dimensions
5 x 6 in
130 x 154 mm

Calle Consejo de Ciento, Barcelona, Spain, 2/95

Bangkok, Thailand, 2/96

Chiang Mai, Thailand, 3/96

113

Designers
Phunk Studio

Design Company
Phunk Studio

Country of Origin
Singapore

Work Description
Pages from the webzine *Transmission*, a collaborative project that showcases creative talent from around the world

Dimensions
Scalable website

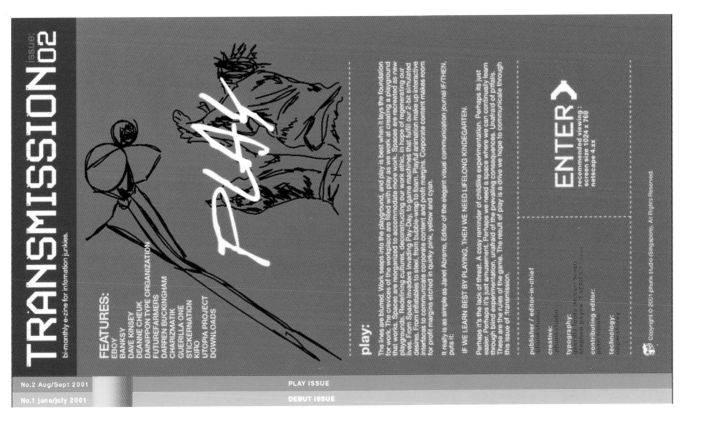

Designers
Phunk Studio

Design Company
Phunk Studio

Country of Origin
Singapore

Work Description
Pages from
the webzine
Transmission,
a collaborative
project that
showcases
creative talent
from around
the world

Dimensions
Scalable website

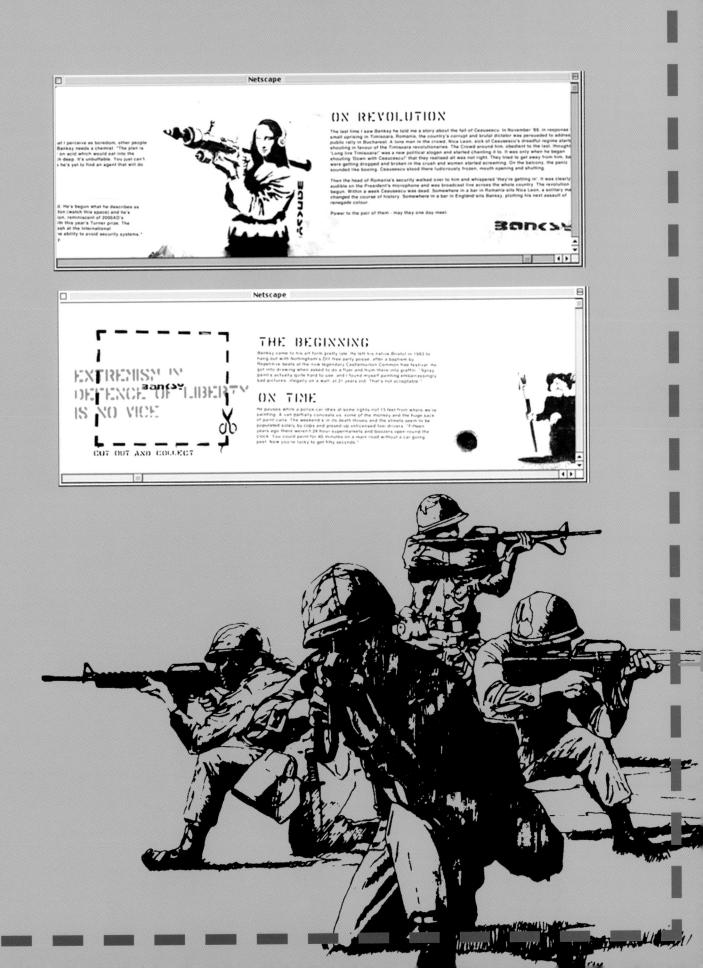

ON REVOLUTION

at I perceive as boredom, other people
Banksy needs a chemist. "The plan is
- on acid which would eat into the
h deep. It's unbuffable. You just can't
s he's yet to find an agent that will do

d. He's begun what he describes as
ion (watch this space) and he's
ion, reminiscent of 2000AD's
ith this year's Turner prize. The
ash at the International
e ability to avoid security systems."
y.

The last time I saw Banksy he told me a story about the fall of Ceausescu. In November '89, in response small uprising in Timisoara, Romania, the country's corrupt and brutal dictator was persuaded to address public rally in Bucharest. A lone man in the crowd, Nica Leon, sick of Ceausescu's dreadful regime starts shouting in favour of the Timisoara revolutionaries. The Crowd around him, obedient to the last, thought 'Long live Timisoara!' was a new political slogan and started chanting it to. It was only when he began shouting 'Down with Ceausescu!' that they realised all was not right. They tried to get away from him, but were getting dropped and broken in the crush and women started screaming. On the balcony, the panic sounded like booing. Ceausescu stood there ludicrously frozen, mouth opening and shutting.

Then the head of Romania's security walked over to him and whispered 'they're getting in'. It was clearly audible on the President's microphone and was broadcast live across the whole country. The revolution begun. Within a week Ceausescu was dead. Somewhere in a bar in Romania sits Nica Leon, a solitary ma changed the course of history. Somewhere in a bar in England sits Banksy, plotting his next assault of renegade colour.

Power to the pair of them - may they one day meet.

BANKSY

THE BEGINNING

Banksy came to his art form pretty late. He left his native Bristol in 1993 to hang out with Nottingham's DIY free party phase, after a bagfrom by Repetitive beats at the now legendary Castlemorton Common free festival. He got into drawing when asked to do a flyer and from there onto graffiti. "Spray paint is actually quite hard to use, and I found myself painting embarrassingly bad pictures, illegally on a wall, at 21 years old. That's not acceptable."

ON TIME

He pauses while a police car idles at some lights not 15 feet from where we're painting. A van partially conceals us, some of the monkey and the huge sack of paint cans. The weekend is in its death throes and the streets seem to be populated solely by cops and pissed up unlicensed taxi drivers. "Fifteen years ago there weren't 24 hour supermarkets and boozers open round the clock. You could paint for 40 minutes on a main road without a car going past. Now you're lucky to get fifty seconds."

EXTREMISM IN DEFENCE OF LIBERTY IS NO VICE

BANKSY

CUT OUT AND COLLECT

Sebastian Helling
Kristoffer Busch
Daniel Mair

Art College
Royal College
of Art

Country of Origin
Norway/Sweden

Work Description
Posters based
on the word
"boredom"

Dimensions
17¹/₂ x 21 in
445 x 533 mm

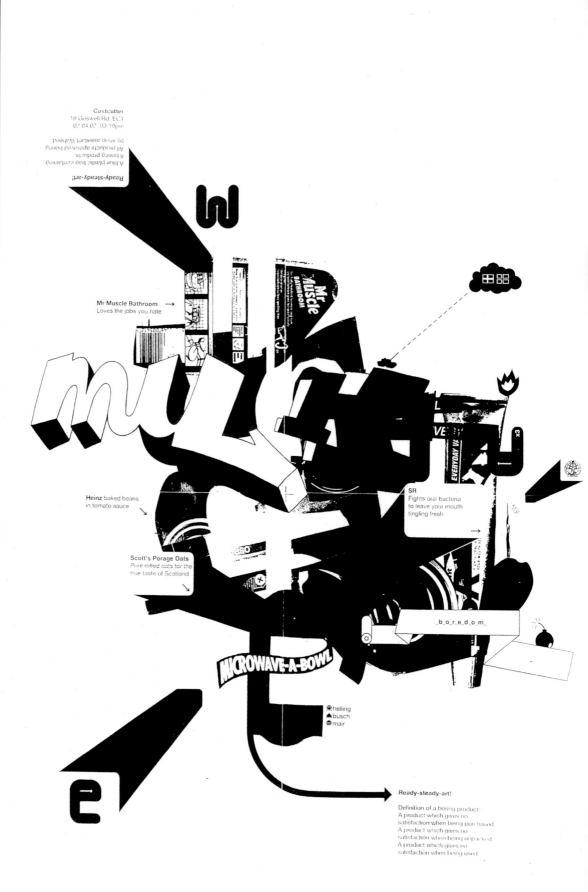

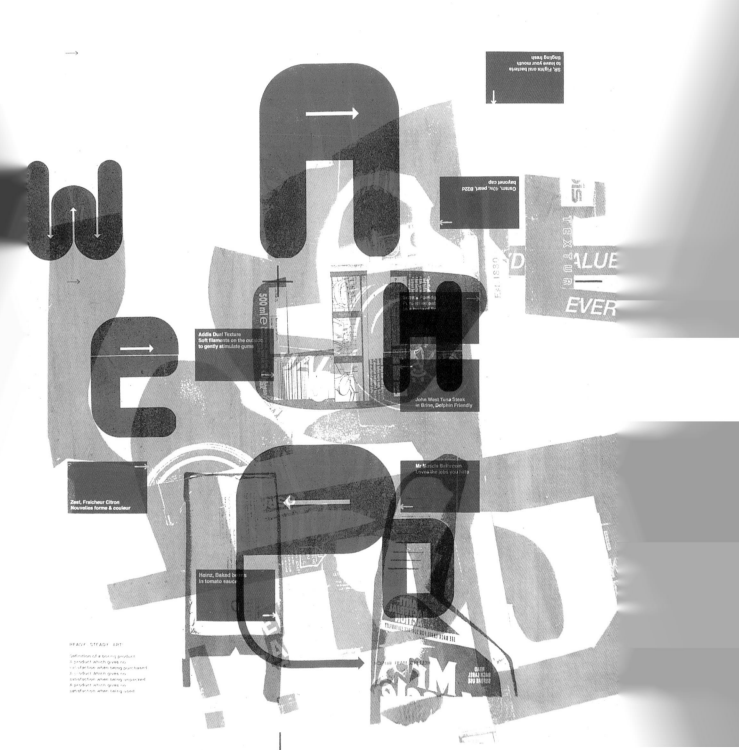

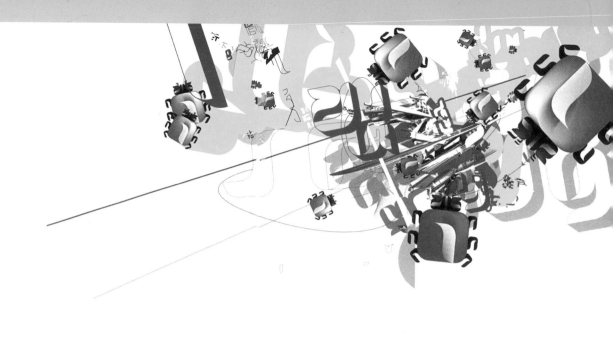

Art Director/Publisher
Deanne Cheuk

Designers
Lucas Surtie (top left)
Phillip Schwarz (top right)
Andrew Fiscalini
(bottom right)

Design Company
NeoMu

Country of Origin
USA

Work Description
Front covers (right) and
spreads from issues 03
and 04 of *NeoMu*, a
mini but magnificent
magazine

Dimensions
4³/₈ x 4¹/₄ in
111 x 110 mm

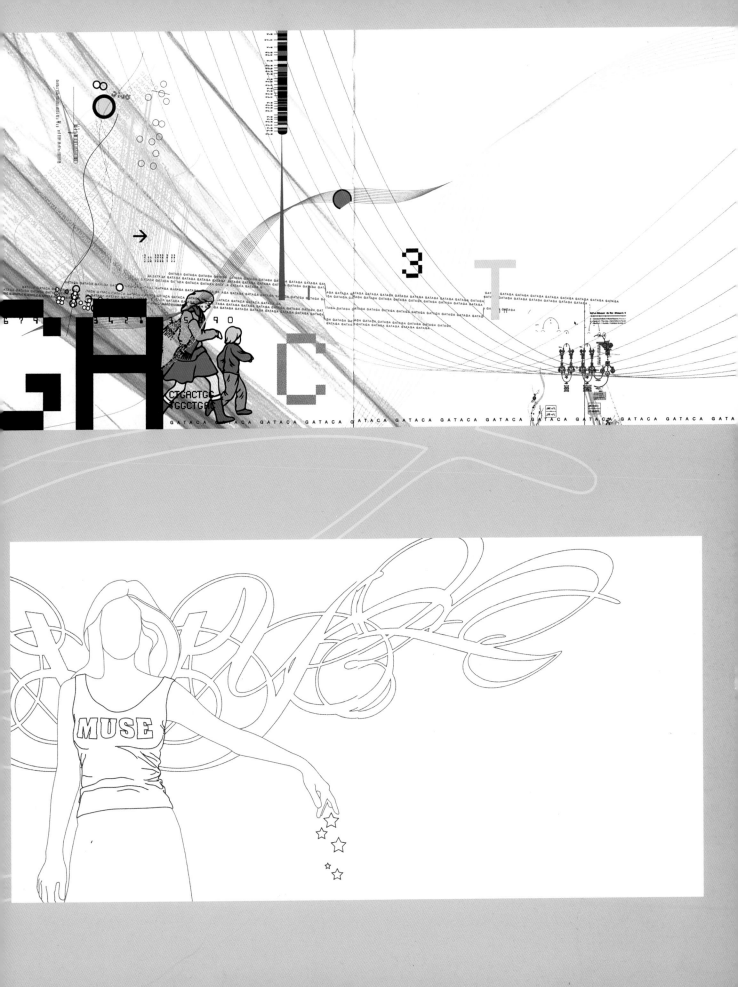

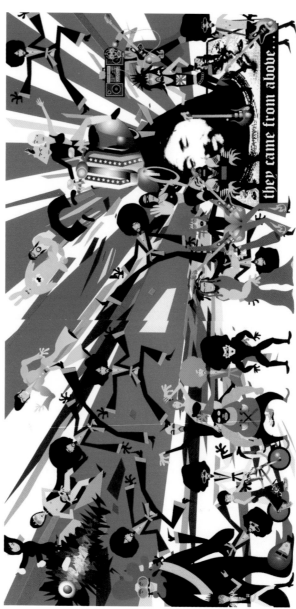

Designers
(Top to bottom)
Fiel Valdez
Esam Salleh
Stuart Medley
Donny Miller
Stuart Medley

Design Company
NeoMu

Country of Origin
USA

Work Description
Spreads from
NeoMu, a mini
but magnificent
magazine

Dimensions
4³/8 x 4¹/4 in
111 x 110 mm

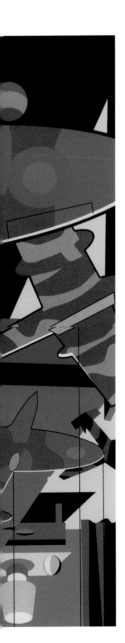

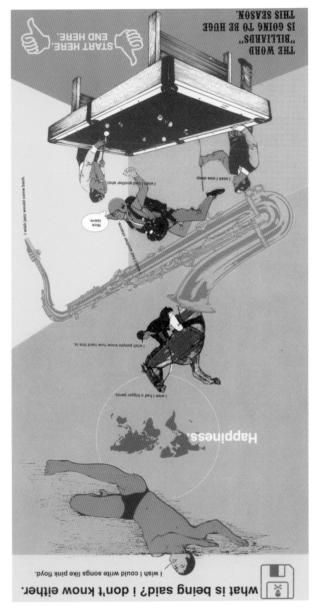

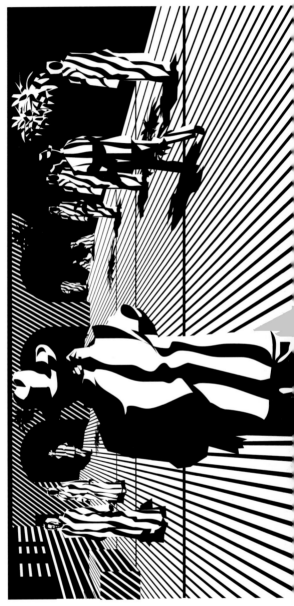

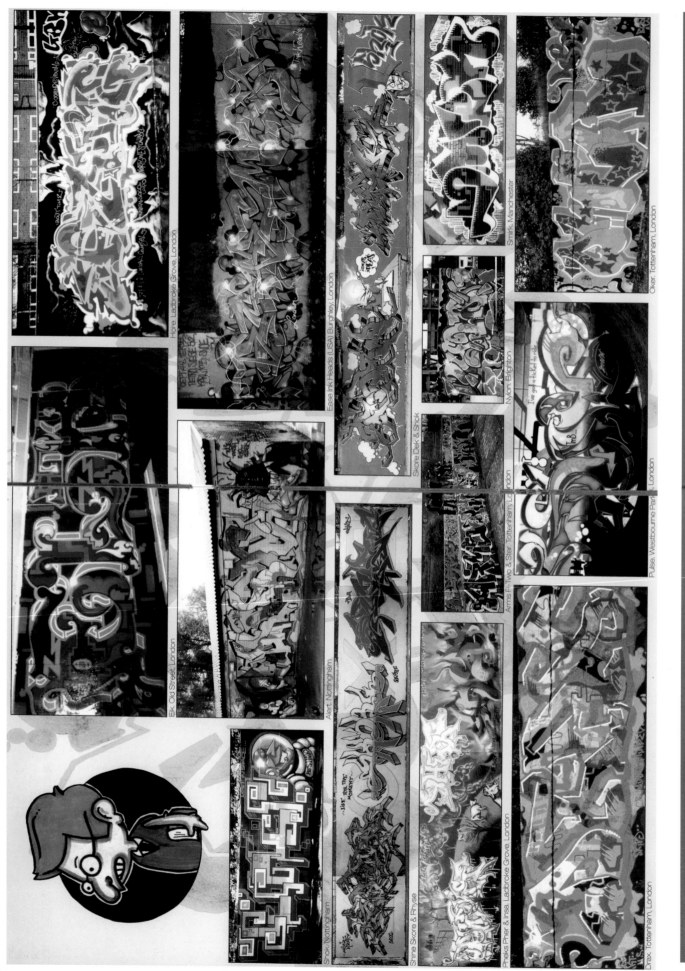

Hare, Ladbroke Grove, London

Ease Ink Heads (USA) Burghley, London

Smirk, Manchester

Oker, Tottenham, London

Skore Dek & Shok

Nylon, Brighton

Elk, Old Street, London

Alert, Nottingham

Arms Ft Two & Ster, Tottenham, London

Pulse, Westbourne Park, London

Shok, Nottingham

Shine Skore & Rhyse

Pheks Pher & Insa, Ladbroke Grove, London

Drax, Tottenham, London

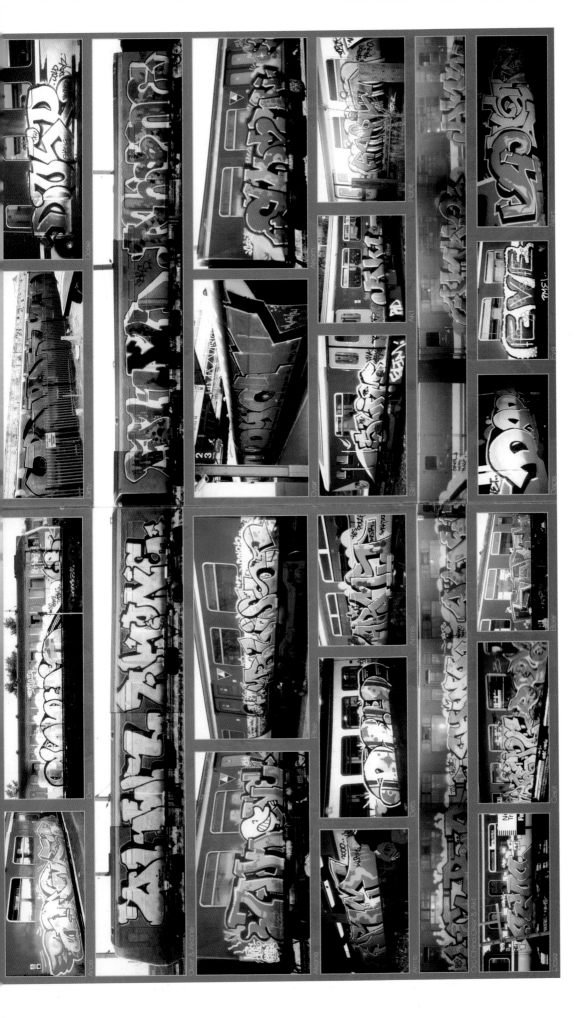

Designers
Alex Shields
Vadim Mytnik

Country of Origin
UK

Work Description
Spreads from *Bomb Alert* magazine, showcasing graffiti performed legally on walls around England (opposite) and illegal graffiti painted on trains (left)

Dimensions
8¹/₄ x 11¹/₂ in
210 x 297 mm

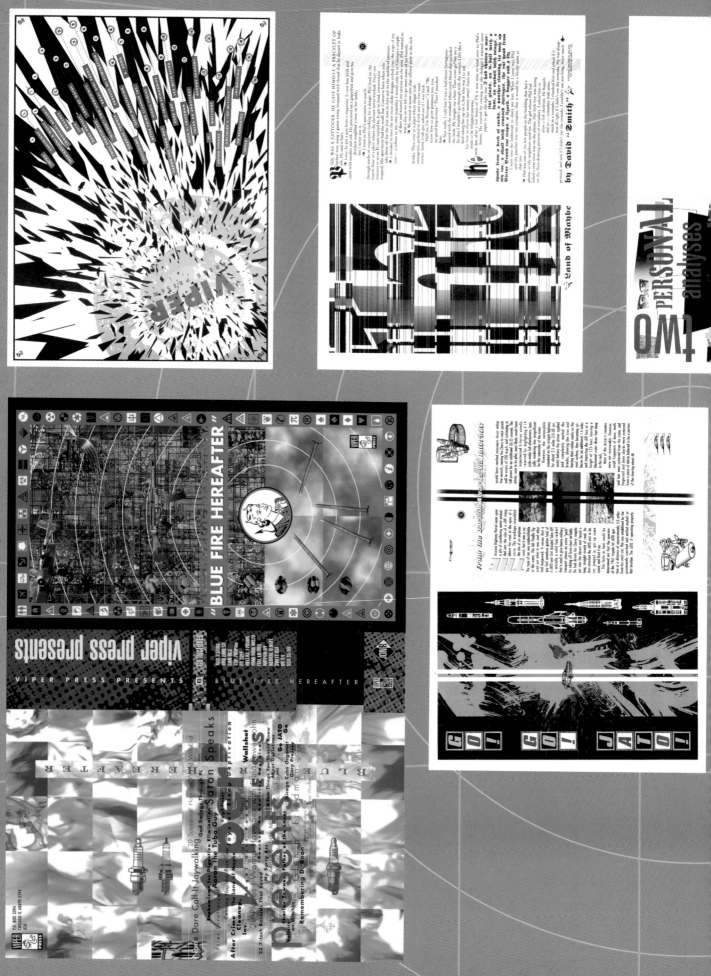

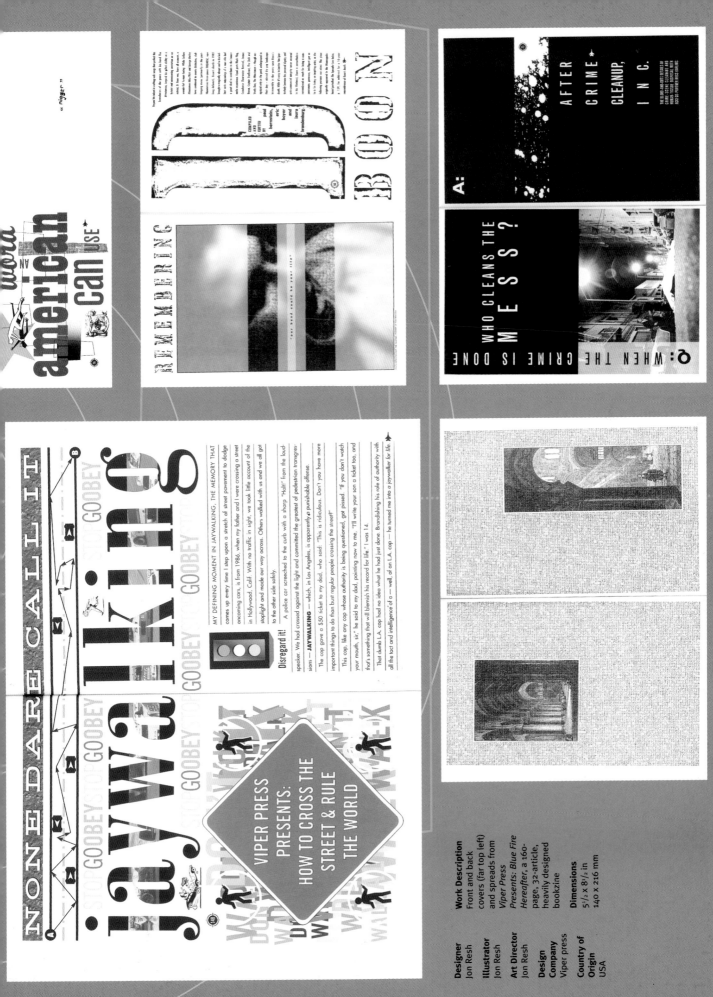

Designer
Jon Resh

Illustrator
Jon Resh

Art Director
Jon Resh

**Design
Company**
Viper press

**Country of
Origin**
USA

Work Description
Front and back
covers (far top left)
and spreads from
*Viper Press
Presents: Blue Fire
Hereafter*, a 160-
page, 32-article,
heavily designed
bookzine

Dimensions
5¹/₂ x 8¹/₂ in
140 x 216 mm

Designer
Jon Resh

Illustrator
John Resh

Photographer
John Resh

Art Director
Jon Resh

Design Company
Viper Press

Country of Origin
USA

Work Description
Posters promoting
the *Deadtech* series
of Electromechanical
Art and Media events

Dimensions
5¹/₂ x 17 in
140 x 432 mm

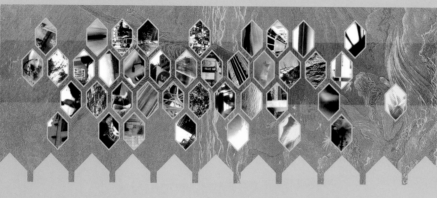

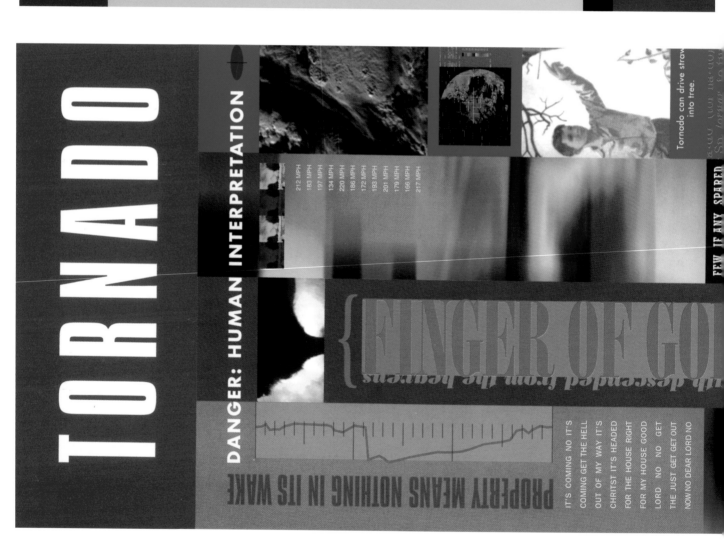

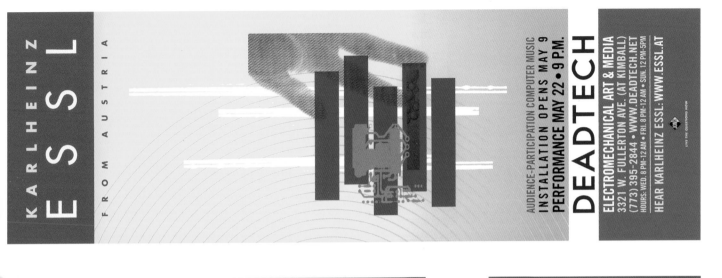

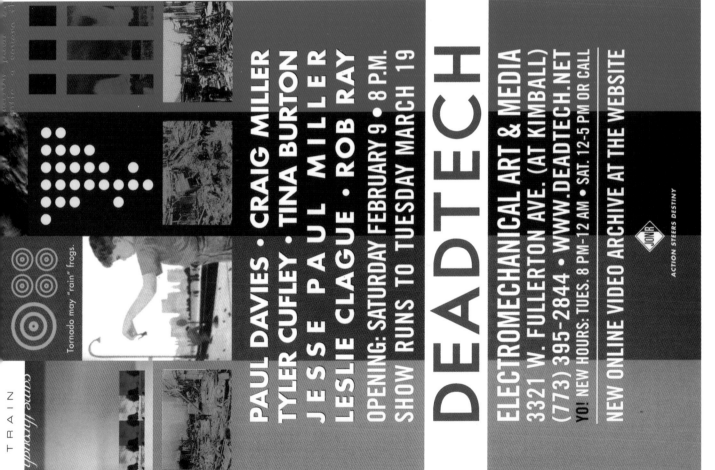

Designer
Jon Resh

Illustrator
John Resh

Photographer
John Resh

Art Director
Jon Resh

Design Company
Viper Press

Country of Origin
USA

Work Description
Posters promoting the *Deadtech* series of Electromechanical Art and Media events

Dimensions
5¹/₂ x 17 in
140 x 432 mm

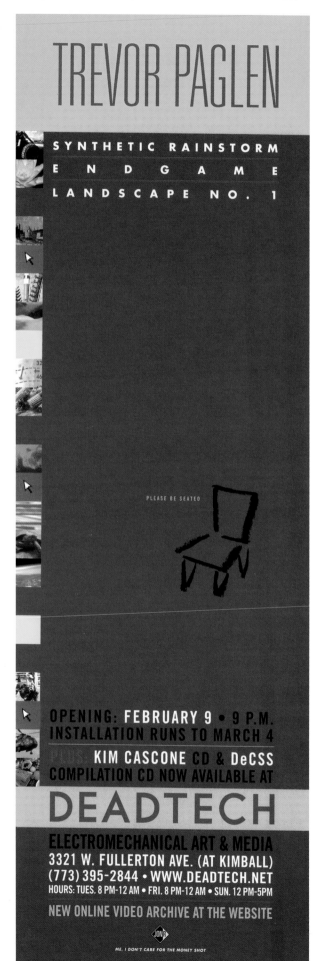

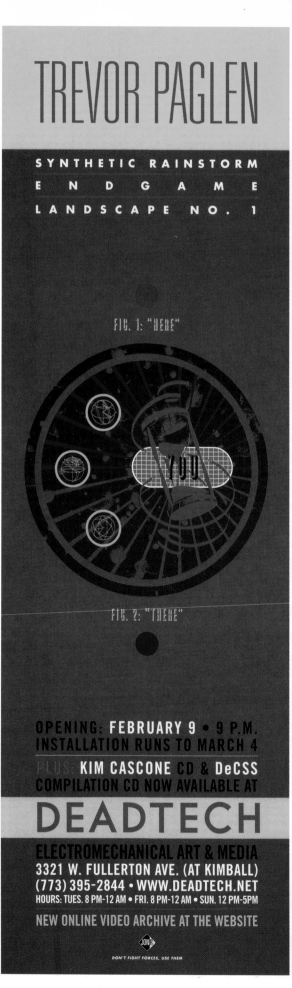

R O B B
DRINKWATER

(INTER)REACTIVE: **AUDIO INSTALLATION**

OPENING: OCTOBER 6 • 9 P.M.
INSTALLATION: OCTOBER 7-29

DEADTECH

ELECTROMECHANICAL ART & MEDIA
3321 W. FULLERTON AVE. (AT KIMBALL)
(773) 395-2844 • WWW.DEADTECH.NET
HOURS: TUES. 8 PM-12 AM • FRI. 8 PM-12 AM • SUN. 12 PM-5PM

BYORC: BRING YOUR OWN REMOTE CONTROL*

*(TV/VCR)

PROBLEMS ARE MY FRIENDS

R O B B
DRINKWATER

(INTER)REACTIVE: **AUDIO INSTALLATION**

OPENING: OCTOBER 6 • 9 P.M.
INSTALLATION: OCTOBER 7-29

DEADTECH

ELECTROMECHANICAL ART & MEDIA
3321 W. FULLERTON AVE. (AT KIMBALL)
(773) 395-2844 • WWW.DEADTECH.NET
HOURS: TUES. 8 PM-12 AM • FRI. 8 PM-12 AM • SUN. 12 PM-5PM

BYORC: BRING YOUR OWN REMOTE CONTROL*

*(TV/VCR)

ALL HAIL THE NEW UNCONSCIOUSNESS

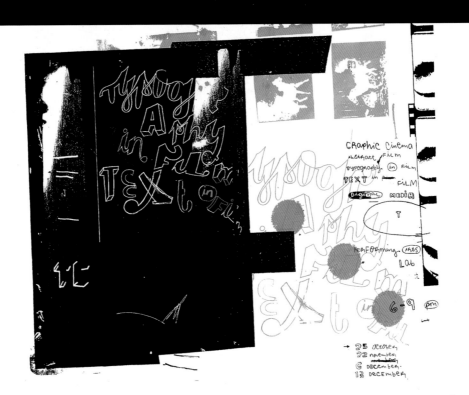

Designer
Sebastian Helling

Art College
Royal College
of Art

Country of Origin
Norway

Work Description
Poster series for Al
Rees film seminars
at the Royal
College of Art

Dimensions
24⅛ X 35⅛ in
620 x 900 mm

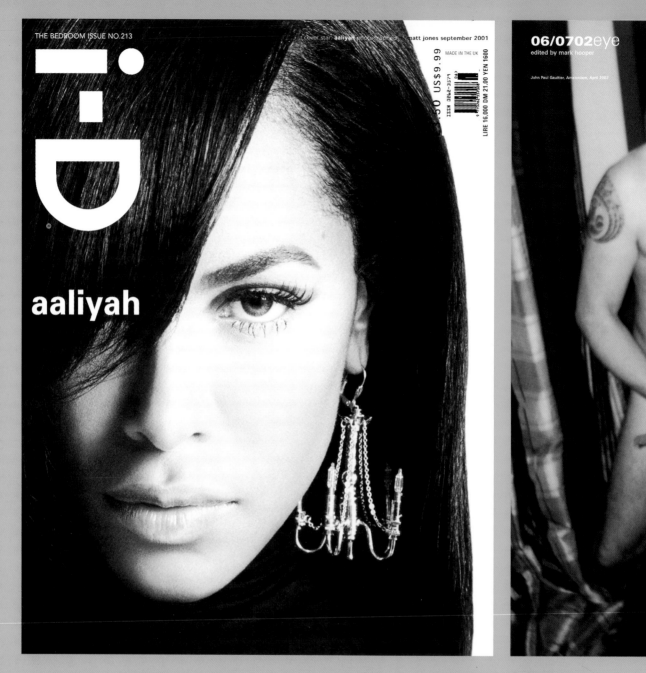

06/0702eye
edited by mark hooper

John Paul Gaultier, Amsterdam, April 2003

THE BEDROOM ISSUE NO.213

i-D

aaliyah

cover star: **aaliyah** photographed by **matt jones** september 2001
MADE IN THE UK

£3.50 US$9.99
LIRE 16.000 DM 21.00 YEN 1600

Creative Director
Terry Jones

Photographers
Corinne Day
Matt Jones

Consultant Art Editor
Laura Genninger,
Studio 191

Art Editor
Dean Langley

Design Company
i-D magazine

Country of Origin
UK

Work Description
Front cover (above left),
pages and spreads from
i-D magazine

Dimensions
9 x 11¹/₂ in
230 x 297 mm

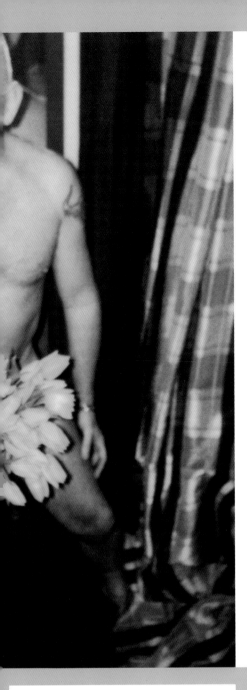

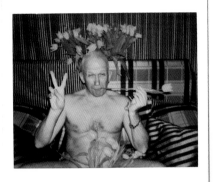

free at last

We'd rather go naked

Mark Roberts has streaked over 150 times, making him officially the world's most prolific streaker. He has streaked at major sporting events, including the Grand National, The London Marathon and numerous football matches. He has also streaked at The Miss World Competition, Crufts and a recent Cast concert. But his most famous streak was an assault on Fred the weatherman's floating map on This Morning in 1995. (Inevitably charity streaks have followed and a single, a streaker rap, is threatened). You probably wouldn't ever want to spend time with Roberts. But he is also an essentially English folk-hero. The cheeky streaker, all pale goose pimples, bobby's helmet covering his tackle, is a peculiarly British icon. How we love watching some hairy-arsed buffoon at full pelt, bollocks a-jangling, knees high in comedy chase, racing, darting and diving to evade capture by stewards or officers of the law. You see the obvious symbolism. The streaker is our liberated self, naked as the day we were born and, for a moment, just as free of responsibility and shit-to-deal-with. The steward/copper is, of course, The Man. As an act of defiance, the streak is only marginally more sophisticated and effective than mooning out of the window of a Charabanc charging up the M6. But the streak, a pantomime meme, is an irresistible mythic loop, played out over and over again, and always with the same result. The mute defiance of the streaker, the roar of approval and encouragement from the crowd, the potential of anarchy and dissent. Then the chase and the capture, the bundling and stifling and squashing, the restraint and the restoration of order. The streak is the fleeting flash of a different shaped world, quickly extinguished. Just how we like it. And this, our Streakers issue, is a salute to all those who break free, just for a moment; whether it's Mark Roberts, Michael Angelow (pictured here famously straddling the Lords wicket in 1975), or any of those we've persuaded to get naked for us throughout the issue; from Jean Paul Gaultier to Rachel Williams and Jeremy Scott. Free thinkers of the world unite: you have nothing to lose but your clothes.
NICK COMPTON

Michael Angelow, Lord's cricket ground,
London, August 4 1975

the high and the mighty

[text illegible]

a word
from
the wise

18-year-old Michael Smith is unconcerned with pursuing a career in music. "I'd rather be a firefighter," he reveals from the phone from Compton, LA. "I've just graduated from the first part of the fire service mentoring programme." In supplying the strikingly gormy rap on the off-beat punk-rock of Sederella's *Abella*, he's helped the band produce a side-cut of the finest moments you'll hear of one not probably the only song...

about dancing on a plane that's about to crash. "I wrote the lyrics for Michael about an experience I had on a plane to the Philippines," recalls Sederellah. The first thing they did was before we put seatbelts on was to warm up a karaoke machine so all the passengers were singing songs. I heard later about a plane crashing their unit a student of Long Beach's premier Poetolcus Academy, this is Michael's first foray into music and spouting for...

ESTICLE
MITE

its all perfectly normal

[text illegible]

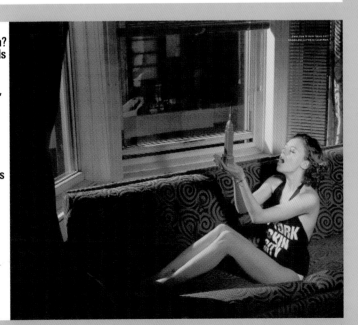

Do you like to watch? Twenty-one year olds Bijou Phillips and Rachel Miner have led very public lives, every detail of their teenage years becoming part of tabloid history. But in Larry Clark's controversial drama *Bully*, the two actors finally justify the hype. Just don't mention teen weddings, missing fingers, other cast members... well, anything really

INTERVIEWS BY GLENN WALDRON
PHOTOGRAPHY BY MATT JONES
STYLING BY CARISA GLUCKSMAN

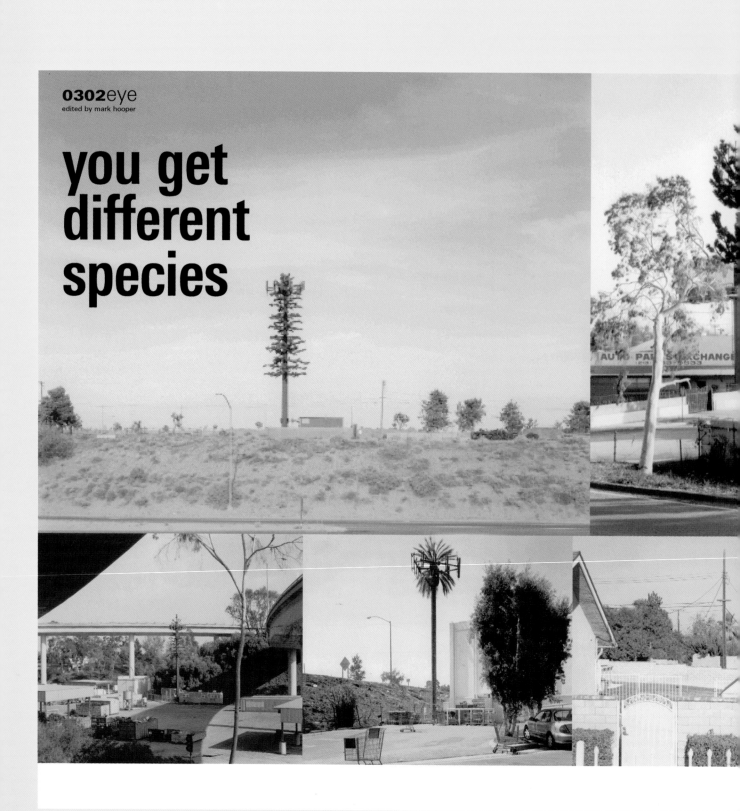

you get
different
species

This is where the city ends

TEXT BY JAMES ANDERSON

Perhaps the biggest challenge to urban addicts is to leave the high streets and the high life behind. To reacquaint ourselves with Mother Nature and all she has to offer could be... well, a trip

May the circle remain unbroken

some of these trees are not like the others

Sometimes, even the most familiar of scenes throws up an unexpected surprise or two. The more you gaze into the landscape around you, the more it reveals itself. So it was that Los Angeles-based photographer Todd Cole became fascinated by the artificiality hidden in the seemingly natural scenery around him. What captured his imagination most of all was the discovery of mobile phone masts disguised as trees in order to blend into their environment. Once he'd noticed them, Cole began to see these man-made imposters everywhere, often in "really inappropriate places - like next to a freeway by Disneyland". And it's not just the Magic Kingdom that's surrounded by fake plastic trees. Having studied and photographed the masts at length, Cole is now something of an expert in this pretend flora. "You get different species," he explains. "It's quintessentially LA; it's artificial and, in a word, fucked-up." This is our Landscape issue. The more you look, the more you'll see.

N34:03:17 W118:14:08 8740.738km +8

Anaheim, Norwalk and Los Angeles, California

Creative Director
Terry Jones

Photographers
Todd Cole
Corinne Day

Consultant Art Editor
Laura Genninger, Studio 191

Art Editor
Dean Langley

Design Company
i-D magazine

Country of Origin
UK

Work Description
Spreads from *i-D* magazine

Dimensions
9 x 11^1/$_2$ in
230 x 297 mm

SECTION

Departments

Designers
Don Hollis
Paul Drohan

Photographers
Various

Art Director
Don Hollis

Design Company
Hollis

Country of Origin
USA

Work Description
Cover (bottom right)
and spreads from
*Sushi performance
and visual art*, a
seasonal catalog
featuring eclectic
performance art

Dimensions
5¹/₂ x 8¹/₂ in
140 x 215 mm

Sunday, Nov 14, 7pm
SUNDAY @ SEVEN SERIES
Gilbert Castellanos headlines an 'All-Star Tribute to the Men and Music of San Diego, jazz treasure Daniel Jackson. The performance will consist entirely of Jackson compositions, and will feature the best of our San Diego jazz musicians, including the man himself - Daniel Jackson. If you love jazz don't miss this show! Co-presenting this event is Webster's Last Word Records.

MIND/BODY EXPANSION

Saturday - Sunday, Nov 6 & 7, 12 - 3pm
Andrew Marcus from San Francisco will teach a movement composition class.

Nov 11 - Dec 11
JAMES SUE NYUN DESTRUCTIVE TESTING
Artist Reception:
Thursday, Nov 18, 5:30 - 7:30pm
Gallery Hours:
Thursday - Saturday, 12 - 4pm or with appointment

James-Sue Nyun invades the visual art space in his Destructive Testing - a meditation on photography and scientific inquiry, beauty and curiosity. Through Nyun's lens we are witness to material destruction and transformation.

Daniel Jackson

Monday, Nov 15, 7pm social,
8pm performance
PROCESS WORKS

Witness inspired moments in maturing art. PROCESS WORKS is an on-going collaborative program between Sushi and Lower Left in which San Diego and Southern California dance and performance artists showcase their newest artistic endeavors. In a "no frills" theatrical setting that recreates a raw studio atmosphere similar to the environment in which these works were first conceived, witness new beginnings and exploration of work where the audience and time itself influence the direction of these developing new works. All tickets are $5.

PROCESS WORKS
20
hours 4.
20s

Saturday, Nov 20, 12 - 12am
Sunday, Nov 21, 2 - 10pm
'20 HRS / $20'

We are trying something new in November. 20 hours of performance for 20 bucks. Beginning at 12 noon on November 20, over 40 Southern California artists will donate their art in a performance marathon to benefit Sushi. What makes this effort extra special is that we have invited Kristen Brandt from Sledgehammer, Nina Martin from Lower Left, former Sushi Managing Director Michelle Cortez, the Taco Shop Poets, Christopher Penny and Thomas Allen Harris to be guest curators. This is the perfect place and time to get a sampling of what San Diego's creative spirit has to offer. It's a come and go as you please kind of day. Schedule of performers and times will be posted upon arrival. Curious? Call Sushi and get updates on who is performing what as this event develops.

Tickets: at least $20.00 for both days.

Victoria Marks

Thursday - Sunday, June 15 - 18, 8pm
VICTORIA MARKS
FATHERS AND DAUGHTERS

Real fathers and daughters spin/recount their relationship, order each other about, and fall into each others' arms. This performance, both tender and aggressive, puts memory, honor, love, and power on the line, in a tender and sometimes transgressive invocation of father/daughter relationships. A piece both challenging to adults and endearing to children, "Father - Daughter Dances" maps the complexity of this very special relationship. A loving and unforgettable experience for Father's Day!

Post Performance Discussion:
Thursday, June 15

Member Freas Out a Friend option.
Thursday, June 15

Not Your Average Discount Campaign Ladies, 1st 20 reservations for Father's Day get Dad in for free

May 21, 7pm social, 8pm performance
PROCESS WORKS

Witness inspired moments in maturing art. PROCESS WORKS is an on-going collaborative program between Sushi and Lower Left in which San Diego and Southern California dance and performance artists showcase their newest artistic endeavors. In a "no frills" theatrical setting that recreates a raw studio atmosphere similar to the environment in which these works were first conceived, witness new beginnings and exploration of work where the audience and time itself influence the direction of these developing new works. All tickets are $5.

MIND / BODY EXPANSION
< see page 20 for more info >
May 5, 7, 10 - 1pm
Nina Martin of Lower Left will teach a workshop entitled "Status."

May 13, 10 - 12noon
Rachel Rosenthal Masterclass

May 11 - June 17
MARK HISS + FIELD RECORDINGS

Artist Reception:
Thursday, May 18.5 - 7pm,
Gallery Hours:
Thursday - Saturday, 12 - 4pm or with appointment

It's time for a walk down memory lane with the help of Sushi's archive photographer for the past 7 years. Mark Hiss has developed into a photo essay his favorite images and is sharing them with you. This exhibition is interesting as history, as meditation between movement and time, and as an is-of-itself.

Monday performance - pay what you can, 1st come, 1st served.

Thursday - Monday, May 11 - 15, 8pm
Thursday - Saturday, May 18 - 20, 8pm
RACHEL ROSENTHAL • Ur-Boor

Rachel Rosenthal will grace Sushi this month with her last solo show entitled UR-BOOR. In collaboration with Canadian set designer Guy Laramee, the veteran performance artist Rosenthal has created a work influenced by the increased violence and lack of compassion in our society. In Ur-Boor, Rosenthal takes issue with a society where the exhibition of polite manners and proper etiquette are suspect and taking the time to care for one another has become a chore, rather than a regular practice.

Laramee's interactive set, large and imposing, acts as a catalyst for Rosenthal's futuristic characters. United States premiere.

Post Performance Discussion: Thursday, May 11
Benefit Performance & Reception with Rachel
Friday, May 12.

Not Your Average Discount Campaign:
Bald people, both naturally or by choice, can purchase 2 for 1 tickets on Thursdays and Sundays.

Rachel

thanks, we are dedicating Sushi Performance & Visual Art's 20th Anniversary Season to the past. to the artists and people who, with their vision and hard work, laid Sushi's foundation. These people number in the hundreds, each important and valued. There are, however, a few names that require special recognition: **Lynn Schuette**, Sushi's founder and director for 15 years, embodies tenacity, focus, and talent. Sushi owes this woman everything. **Larry Dvault** is an original member of the board of directors and constant friend to Sushi. To this man, with even temperament, open heart, and kind laugh and hug, Sushi bows in deep admiration and gratitude. **Whoopi Goldberg, Philip Dimitri Galas** and **Dan Victor**, the first performers at the Sushi Soirée December 1979, are the people we'll forever remember. You as in the essence of Sushi is past, present, and future. One who has become an international icon, one we have lost to AIDS and the other remains a talented artist in the San Diego community.

20 years. We're an institution. The question is can we be an institution and still be cutting edge? **YES.** We have to be. There's still a need to be look around. We are in a world dominated by corporate food and coffee, corporate clothes, and corporate entertainment. The formula is shoved at us all. No more decisions need be made. Rarely is the critical thought or the curiosity of spirit encouraged or even demanded.

Luckily, there remains people who expect critical thought and a curious spirit from themselves and the people around them. These are our contemporary artists. It is through their **eyes, bodies, hands, instruments,** and **interpretations** that the world in all its **beauty** and **beastliness** is laid before us. Glimpses into ourselves and **our secrets** - journeys to new aesthetics and **storytelling** broaden our perspective and hopefully our understanding and defense of difference. Change, a journey of each other. Their art reflects and predicts human evolution.

As one of our culture's prettiest breaking art - Sushi art is ground made history, to make history. Why continue to make history... Because Sushi art isn't prettified. Sushi art kicks you out of your burrow and forces you to meet **The Other** of **The Different**, face-to-face. Sushi art introduces you to parts of yourself you didn't even know existed, parts of the words that you could not find the words, pictures and movement to describe.

It is in this **spirit** that Sushi has its **future**. It is in this spirit that Sushi finds its **purpose.** To ensure that our world's most adventurous artists have a venue and that **you**, as its audience and witness, keep on coming back.

We thank **you** for coming and look forward to a long and lasting friendship with you.

Brain Food.
sushi performance & visual art @PVA/20

S U S H I

players

diRT

Volume 1

design + fashion *and urban encounters*

EAR FOOD

how 'bout a slice of plastic pie?

Chuck Perrin is a glimmer of cool on the sometimes bland San Diego sun-drenched landscape. Taking a cue from SF's beats of the mid 1950's, Perrin introduces new listeners to the vibe and feel of the beat scene.

Combining straight-ahead jazz and spoken word, Perrin infuses the two art forms, creating a new, fresh sound. In Perrin's own words: "Let's crush routine, promote chaos."

The Holy Barbarians Beat.itude w1w.

Jazz vet Scott who can list Sinatra, Sammy and Tony Bennett on his musical resume reunites musical cohorts for a night of jamming.

Honing his chops with the hottest showrooms in Vegas the past 20 years, Scott finally gets the chance to shine one hot, summer night last year, appropriately on John Coltrane's birthday.

Gary Scott Just Friends w1w.

Lyrical and blistering at the same time, Scott solos and soars through ten classic ballads with San Diegans Mike Wofford on piano and bassist Bob Magnusson.

Prominent tracks include "Someone to Watch Over Me," a moving version of "Lover Man" and a soothing "As Time Goes By." Recommended for lovers everywhere.

Gary Scott Tenderness w1w.

The spirit of Konitz, Tristiano and other cool, East Coast horn-rimmed jazz geniuses live on in Loescher's latest. A huge nod to Konitz is given on track two with a faithful update on Konitz's "Subconscious-Lee."

We're also treated to a wonderful, mesmerizing ballad "No Other Love," followed by a Loescher original "Mass-Waltz." After graduating from Berklee, Loescher moved to Eastern Europe, taught jazz and made this recording, eventually leaving teaching to perform full-time. Lucky for us.

Shawn Loescher Distant Pieces w1w.

pg 04

URBANdotCOM

metro pulse

"Neruda will touch your soul and the music will fill your eyes." Said Carol Thuet. Keep your eyes--and mind--open for more SOS events.

Envision. Inspire. **Ignite.**

hollis studio tour

Housed in a former coffee-roasting plant, the spirit of caffeine lives on in the high-powered design of this marketing communications firm, evidenced by an energetic design staff and their quality of work.

Climbing the stairs to the studio, the first noticeable vibe is the 1950's stoplight, and an inspired waiting room, replete with a baby blue princess phone, cool mid-century furniture, Fisher-Price record player and a stack of favorite 45's. It's a wonder clients ever want to leave.

The hub of the office, is a lesson in contrast: mid-century meets millennium. Instead of buying boring, non-descript work cubicles, Hollis opted to use atomic-age industrial-strength metal office desks. Rescued from an old warehouse in East County, the surfaces were sandblasted, clear-coated and given new life on wheels. Completely functional, and fast too! The studio slogan: "Envision. Inspire. Ignite." says it all.

Keep On Truckin'... The East Village jazz scene begins at Culy Trucking's Warehouse No. 7. Friday nights from midnight to the early morning. Check out Gilbert Castellanos and his screaming quartet bring down the house.

The Culy Warehouse used to house a trucking company in the early 1900's delivering goods to San Diego's earliest residents. Given a new lease on life and a recent remodel, it's well worth checking out.

Jonas Salk would be proud Down a few blocks at the Sushi (profile page 6) Scientists of Sound are inventing and reinventing a new art landscape with their new Sundays at Seven series. Kicking off year two was a celebration of the late poet Pablo Neruda featuring music, poetry and spoken word. A warm, romantic vibe fed both audience and performers.

FUELED BY ATOMIC POWER:

A great product without a great package is still a great product, but how do you stand out in an already crowded marketplace filled with competition using the boldest type and loudest screaming neon available? The Fuel Power solution was to attack on all fronts. Now part of a Fortune 500 corporation, the entrepeneural venture contracted a firm that specializes in creative problem-solving. All avenues were explored in developing a unique identity and branding strategy, leading to market advantage and competition on a Fortune 500 level. Big things do come in small packages.

Fuel Power
MARKETING

A SEARCH FOR THE BIGGER BANG

THIS IS NOT A TEST.

Designers
Don Hollis
Heidi Sullivan
John Hofstetter

Photographers
Various

Art Director
Don Hollis

Design Company
Hollis

Country of Origin
USA

Work Description
Front cover (top far left) and spreads from *Dirt*, a magazine featuring the urban encounters of design firm Hollis and its clients

Dimensions
$2^5/8$ x $4^1/8$ in
67 x 105 mm

pg (10)

form, function

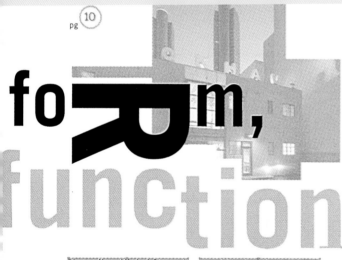

Normally a Kinko's® brand, Xerox™ process of communication, a Southern Californian movement is underway to redefine industry standards toward tomorrow's shopping experience. Well-concepted, multi-folding, detail oriented and informative publications are on the rise, promoting innovative visual merchandising and retail design.
Clear communication is conveyed to architects and designers through rich, photographic detail combined with striking illustrative examples to promote harmonious environmental graphics among an eclectic mix of retail tenants. Like it or not, the mall is back and, ergonomically speaking more fun than ever.

CONCRETE

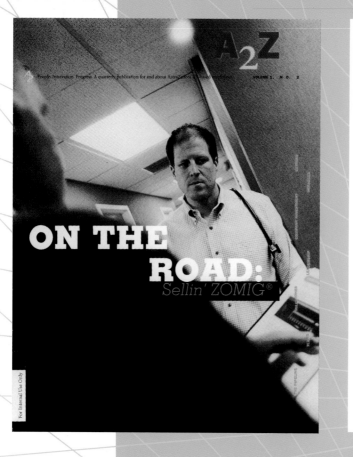

A2Z

People. Innovation. Progress. A quarterly publication for and about AstraZeneca US-based employees. VOLUME 1, NO. 2

ON THE ROAD:
Sellin' ZOMIG®

A2Z

People. Innovation. Progress. A quarterly publication for and about AstraZeneca US-based employees. VOLUME 1, NO. 1

ready, set, go!

40 mg

Global DISCOVERY ALLIANCES

Specify. Identify. Evaluate. Secure. Manage. That, in a nutshell, is what the Global Discovery Alliances (GDA) organization does.

Yes, but...what does that really mean?

If you're a scientist, it means there's a kind of research "help desk" you can go to when your project hits a stumbling block. Licensing directors within the research areas (RAs), Enabling Science and Technology (EST), and Safety Assessment can help in gaining access to external solutions that can get you to the next milestone. These solutions could include consulting agreements with experts in the field, cell lines that express certain drug targets, special reagents, or novel research tools.

For the corporation as a whole, it means entrée to a broader range of exploratory research and access to a wider base of scientists and technologies. GDA coordinates activities across RAs in order to get the most benefit from strategic collaborations with biotechnology companies and leading academic centers of excellence.

"There are more than 300 external collaborations currently underway in Discovery," says Chris Yochim, GDA director. "As a company, we rely on strategic alliances to augment the drug-discovery process by providing special knowledge, skills, or technologies we don't have in-house. With the global nature of our group, we work in concert with one another to streamline the licensing process, leverage each member's expertise, and present a unified face to potential external partners."

Alliances are also used to jump-start efforts in attractive, new research areas for the company. Such was the rationale behind the alliance formed in March with NPS Pharmaceuticals Inc. Together, the companies are working to discover drugs that act on metabotropic glutamate receptors (mGluRs), which have application in both the Central Nervous System and Pain therapeutic areas.

"The mGluR family consists of eight currently known receptors. It's one of the most important targets in the brain because these receptors modulate nearly all signaling between nerve cells," says Ed Johnson, program director for the NPS alliance. "By working as partners with NPS, we now have access to know-how, compounds, intellectual property, and the ongoing work of their scientists."

The NPS alliance is expected to run for five years. Initially, it will involve discovery projects run in Wilmington, DE, and Södertälje, Sweden. The agreement also includes the development and marketing of jointly discovered molecules.

"Identifying ways to meet the increasing demand for new candidate drugs is our highest priority," says Christof Angst, vice president of CNS/Pain Discovery who also chairs the alliance's steering committee. "The synergies of our two companies – the CNS discovery and development expertise of AstraZeneca and NPS's scientific knowledge, experience and patent position with mGluR's – enables us to maximize our ability to deliver high quality candidate drugs."

Discovery Alliances EST manages collaborations that cross RA boundaries, such as the alliance with Incyte Pharmaceuticals Inc. that gives AstraZeneca access to a comprehensive set of genomic databases and bioinformatics tools. In such cases, centralized management is clearly valuable to the Discovery organization as a whole.

Several of the strategic alliances in EST differ from those made by the RAs, says Maggie Flanagan, director of Discovery Alliances EST. "Our mandate is to explore technologies with the potential to transform the discovery process at AstraZeneca. We have the responsibility, and the opportunity, to take more risk."

The process of establishing alliances follows a predictable series of steps, yet each step is unique to the specific deal being worked on. The role of GDA is to orchestrate and facilitate the process, working with people in Research, Legal, Intellectual Property, and Finance.

At the same time, GDA works in a proactive mode with potential partners, helping to demystify AstraZeneca and providing a single point of contact for inquiries about possible collaborations.

"We make sure their proposals land on the right desk, to be evaluated by the right person, so we can give them a prompt response," says Yochim. "Several times a year, we participate in partnering meetings with biotech companies from around the world. It's all part of our continuous effort to identify emerging technologies that could play a role in AstraZeneca's future drug-discovery efforts."

As with most problem-solving situations, alliances prove that two minds—or two companies—can be better than one.

NPS PHARMACEUTICALS

THE ROLE OF GLOBAL DISCOVERY ALLIANCES

Specify:	Develop external investment needs and internal clients
Identify:	Search and screen opportunities to meet
Evaluate:	Progressive evaluation of technical, commercial and strategic merits of individual prospects
Secure:	Develop deal proposition, negotiate terms, prepare contracts, secure approval to sign
Manage:	Effective handover to recipient manager in the business, project manage non-specific aspects of alliance

On Time, In Full

GO
FISH

Designers
Ian Almquist
Krystina Ciavardone
Val Nistico
Staff

Illustrators
Various

Photographers
David Fields
Peter Olson

Art Director
Ian Almquist

Design Company
Allemann Almquist & Jones

Country of Origin
USA

Work Description
Front covers (above left) and spreads from *A₂Z Magazine*, an internal-use pharmaceutical publication

Dimensions
9 x 11³/₄ in
228 x 298 mm

FDA/AZ ONGOING TIMELINE FOR DRUG APPROVAL
for Faslodex® (ICI 182,780): indicated for treatment of post-menopausal women with advanced breast cancer who have progressed following previous endocrine therapy.

WINNING
THE
FDA

The bubbles you add to your morning bath. The eye shadow, hand cream and deodorant you apply. The orange juice you drink, and the allergy medicine with which you start your day. Before you leave for work each day you're likely to encounter half a dozen products regulated by the US Food and Drug Administration (FDA) – products that account for about 25 cents of every dollar US consumers spend.

Promoting and protecting the public health by helping safe and effective products reach the market is the FDA's mission. AstraZeneca has a related mission: that of improving human health through discovery, development and delivery of prescription medicines.

Because pharmaceutical companies need FDA approval to distribute medicines that improve human health, many in the industry regard the powerful agency as an adversary, stumbling block or necessary evil. Changing the way AstraZeneca views the FDA will best position the company to win in the US.

"AstraZeneca will not be able to sell Crestor or any other product in LA and New York and Chicago unless we're successful in first selling it in Rockville, Maryland (home of the FDA)," AZ VP/Regulatory Affairs Tony Rogers says. "The FDA is the first customer we have to satisfy." Thirty years in the pharmaceutical industry have taught Rogers that "when we do good work it's usually because we've worked well with the FDA and we have a product that works."

A prime example of an effective partnership with the FDA is AstraZeneca's effort to secure approval for the oncology drug Iressa™ (ZED 1839), Rogers said. Gerard Kennealey, MD, AZ VP/Medical Oncology, said he hopes the partnership will translate into a more rapid FDA review of the data. "If the data warrants it, we hope to see a faster approval than we might otherwise see."

The FDA has streamlined its review process in recent years to help speed important new medical treatments to patients. For example, the FDA says the average review time for an innovative new drug is now only six months, and some have been approved even faster.

IRESSA is among products receiving fast track FDA review. Fast track designation does not guarantee speedy approval, but is simply an FDA commitment to cooperate with AZ getting the drug submission accomplished as quickly as possible. IRESSA has shown encouraging antitumor activity, particularly in non-small cell lung cancer. Because the drug showed dramatic but very early

DEMOCRACY.ORGANIZE.EQUITY.BUILD.SUPPOR
ANTHROPY.RESOURCE.AUTONOMOUS.JUSTICE
Y.BUILD.MCKAY FOUNDATION.SUPPORT.COMM
S.JUSTICE.COMPASSION.POWER.CHANGE.ACC
IZE.EQUITY.BUILD.SUPPORT.COMMUNITY.POW
CESS.DEMOCRACY.ORGANIZE.EQUITY.BUILD.S
E.AUTONOMOUS.MCKAY FOUNDATION.JUSTICE
MOCRACY.ORGANIZE.EQUITY.BUILD.SUPPORT.C

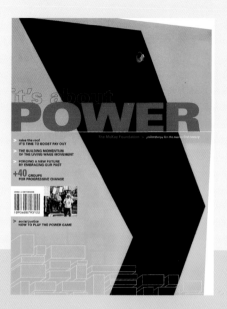

it's about
POWER
The McKay Foundation ▸ philanthropy for the twenty-first century

▸ raise the roof
IT'S TIME TO BOOST PAY OUT

THE BUILDING MOMENTUM
OF THE LIVING WAGE MOVEMENT

FORGING A NEW FUTURE
BY EMBRACING OUR PAST

+40 GROUPS
FOR PROGRESSIVE CHANGE

▸ social justice
HOW TO PLAY THE POWER GAME

Designers
Guusje Bendeler
Shelly Hays

Illustrator
Shelly Hays

Photographers
Gina Elefante
Various news services

Art Director
Don Hollis

Design Company
Hollis

Country of Origin
USA

Work Description
Front covers (above
centre), folder (above),
and spreads from an
annual report for the
McKay Foundation

Dimensions
9 x 12 in
232 x 305 mm

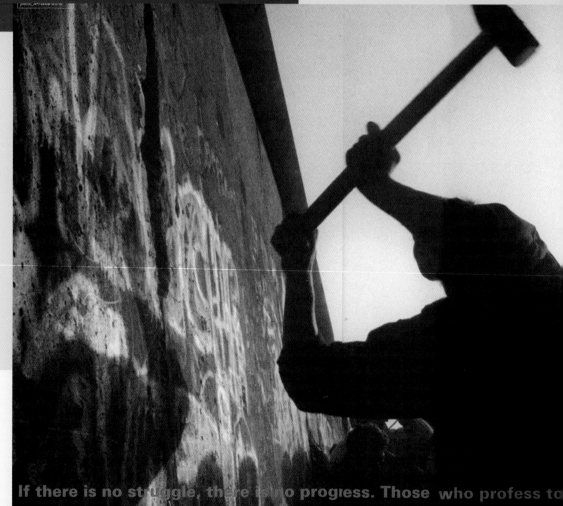

If there is no struggle, there is no progress. Those who profess to
agitation want crops without plowing up the ground. They want
They want the ocean without the awful roar of its many waters. F
demand. It never did, and it never will.

—Frederick Douglass (1817-1895), Ame

146

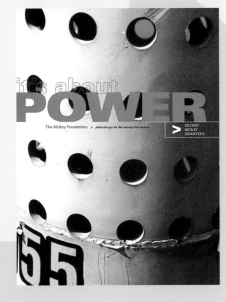

it's about
POWER

The McKay Foundation › philanthropy for the twenty-first century

› RECENT McKAY GRANTEES

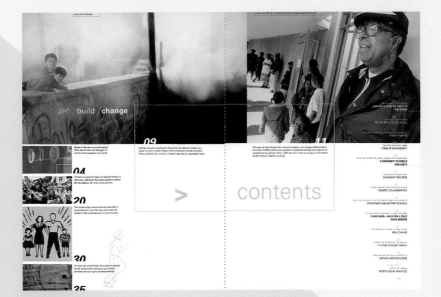

join _ build _ change

09

04

20

30

35

> contents

TERMS OF ENGAGEMENT

A COMMUNITY OF REBELS
GARY SMITH

COMMUNITY BUILDERS

FUNDER COLLABORATIVES

INFRASTRUCTURE/SUPPORT SERVICES

LIVING WAGE—GOOD FOR A STATE
DAVID MEDINA

REAL CHANGE

IT'S TIME TO DOUBT PARKSIT

MISSION AND GUIDELINES

RECENT McKAY GRANTEES

The One Who
Teaches Us All

A Tribute to David R. Hunter

06

reports from the field

Power Players

join _ build _ change

...eedom and yet depreciate

...out thunder and lightning.

...ncedes nothing without a

...and former slave

Operational Contacts

General info
info@vivid.org.uk
t. 0121 233 4061
f. 0121 212 1784

Research & Development
Yasmeen Baig Clifford: Director
yasmeen@vivid.org.uk

Projects
Patrick Courtney: Project Co-ordinator
projects@vivid.org.uk

Facilities Hire
Marian Hall: Facilities Co-ordinator
marian@vivid.org.uk

Training
Glynis Powell: Training Co-ordinator
training@vivid.org.uk

Admin / Finance
Paula Green: Administrator
admin@vivid.org.uk

film/video/digital imaging
/photography /animation

148

VIVID

Project Development
Artist Opportunities
Training
Access to Production Facilities
Support & Advice

multimedia/internet

Unit 311f The Big Peg
120 Vyse Street
Jewellery Quarter
Birmingham B18 6ND

Tel. 0121 233 4061
Fax. 0121 212 1784

www.vivid.org.uk
VIVID is the trading name for Birmingham Centre for Media Arts Ltd (company no.2753780)

Getting to Vivid
Train/Metro: Jewellery Quarter train station on Worcester to Leamington Spa line calling at
Birmingham Snow Hill and Moor Street stations
Bus: 101 from city centre, 8 inner circle
Disabled access
All areas of VIVID are fully accessible to wheel chair users. Please contact us for more information

Designers
Fluid design

Design Company
Fluid design

Country of Origin
UK

Work Description
Promotional poster
for *Vivid*, a Multi
Media training centre
in Birmingham

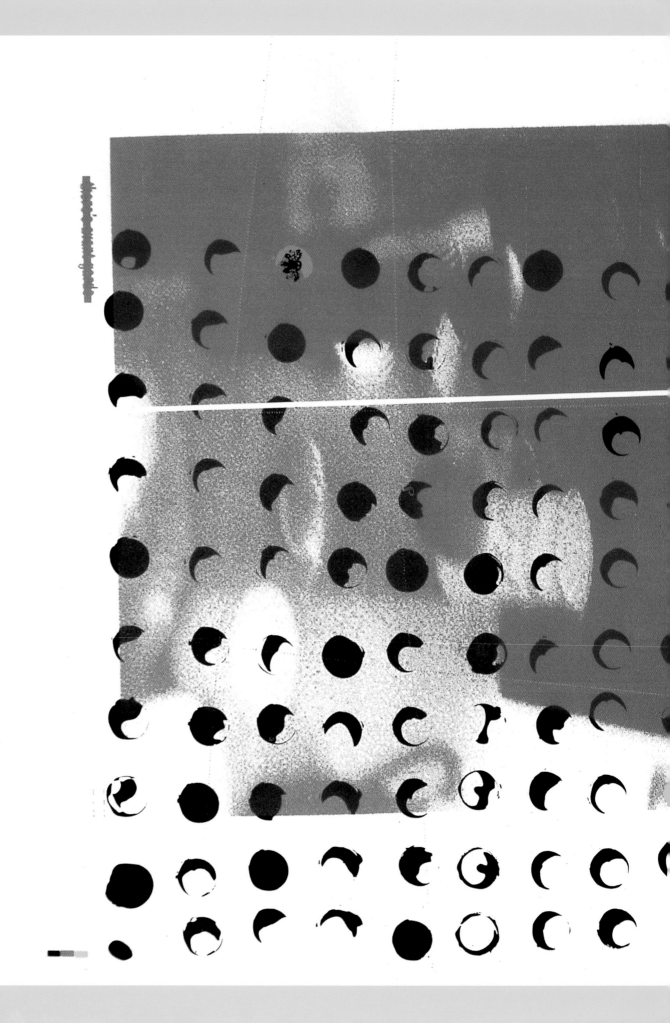

Graphic Cinema

graphic cinema
abstract film
typography in film
text in film
digital media

performing arts lab
thursday 6:00 to 9:00 pm
22 november
06 december
13 december

school of communications
introduction: Al Rees

Designers
Sebastian Helling
Ellen Jacobsby

Art College
Royal College
of Art

Country of Origin
Norway/Germany

Work Description
Poster for an Al
Rees film seminar
at the Royal
College of Art

Dimensions
$22^5/_8$ x $32^3/_4$ in
580 x 840 mm

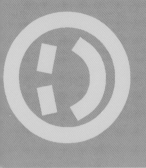

Designer
David Hand

Illustrator
David Hand

Design Company
Burn

Country of Origin
UK

Description of Artwork
Self-promotional poster
for Burn design

Dimensions
9³/₈ x 27 in
240 x 690 mm

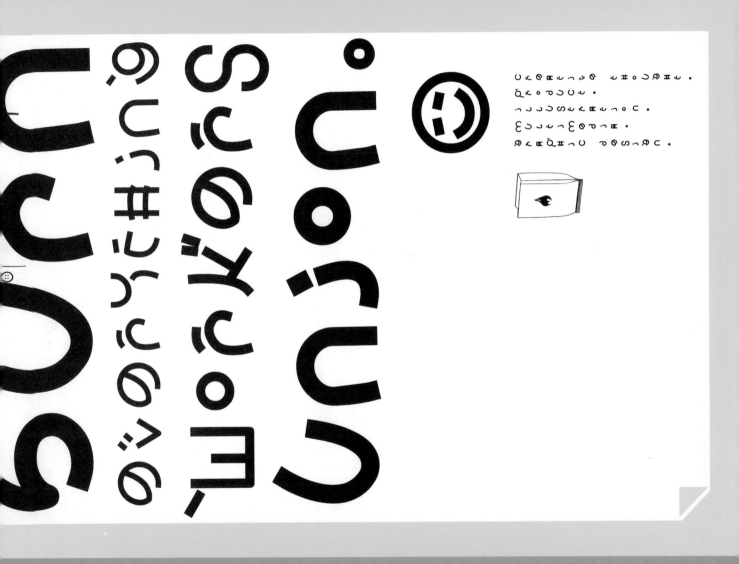

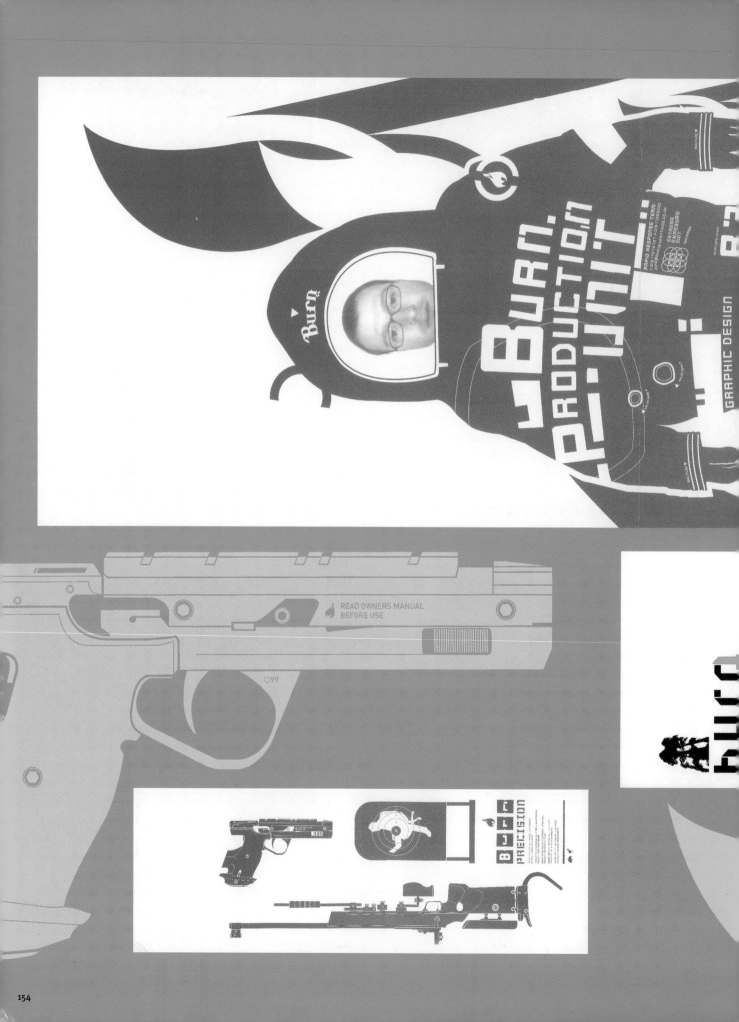

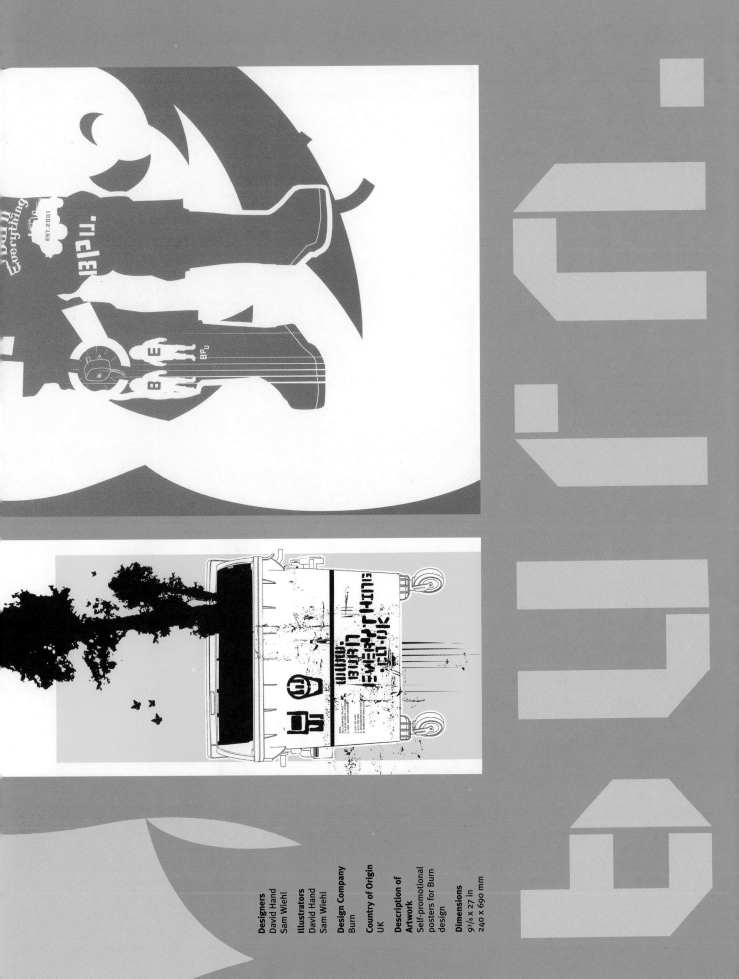

Designers
David Hand
Sam Wiehl

Illustrators
David Hand
Sam Wiehl

Design Company
Burn

Country of Origin
UK

Description of Artwork
Self-promotional posters for Burn design

Dimensions
9³/₈ x 27 in
240 x 690 mm

Designers
Sam Wiehl
David Hand

Illustrators
Sam Wiehl
David Hand

Design Company
Burn

Country of Origin
UK

Description of Artwork
Self-promotional
booklet cover (right),
and page and spreads
for Burn design

Dimensions
Booklet
7³/₄ x 6¹/₄ in
200 x 160 mm

CAT. 254
BURNEVERYTHING. 0.1

20 X 16cm

20 Pages

Exhibition Booklet

Ref: ex01

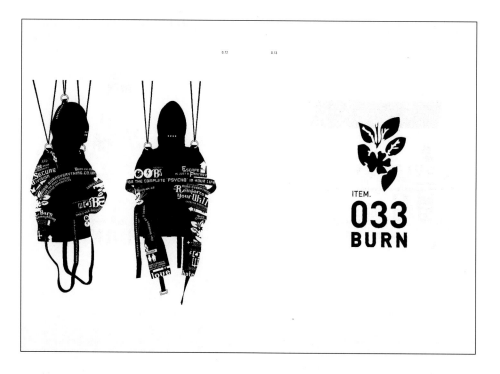

HELLO.

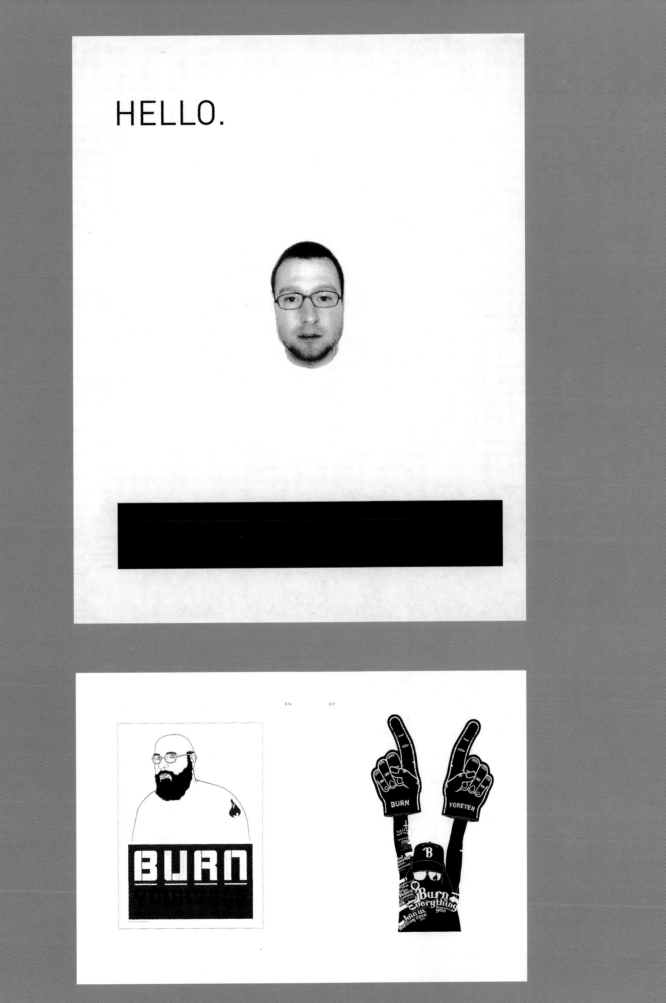

Designers
Stuart Bailey
Peter Bilak

Design Company
dotdotdot

Country of Origin
Netherlands

Work Description
Spreads and page
from *dot dot dot*, an
independent, after-
hours, graphic
design magazine

Dimensions
6¹/₂ x 8⁵/₈ in
165 x 220 mm

1

Why another graphic design magazine?

This pilot issue of ...
 (a graphic design / visual culture magazine)
hopes to answer itself
 being an encyclopaedia of previous attempts
 with extended articles on a select few

During this field trip we hope to plot the next issue
 i.e. how?
 where?
 when?
 who?
 based on the experiences of those who
 tried already

Those 3 dots were chosen as the title for being
something close to an internationally-recognised
typographic mark
but now they seem even more appropriate as
a representation of what we intend the project to become:
 A magazine in flux
 ready to adjust itself to content

and here is the first list of our aims to date:
(to be) critical
 flexible
 international
 portfolio-free
 rigorous
 useful

KEYWORDS: 1980S/1990S. APPLE MAC. CALIFORNIA.
CONSTRAINTS. DEBATE. ZUZANA LICKO. TYPE DESIGN.
RUDY VANDERLANS.

This is an updated version
of an essay first published
in Danish journal *Bagvennen*
in 1997. The original piece
dealt with *Emigre* as a
company, discussing both
the type design and magazine.
For I have edited out
most of the typeface
references, in order to focus
on the magazine, but it is
worth remembering the
essential symbiosis of the two
aspects. As a reminder, *Emigre*
will be used as a singular
rather than a plural noun.
Also worth mentioning is
that in looking through
the small-format issues again,
I realised the company's
ever-morphing attitude is best
experienced by reading Rudy
Vanderlans' candid editorials.
As a whole, they provide one
of the most digestible
overviews of graphic design
concerns approaching the end
of the twentieth century.

emigr

Growing up
in public

The prevailing US stronghold of Postmodern
graphic design is cluttered with icons.
From the late 1980s onwards, a number of key
schools (CalArts, Cranbrook, Rhode Island),
personalities (Keedy, Carson, Makela, Deck)
and publications (Ray Gun, Beach Culture)
combined to form a catalyst, gradually
establishing a network of ideological
typographic discourse. Constantly in-breeding
and multiplying, the wide-ranging debate has
since reached a certain level of distinction
most convincingly articulated through the
work of Miller and Lupton.

See: Lupton, E, & Miller, J A: *Design Writing Research* (New York; Princeton Architectural Press; 1996)

Editors:
Jürgen X. Albrecht
corporate designer, Leipzig
ixa@sqblue.de
Stuart Bailey
graphic designer, Arnhem/London
melestai@dds.nl
Peter Bilak
graphic designer, The Hague
peterb@inem8k.sk
Tom Unverzagt
graphic designer, Leipzig
enzym@sqblue.de

Other contributors to this issue:
Paul Barnes
graphic designer/writer, London
pfbarnes@zoo.co.uk
Max Bruinsma
writer/design critic, Amsterdam
maxb@xs4all.nl
Richard Hollis
graphic designer/writer, London
hollis@lukas.com

Acknowledgements:
Bagenenns Journal
Eugene Bögelsrabenhaus
Simon Daniels
Studio Dumbar
Rein Hoeles
John Morgan
Rick Poynor
Rudy Vanderlans
Nick Vermeulen
Sophie Kate Watzow
WerkPlaats Typografie, Arnhem
Christopher Wilson
Carl H. K. Zakrisson

Special thanks to Robin Kinross for editorial oversight and advice.

Special thanks to the Jan van Eyck Akademie, Maastricht, for early support.

Printing:
Veenman drukkers, Ede

Fonts:
reEurekaSans and reEurekaSerif
distributed by the FontShop
nemwork, EurekaMonospaceIT
distributed by www.typotheque.com

Subscriptions, advertising and sales:
sales@dot-dot-dot.de
www.dot-dot-dot.de

Correspondence:
We welcome feedback. Send contributions, comments and criticism to:
editor@dot-dot-dot.de

Advertisers:
FontShop International, p.8
FontShop Benelux, p.31
Typotheque, p.54
HTS, Leipzig, p.55
Lars Müller Verlag, p.56
Dekatur, p.57
Veenman Drukkers, p.64
Studio Dumbar, p.65
The Foundry, p.27
Theatre Zeebelt, p.93
Paul Barnes, p.94
Jon van Eyck Akademie, p.95
Linotype [insert]

... is the pilot issue of a graphic design/visual culture magazine released in spring 2000. We intend to continue publishing the magazine twice a year.

... is available in specialized bookstores around Europe. If you are interested to carry the magazine in your bookshop contact the editors:
sales@dot-dot-dot.de

If you are interested in receiving future issues send your name and address to the editors.

... magazine
(issn 1615-1968)
Broooba & Kaas publishing house
Kochstraße 25b
D-4275 Leipzig
Germany
t +49 (0)341-99 94 232

© 2000, Brooßja & Kaas publishing house. All rights reserved. All material is compiled from sources believed to be reliable, but published without responsibility for errors or omissions. Nothing in this publication can be copied or reproduced without prior written permission of the editors.

Thanks to Wolfgang Weingers and Lars Müller Publishers for permission to reprint the text on p.31

96

blackda

```
;;;$$$$$$$$$$$$$$$$;;;;;;;;;;;;;;;;;;;;;;;;;;;$$$$$$$$$$$;;;;
;;$$$$$$$$$$$$$$$$$;;;;;;;;$$$$$$$$$$$;;;;;;;;$$$$$$;;;;;
;$$$$                           $$$$$$$$$$$            $$$$$;;;
;$$$                    $$$$$$$$$$$$$$$$$$$$          $$$;;;;
;$$$             $$$$$$$$$$$$$$$$$$$$$$$$$$$$          $$$;;;;
;$$$         $$$$$$$$$$$$$          $$$$$$$$$$$        $$$;;;;
;$$$       $$$$$$$$$$            ;;;;;$$$$$$$$$$      $$$;;;;
;$$$     $$$$$$$$;;         ;;;;;;;;;;;$$$$$$$$$     $$$;;;;
;$$$    $$$$$$$;;;     ;;;;;;;;;;;;;;;;$$$$$$$$    $$$;;;;
;$$$$  $$$$$$$;;    ;;;;;;;;;;;;;;;;;;$$$$$$$$   $$$;;;;
;$$$$$$$$$$$$;   ;;;;;;;;;;;;;;;;;;;;$$$$$$$$  $$$;;;;
;$$$$$$$$$$$;  ;;;;;;;;;;;;;;;;;;;;;$$$$$$$$;;$$$;;;;
;$$$$$$$$$$$ ;;;;;;;;;;;;;;;;;;;;;;$$$$$$$$;;;$$$;;;;
;$$$$$$$$$$$;;;;;;;;;;;;;;;;;;;;;;$$$$$$$$;;;$$$;;;;
;;$$$$$$$$$$$;;;;;;;;;;;;;;;;;;;$$$$$$$$$;;;;;;;;;;;
;;;$$$$$$$$$$$$;;;;;;;;;;;;;;$$$$$$$$$$;;;;;;;;;;;;;
;;;;;$$$$$$$$$$$$$$$$$$$$$$$$$$$$$$$$;;;;;;;;;;;;;;;;
;;;;;;;;;;;;;;;;;;;;;;;;;;;;;;;;;;;;;;;;;;;;;;;;;;;;;
```

KEYWORDS: CHAT-ROOM. DUTCH DESIGN.
HOTLINE. INTERNET. FRIENDS. MAX KISMAN.
PETER MERTENS. TYPOGRAPHY.

by Peter Bilak

This conversation took place in a TYP Hotline chatroom (194.109.81. 64). Following the chat, additional questions were asked, which appear in the margins.

Peter Mertens (Amsterdam), Max Kisman (San Francisco), Peter Bilak (Maastricht)
<<peter mertens is now known as Answering Machine>>
<<peter bilak is now known as investigator>>
<<max kisman is now known as vaguely>>

investigator: Ok, when did you start the TYP?
Answering Mac: 1986.
investigator: Was the idea to make it a type magazine?
vaguely: Peter and Jan Dietvorst had their birthday party and they asked everyone to contribute. I played around with cutting and pasting and collage those days.
investigator: You and Peter Mertens were the founders?
Answering Mac: Max initiated!
vaguely: ... and produced a photocopied pamphlet piece of paper TYP/Typografisch papier
investigator: Max, why did you feel like making a new magazine?
vaguely: There was not much happening in Typoland in 1986.

vaguely: All the older guys weren't interested in the new and we (Peter M, me and others) were very much into the new, not only in computers, but...
Answering Mac: It was a graveyard, protected by old men.
vaguely: ... but also the ideas behind it, the images, the words.
investigator: Did you think it would last that long?
Answering Mac: It had the force of the urge!
vaguely: Peter, Jan and Henk immediately wanted to continue TYP.
investigator: How many issues did you make, both on paper and Web?
vaguely: Peter?
Answering Mac: 31
investigator: Really?!
vaguely: TYP moved typographic borders, when everybody thought they were stuck.
investigator: It has always been in Dutch, right?
Answering Mac: No! Spanish! English!
vaguely: TYP reached a small but dedicated audience it moved designers and gave them some understanding of different things going on.
investigator: The last issue on paper was quite cryptic...
Answering Mac: TXT only! You can start reading wherever you want.
investigator: No images anymore?
Answering Mac: Images everywhere! The Web! Hotline Colour, Moving! Sounds!
investigator: Why 'TXT only' then?
Answering Mac: The images are elsewhere.
investigator: On the WEB?
Answering Mac: Yep, 194.109.81.64 On the ROM, on our own browser...
investigator: Will you continue the magazine on all three media (paper, CD, WWW)?
Answering Mac: Yep!
investigator: How was the analogue comeback? And why did you interrupt the paper version at the first place?
Answering Mac: We will have an exhibition in Hoorn.
investigator: Where is Hoorn?
Answering Mac: The north of Holland.

photo: Hans Wendriks

Typ/Typographic Paper was initiated by Kisman on an obscure, but vibrating birthday party of Mertens and Dietvorst on a hot and sweaty August night in 1986. Kisman declared war on the current state of design, typography and taste of the Dutch aesthetic elite. By smashing a milk bottle with the zero issue of TYP against the edge of the chimney in the lounge, TYP was born.

Soon the official TYP was formed by editors Dietvorst, Groenendijk, Kisman, Naas and Mertens. A while later Jongstra joined. In the following years the group produced a number of publications on the broad field of design, typography, art, visuals and literature. As the slogan says: TYP informs and opinices about the image in design, art and !literature. The quality of content is TYP's identity. TYP takes a special place in the debate on good taste in design and typography and is appreciated for its platform function. TYP is a voluntary activity and is supported by a large number of creative minds and sponsors in the field of the graphic industry.

Between 1986 and 1990 TYP officially published 6 regular issues (always in a limited edition of 500 copies), 2 secret issues and 1 special issue of five loose. After a difference of opinions, TYP No.8 a carton box with individual contributions of the editors, was the last to be publication of the group. In the summer of 1992, TYP published one week, every day a daily newspaper. Especially these days, while useless information and bad taste in design and visuals is pouring out of our screens, TYP seems to be more necessary than ever before.

Typ Story 1986-1995
www.typ.nl/TYP01/typstory.html

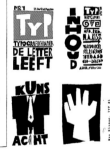

78

79

Form + Zweck

...erman design yearbook 'Form + Zweck' (...orm and Purpose') first appeared in 1956. It was changed to a journal in 1968. Following the reunification of Germany, the East German couple, Angelika and Jörg Petruschat took over the publication. After a difficult period of rejuvenation, the magazine has become a notable stage for both its editorial handling of design issues, and surprising art direction. The following text is an interview with Angelika and Jörg.

Text by Jürgen X. Albrecht
Photographs by Jörg Gläscher

KEYWORDS: EAST/WEST GERMANY. FORMALISM.
GRAPPA. HISTORY. ANGELIKA & JÖRG PETRUSCHAT.
REUNIFICATION.

When was *Form + Zweck* founded, and wh...
the reasons for the movement?

A: There was the opinion in the former ... the country needed its own design public... So, the design yearbook *Form + Zweck* app... 1956. Up until 1968 the publication appea... ally as a year-book, and thereafter as a jo... *Form + Zweck* was to be a resurrection of t... war magazine *Die Form* (1925–1934), from t... German 'Werkbund'; later, it was also a c... part to the West German *Form*, which wa... founded in 1959.

And in order to separate itself from the ... traditional *Die Form*, '+ Zweck' was simply ... onto the name...

A: No, no – it wasn't so simple. There w... thought put into it. *Form + Zweck* was est... in the IIG[1]. This institute was founded a... beginning of the 1950s by Mart Stam[2] wi... intention of influencing industrial prod...

J: This institute was connected to the A... emy of Berlin Weißensee, where Mart S... director at the time (1950–1953). Out of t... came the IAG[3]. At the same time, the for... discussions began in the GDR – that is, t... tion of which styles one tolerates alongs... socialism on German soil. Everyone wan... internationalism of the west. The IAG p... series of so-called 'model books', *Form un*... These books were a collection of superb... and applied artistic designs. These mod... had a very long tradition – before fascis... However, since *Form und Dekore* only con... the final product and nothing of the des... processes, the attempt was made to rep... with the *Form + Zweck* yearbooks. In this... the addition of '+ Zweck' was not merely ... appendage; in 1958 this also meant the c... from a simple aesthetic view. Hence, *Fo*... rather than *Form und Dekore* (form and d... An imitation of the Bauhaus ideology?

J: Yes. On the one hand an attempt to p... the Bauhaus tradition, which had been ... through formalist discussions. On the o... already in 1958 you could see the first si... such ornamental and monumental conc... such as the 'Stalin Allee' in Berlin, coul... carried out. Such a conception's archite... construction and graphic design made it ... because of its huge production costs. Th... there were also those who pleaded for o... in industrial design. And therefore, thi... appendage '+ Zweck'. It was, as already ... perhaps a replacement of *Form und Deko*...

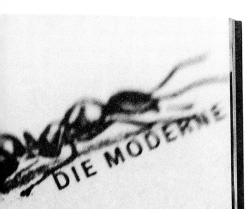

1: Institut für industrielle
Gestaltung (Institute of Industrial
Design)

2: The Dutch architect Mart Stam
(Martinus Adrianus, 1899–1986)
spent a short period as a student
at the Bauhaus Weimar and in 1928
became a teacher at the Bauhaus
Dessau. In 1948, he worked as a
professor, then later a director,
of the Art Academy Dresden
(German Democratic Republic).
After Dresden he was a director in
East-Berlin. In 1953 he moved back
to Amsterdam. He also co-edited
several other magazines: *ABC-Beiträge
zum Bauen* (1924, Zurich); *Open Oog*
(1946, Amsterdam); and *Goed Wonen*
(1948, Amsterdam).

3: Institut für angewandte
Gestaltung (Institute of Applied
Design)

'perhaps' because what we are talking about are
merely assumptions and associations. Can it also
be seen as a small argument against the West
German *Form*? It was perhaps thought that one
could socially discuss the aims and purposes of
design, and that this would be something social-
ism – a real, producing society – could have
where capitalism could not. I assume that these
were some of the considerations made during
the formation of *Form + Zweck*.

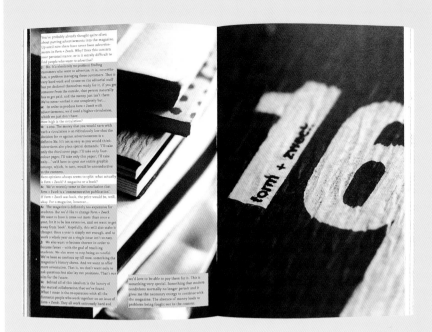

Designers
Stuart Bailey
Peter Bilak

Design Company
dotdotdot

Country of Origin
Netherlands

Work Description
Spreads from *dot dot dot*, an independent,
after-hours, graphic design magazine

Dimensions
6 1/2 x 8 5/8 in
165 x 220 mm

THE WIRE ADVENTURES IN MODERN MUSIC
WWW.THEWIRE.CO.UK ISSUE 219 MAY 2002 £3.30

Copyrights and wrongs

JOHN OSWALD

Shirley Collins The Fall El-P
Hillbillies, hoedowns & hellcats

Jewelled Antler Collective Mission Of Burma Mick Beck Vinko Globokar Patti Smith

THE WIRE ADVENTURES IN MODERN MUSIC
WWW.THEWIRE.CO.UK ISSUE 221 JULY 2002 £3.30

Secrets of a dark magus

KEIJI HAINO

John Coltrane Nurse With Wound
Wordsound Philip Jeck

Simon Fisher Turner DJ/Rupture Goodiepal DJ Spooky Peter Brötzmann Musique Actuel

THE WIRE ADVENTURES IN MODERN MUSIC
WWW.THEWIRE.CO.UK ISSUE 218 APRIL 2002 £3.20

ALICE COLT

Her story. Exclusive LA interview

Steve Beresford
David Grubbs
Bootlegs & plagiarhythms
Rebuilding Berlin Techno
Taylor Deupree
Vibracathedral Orchestra
Sunn 0)))
Boards Of Canada
Antipop Consortium
Reynols
Vinko Globokar
Frank Zappa

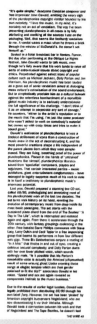

John Oswald

AS THE INSTIGATOR OF PLUNDERPHONICS AND THE NEMESIS OF MICHAEL JACKSON AND COPYRIGHT LAWYERS WORLDWIDE, **John Oswald** HAS BECOME NOTORIOUS FOR SUBTLY TESTING THE LIMITS OF CORPORATE CONTROL OF ARTISTIC PRODUCTION. YET FROM THE MULTILAYERED RAVING CONTOURINGS OF GRAYFOLDED TO THE SUPERDENSE SOUND GRAINS OF PLEXURE, THE CANADIAN SAMPLING AND SAXOPHONICS CLAIMS FAIR USE IN PURSUIT OF DAZZLING NEW NORMS.

Undoing time

AFTER HER KEY ROLE IN JOHN COLTRANE'S ECSTATIC JAZZ EXPERIMENTS OF THE LATE 60S, PIANIST AND HARPIST **ALICE COLTRANE** EMBARKED ON A JOURNEY INTO THE OUTER SPIRALS OF THE MUSICAL GALAXY, PROPELLED BY THE ELECTRIC ENERGIES OF FREE JAZZ, ASIAN MUSIC'S COSMIC VIBRATIONS, AND A BELIEF IN UNIVERSAL CONSCIOUSNESS. IN AN EXCLUSIVE INTERVIEW AT HER HOME IN CALIFORNIA, EDWIN POUNCEY HEARS HOW HER OWN TRANSCENDENT, QUESTING BODY OF MUSIC WAS INHABITED BY HER LATE HUSBAND'S SPIRIT, NOURISHED BY THE TEACHINGS OF SWAMI SATCHIDANANDA AND IGOR STRAVINSKY, AND DRIVEN BY AN UNSHAKABLE FAITH IN THE HEALING POWER OF SOUND
Photo: Jake Walters

Enduring love

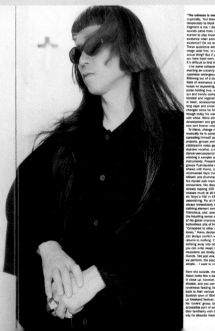

THE ELECTRICITY COMES ON ONLY AFTER THE LIGHTS GO OUT IN THE COLD, DARK UNIVERSE OF TOKYO'S **KEIJI HAINO**. EITHER ALONE, WITH HIS GROUPS FUSHITSUSHA AND AIHIYO, OR IN HIS CURRENT FLIRTATION WITH DJ CULTURE, HE HAS SPENT 20 YEARS REALISING HIS SOLITARY VISION OF UNDERGROUND ROCK AS RESISTANCE TO SOCIAL CONTROL AND WESTERN CULTURAL IMPERIALISM. WORDS: ALAN CUMMINGS. PHOTOS: JUNKO YAMADA

WHEN THE MUSIC'S OVER

Designers
Kjell Ekhorn
Jon Forss

Photographers
Johnny Volcano
Junko Yamada
Jake Walters
Kareem Black
Marc-Henri Cykiert
Jo Ann Toy

Art Directors
Kjell Ekhorn
Jon Forss

Design Company
EkhornForss/Non-Format

Country of Origin
UK

Work Description
Covers (opposite) and spreads (see also p.164–165) from *Wire* magazine

Dimensions
9 x 11 in
230 x 280 mm

WORDS: DAVE MANDL //
PHOTOS: KAREEM BLACK //

WITH A MULTI-FACETED STYLE THAT COMFORTABLY SPANS WRIST-SNAPPING, FREE JAZZ BLOWOUTS AND PAINTERLY, CALLIGRAPHIC BRUSH STROKES, DRUMMER AND COMPOSER SUSIE IBARRA HAS RAPIDLY BECOME ONE OF THE MAINSTAYS OF NEW YORK'S EVER FERTILE DOWNTOWN SCENE

In scarcely more than the blink of an eye, drummer Susie Ibarra has become one of the more prominent figures on New York's avant jazz scene. She has worked with a staggering number of downtown denizens, including William Parker, Butch Morris, John Zorn, Thurston Moore and Zeena Parkins, and has won a clutch of honours from various local and national magazines, in addition to her own groups' numerous releases, over the past few years she has also recorded a collection of duets with free guitar master Derek Bailey called *Daedal* and a dance performance with The Dave Douglas Ensemble, *El Trilogy*, as well as adding percussion to avant rockers Yo La Tengo's *And Then Nothing Turned Itself Inside Out* album and single, "Saturday".

It's easy to see why Ibarra, still only in her early thirties, is in such demand these days. Her sensitive, expressive drumming moulds itself perfectly to whatever context she happens to be playing in. Equally at home in free improv, modern composition and Philippine gong music, her mercurial style is nonetheless easily recognisable. Her stickwork is forceful enough to carry the blazing power of The David S Ware Quartet, but she can just as easily switch over to soft mallets, handbells and rattles for the more delicate, near classical passages she composes for her trio.

Born in Anaheim, California, and raised in Houston, Texas, Ibarra embarked on a drumming career relatively late in life. Her taste for jazz blossomed even later. However, coaxed early on by her mother, she began studying piano at a very young age, along with her four older siblings. "I started playing classical when I was four," Ibarra recalls. "I played it all through grade school up through high school, when I was 14. My mother's not a musician, but she's always loved music, and she's the one who had us all learn piano... [My father] played piano by ear. He grew up in the Philippines during World War II, so he learned with his sisters off the radio. He'll usually play just for himself, but if he really feels animated and a lot of the family's home, we might all play together... My parents liked Ella Fitzgerald, Dinah Washington, Doris Day, Frank Sinatra. And they had some Count Basie. Then, of course, there was pop and rock from my siblings, my brother and sisters records. I don't think I bought a record until I was 13," she says with a mischievous laugh.

The dramatic flair Ibarra evinces today in her playing and composing may have been shaped in part by her early exposure to opera – again thanks to her opera-enthusiast mother. "When I was little we would take turns going to see opera," she recalls, "so as a kid I got to see these incredible productions. Since I was young I didn't always have the patience, but it eventually grew on me." So much so that she is currently working on a score for a contemporary opera, *Shangri-La*, with a libretto by poet Yusef Komanyakaa.

Although both of Ibarra's parents grew up in the Philippines, and she herself would later embark on extensive studies of Asian percussion and gamelan, she didn't hear very much traditional music played at home while she was growing up. "We had some gong music records in my family's house and my cousins' house. We had Kulintang gong. But no one played them," she remembers, mock-promising to bring them

WORDS: PHILLIP CLARK //
PHOTOS: MISCHA RICHTER //
THROWING DOWN A CHALLENGE TO THE LAZY OR HOOKLESS OF CONTEMPORARY MUSIC,
FREDERIC RZEWSKI'S SELF-STYLED 'TRADITIONAL MUSIC' HAS BEEN FUELLING THE TENSIONS
BETWEEN IMPROVISATION AND COMPOSITION FOR FOUR DECADES. AFTER MOVING FROM
THE CONCRETE RADICALISM OF MUSICA ELETTRONICA VIVA THROUGH ENCOUNTERS WITH
STOCKHAUSEN AND CORNELIUS CARDEW, THE EX-PAT AMERICAN COMPOSER IS NOW
WRINGING NEW FORMS OF PROTEST FROM THE PIANO

Manufacturing dissent

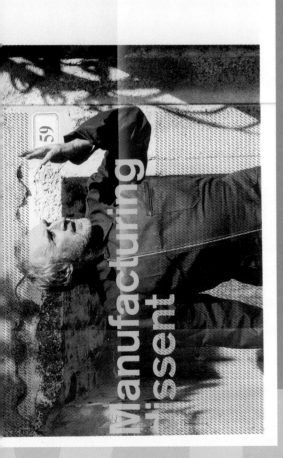

fighting the good fight

EXTENDING THE CUT 'N' PASTE TECHNIQUES OF SUCH PIONEERING FIGURES AS DOUBLE DEE & STEINSKI, MANTRONIX AND THE LATIN RASCALS, DJ SHADOW RECONFIGURED AND REIMAGINED HIPHOP ALONG PURELY TEXTURAL AND PATTERNED LINES. BUT AFTER HIS SPACIOUS, EMOTIONAL COLLAGES WERE MISINTERPRETED AS TRIPHOP, HE RETREATED INTO THE MORE CHALLENGING AND PERSONAL MUSIC CONTAINED ON HIS NEW ALBUM, *THE PRIVATE PRESS*.

THE BEGINNING OF THE END

ISSN 1444 - 7681
9-771444-768009
AUD: $17 US: $14 JAP: 1800¥ UK: £8 FR: 80ff inc gst
PROCESSED

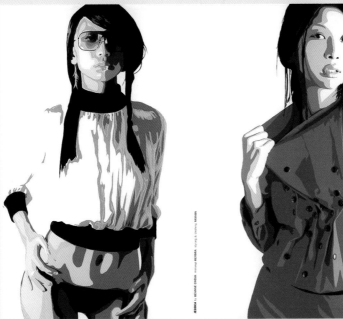
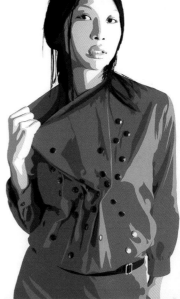

Art Director
Deanne Cheuk

Illustrator
Deanne Cheuk

Photographers
Pierre Toussaint
Derek Henderson

Creative Director/Editor
Pierre Toussaint

Country of Origin
Australia

Work Description
Front cover (opposite)
and spreads from
Processed, a photography
and design magazine

Dimensions
6⅝ x 9⅜ in
170 x 240 mm

TOO CASUAL

Whilst it is true that some people grow more beautiful with maturity, the majority by far look at their best during their teens and twenties. It surprises me therefore that females in this age group do not make the most of these years by looking as attractive as possible with flattering clothes and hairdos. The denim and secondhand clothing look, and the scruffy hairdos that go with them, which are the "in" thing today, does nothing for the person at all. It should be borne in mind that to look fashionable, and does not necessarily look attractive. I am sure many youngsters today will regret that they did not wear prettier "gear".

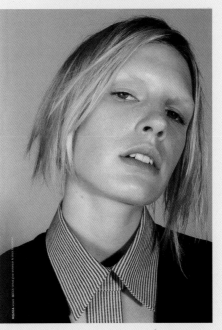

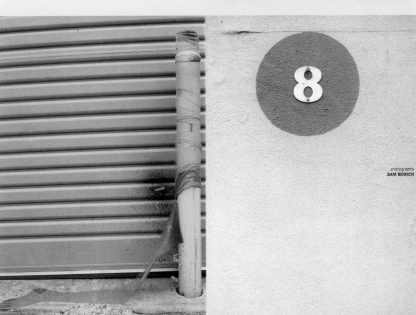

photographs
SAM BORICH

styling **Marcel Van Doorn** hair and make-up **Dotti** model **Kim**

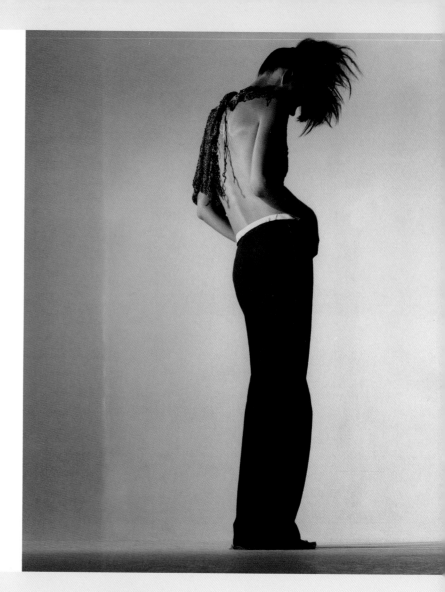

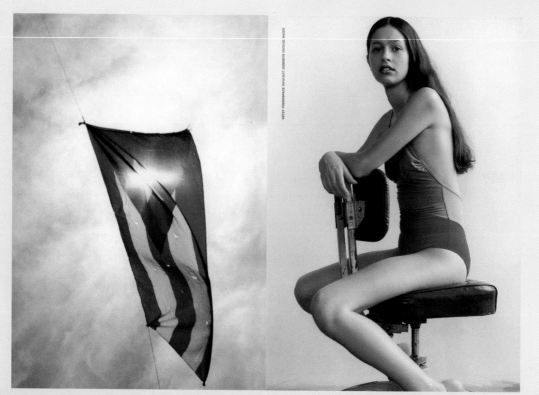

Art Director
Deanne Cheuk

Photographers
Tim Richardson (above)
Max Doyle (left)
Sam Borich (opposite/top)
Derek Henderson (opposite)

Creative Director/Editor
Pierre Toussaint

Country of Origin
Australia

Work Description
Spreads from *Processed*,
a photography and design
magazine

Dimensions
6⁵/₈ x 9³/₈ in
170 x 240 mm

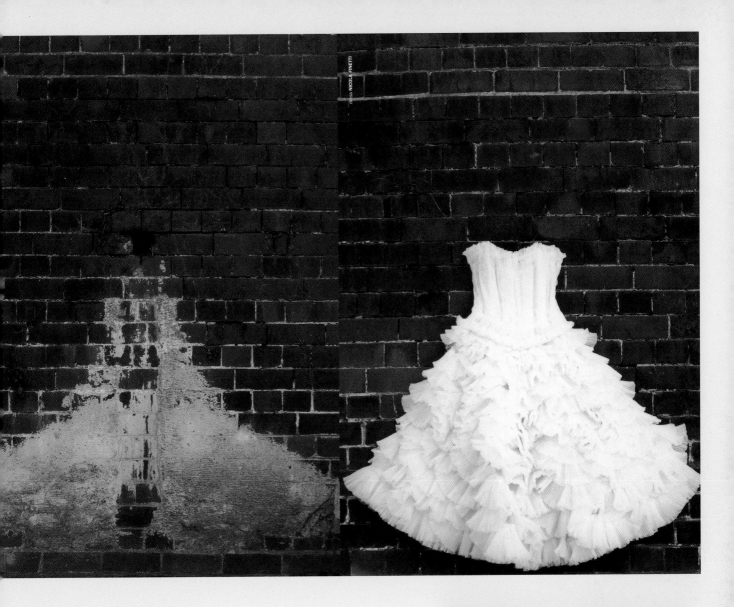

he dreamt he was dying

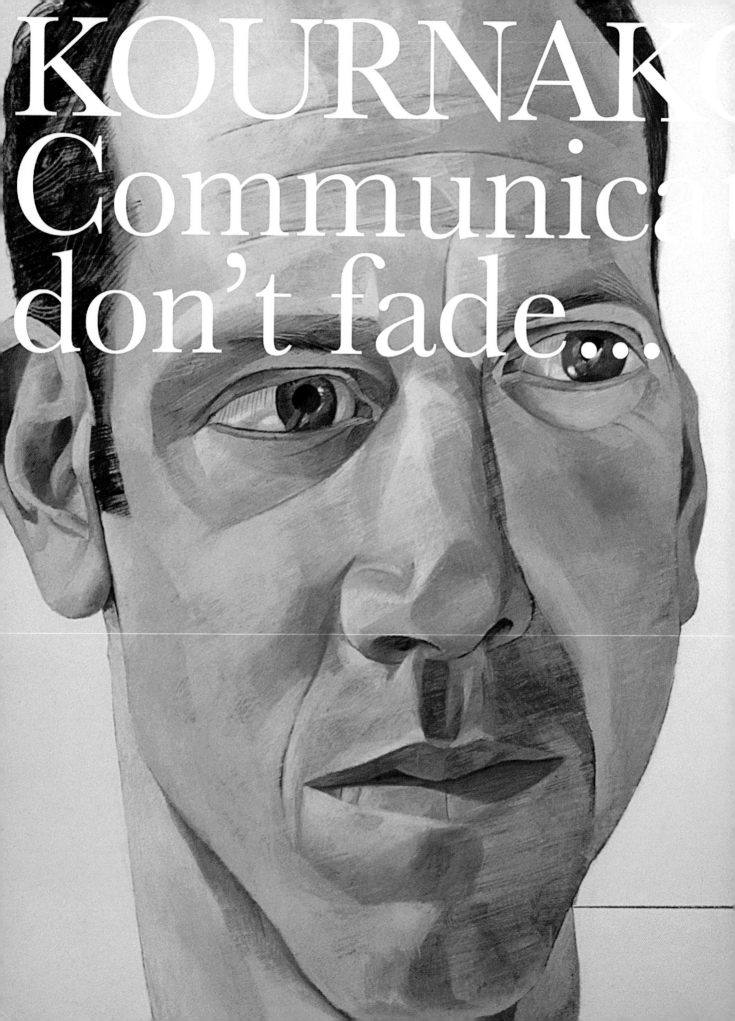

KOURNAK

Communica
don't fade...

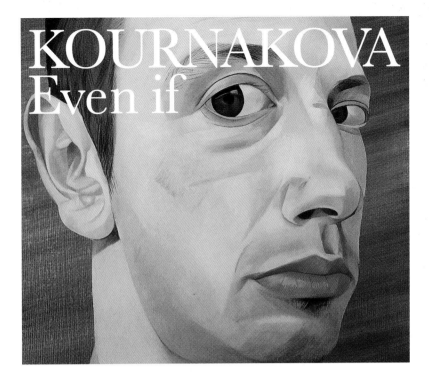

KOURNAKOVA
Even if

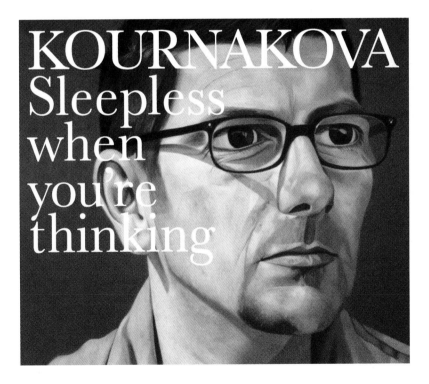

KOURNAKOVA
Sleepless
when
you're
thinking

Designers
Paul Humphrey
Luke Davies

Artist
James Hague

Art Directors
Paul Humphrey
Luke Davies

Design Company
www.insect.co.uk

Country of Origin
UK

Work Description
Single and album
cover designs for the
act *Kournakova*

Dimensions
16³/₈ x 9³/₈ in
420 x 240 mm

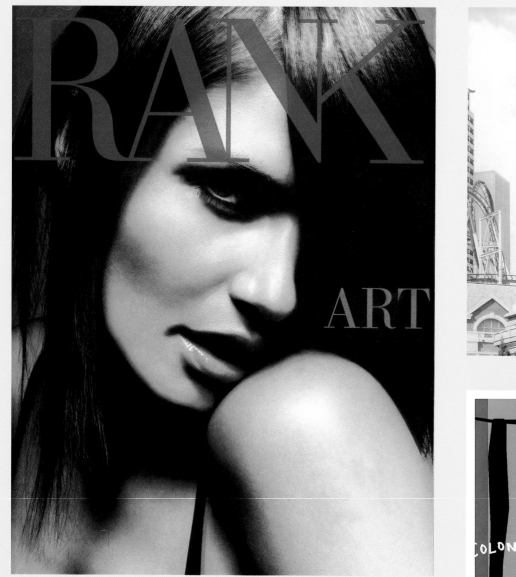

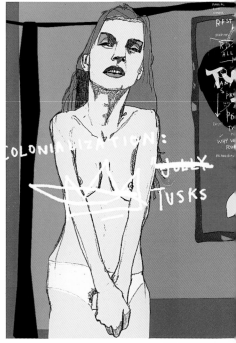

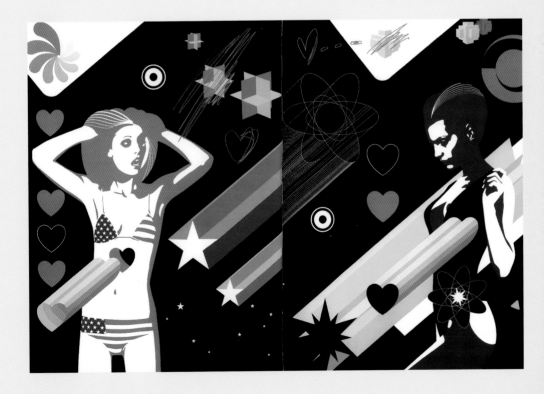

Creative Director
Rankin

Art Director
Way Young Hung

Fashion Editor
Miranda Robson

Illustrators
Patrick Morgan (bottom center)
Jasper Goodall (below)

Photographers
Rankin (far left)
John Clang (top center))

Country of Origin
USA

Work Description
Front cover (far left) and
spreads from *Rank* magazine

Dimensions
9^1/$_2$ x 12^5/$_8$ in
240 x 320 mm

Creative Director
Rankin

Art Director
Way Young Hung

Fashion Editor
Miranda Robson

Photographers
Rankin (right)
Laurie Bartley
(below right)
Derrick Santini, ESP
(opposite)

Country of Origin
USA

Work Description
Spreads from
Rank magazine

Dimensions
9^1/$_2$ x 12^5/$_8$ in
240 x 320 mm

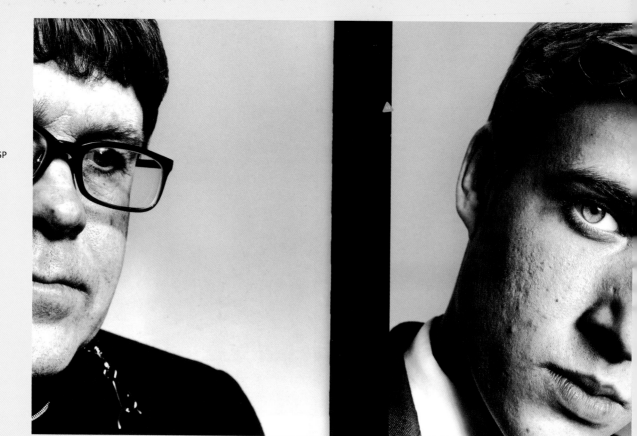

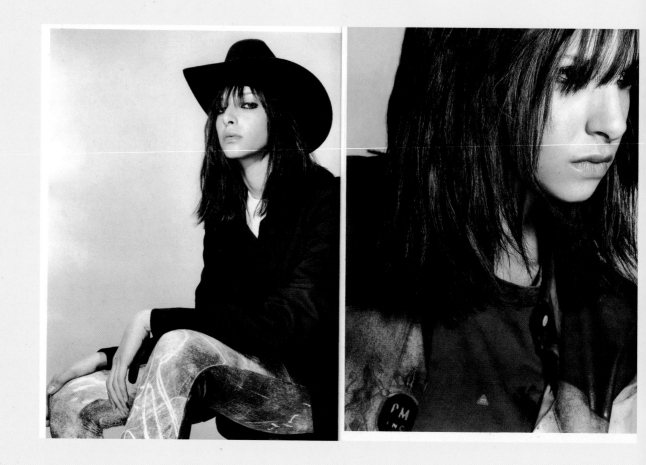

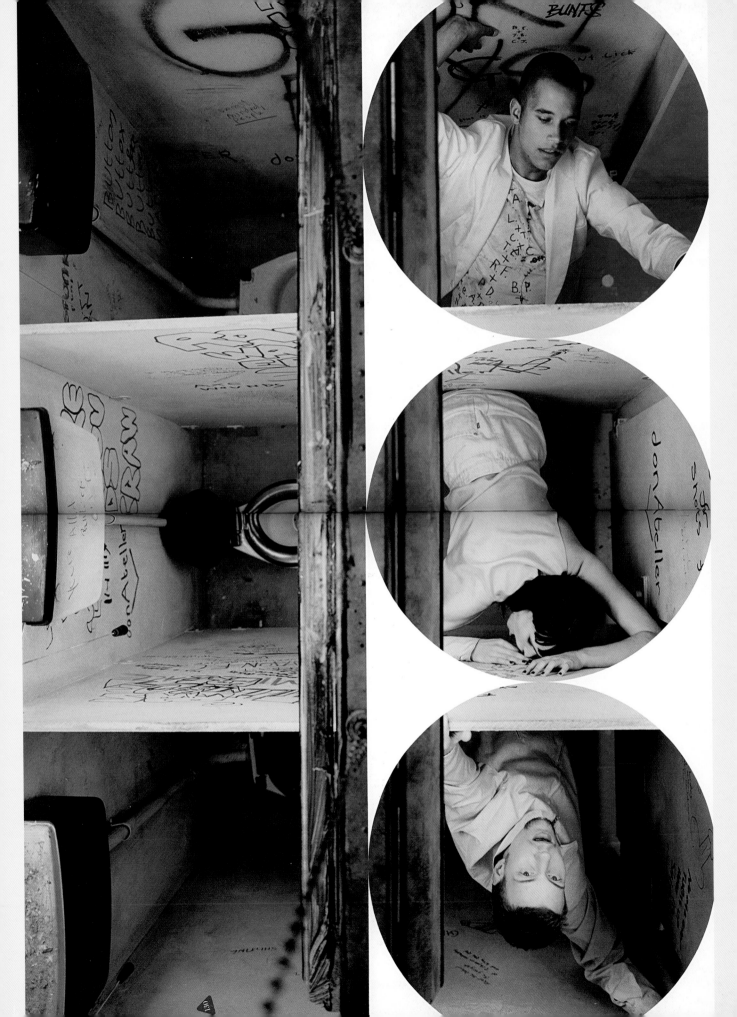

Designers
David Slatoff
Tamar Cohen

Photographers
Josh McHugh
Christopher Gallo
Tamar Cohen

Art Directors
David Slatoff
Tamar Cohen

Design Company
Slatoff + Cohen
Partners Inc.

Country of Origin
USA

Work Description
Front covers
(above) and
spreads from the
*Lincoln Center
Theater Review*, a
literary magazine
for the Lincoln
Center Theater

Dimensions
8¹/₂ x 11¹/₂ in
215 x 297 mm

New Orleans at Night

by Rich Cohen

Late at night, after everything else had shut down, you could still go to Benny's, a musty little underground club off Magazine Street in the Garden District. It was just a tired old house, no different from the other houses on that sad street, with their dusty interiors and sagging porches, only the rooms had been gutted and a stage set up in what had been a living room. There was no cover charge and the music rarely got going before three a.m., when musicians turned up from the big clubs and arenas—their shows over and still they wanted to play. I saw dozens of bands at Benny's, rock-and-roll and the blues and jazz, but mostly it was just the sound of New Orleans, a man alone with a guitar onstage, sweating and smiling, carrying everyone along some drawn-out note, an emotion brought into the light of the world. But even inside, the room crowded with music and smoke, you still knew the city was out there, with its ramshackle houses and its ghostly avenues, and the streetcars rattle and the steamship's blow—the great howling music of a city that never stops soloing.

There are really two night time New Orleanses: the night of the businessman who checks his watch and honestly believes there is a good reason to get up early the next morning; and then the night for the careless, an after-hours revel that begins each evening at around two a.m., after that first night has gone off to sleep. When I lived in the city, it knocked me out that so many of my friends had never even seen this other city. Yes, they frequented the fancy restaurants that serve heavy food, and visited the white tigers at the zoo, and could even sing the words of "They All Asked for You," a great New Orleans anthem by the Meters: "I went on down to the Audubon Zoo and they all asked for you, the monkey asked, the giraffe asked and the elephant asked me, too." But they had never seen how the city fills with a new crowd in the small hours, how the cars cruise the boulevards, how a strange and exotic life is revealed in the bars like marine animals exposed by an outgoing tide.

I lived in a pink building a few blocks from the river. I would usually take a nap and hit the streets in time to watch the shift change, the nine-to-fivers leaving the party like children sent to bed. There was a lull and then the streets came alive, the predators creeping out of their boroughs—a desert scene shot in ultraviolet. Soon the jukeboxes were wailing and the bands kicking into the bonus set, taking requests and playing for free, or for whatever the crowd stuffed into the water jugs passed around the room. In these jugs you would see coins and bills but also watches and bracelets and wedding rings, heirlooms from a distant daytime world. On such nights, you traveled as you had as a kid on Halloween, in excited packs, tight as Mafia crews, following your own path across the universe of the city. My friends and I went first to Miss Mae's, a dive which served mixed drinks for under two bucks and still had a three-for-one night, a few dollars covering a table with sticky sweet cocktails. We then went to the Camellia Grill, a whistle-clean lunch counter for pecan pie warmed on the grill, or omelets, or cheeseburgers, the waiter saying, "Want it plain or dressed?" Or to Frankie and Johnny's for beer and shrimp po'boys, or across the Huey P. Long Bridge, to the edge of the bayou, for crawfish pie and turtle soup at Mosca's, the wine cool and delicious.

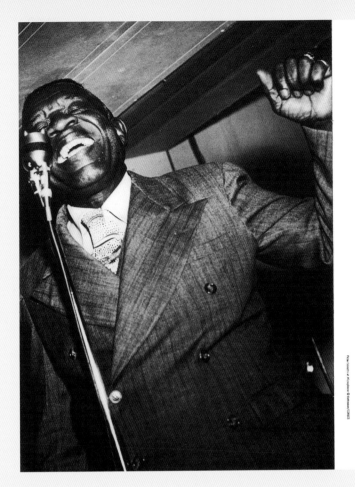

On Coming Home

by Nathan Englander
photography by Tamar Cohen

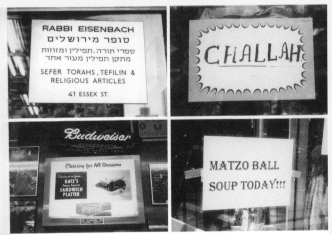

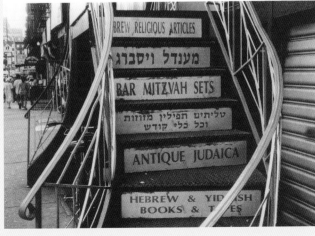

It's a dog day outside, and not much better in. The air must be circulating somewhere in Katz's Deli, because an old dangling sign spins on its string from the ceiling. The sign says something like, "Send a Salami to Your Boy in the Army." I know almost nothing at all about my father's stint in the U.S. Army except that he once mentioned having a salami in his foot locker. This always seemed vaguely disturbing. A couple of hours on the Lower East Side and already my visit affords a little clarity. I've managed to make it one generation back.

Despite the heat, I get a matzo-ball soup, a hot pastrami, and a kishke. I drink Dr. Brown's and drip pickle on a *New York Post* that sits on top of my *Times*. I'm here to hunt a link between myself and the immigrants from a time gone by, with their pushcarts and patched pants, a link to the Lower East Side of Henry Roth, with its teeth-breaking English and New World feel. American born and raised, I seem to have done what I thought impossible. I lived so far away for so long that I accidentally turned myself into an immigrant by coming home.

I have no personal ties to the Lower East Side, only a hazy memory of eating at Ratner's—which I try first for lunch, but they're only open on Sundays in the summer, and inside among the stacked chairs are three hipsters with clipboards who I'm guessing have

more to do with Lansky Lounge, the romanticized Jewish-gangster-inspired nightclub that shares the space. At first glance, the neighborhood is changing like every other, but it still feels true to the newcomer, as if it belongs to the last group in. The Lower East Side changes its face but keeps its soul. Showing up here in search of a specific period is much like trying to find your way back to childhood. I come up with only two routes, nostalgia and food. So you catch Mandy Patinkin singing in Yiddish in a refurbished shul or stop at Yonah Schimmel's for a knish. You show up, you hunt it down, you eat it. The remaining venues compromise to meet you halfway. Ratner's is more bar than bagels, and Katz's is filled with tourists looking for the authentic slice of rye. Two women rushed in right after me asking urgently if they could get kishke here, two women who clearly had no idea what it was, or that they were carrying their own kishkes, physical and spiritual, bubbling inside.

I did not grow up with any old relatives speaking to me in accents. In Jerusalem, when asked where my family is from I say New York, and when pressed with, "No, before, before, where do they come from?" "Boston" is my answer. I do not even know the origin of my family name. As much as I was isolated as a religious Jew in suburbia, my immediate family was isolated in its Americanness. I

Supplemento al quotidiano la Repubblica del 22 settembre 2001 - spedizione in abbonamento postale Articolo 2, comma 20/b, legge 662/96 - Roma

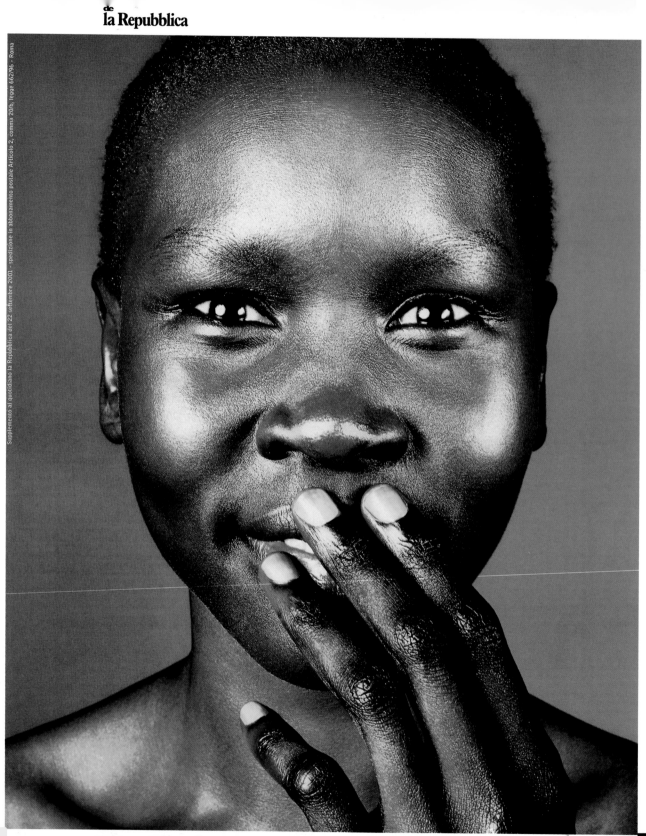

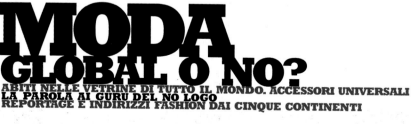

MODA
GLOBAL O NO?
**ABITI NELLE VETRINE DI TUTTO IL MONDO. ACCESSORI UNIVERSALI
LA PAROLA AI GURU DEL NO LOGO
REPORTAGE E INDIRIZZI FASHION DAI CINQUE CONTINENTI**

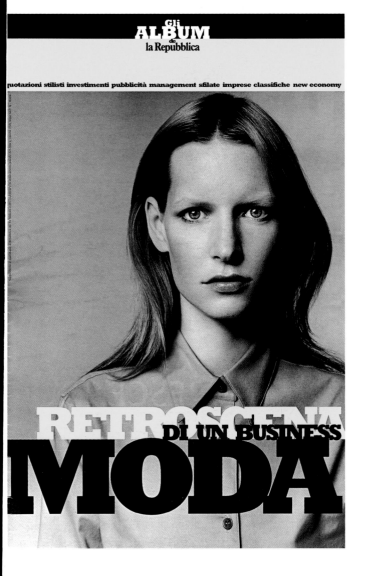

RETROSCENA
DI UN BUSINESS
MODA

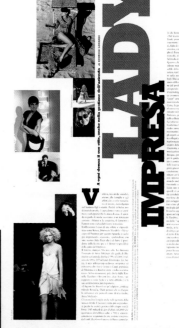

MASCHIO
QUANDO CAMBIERAI?

**Sembrano diversi, più moderni.
Parlano con le donne.
Ma siamo sicuri che quello degli
uomini sia un pianeta in movimento?**

Work Description
Pages (right) and front
covers from *Gli Album
de la Repubblica –
Speciale Moda*,
fashion supplements
published twice yearly
with *la Repubblica*
newspaper, for the
Milan Fashion Shows

Dimensions
11^1/$_2$ x 18^1/$_8$ in
297 x 470 mm

Il nuovo è tutto ciò che è prezioso,
fastoso, elegantemente smodato.
Ma non è un ritorno agli Ottanta.
È l'eterno, femminile, gioco della moda

un sogno
un segreto
un brivido
un piacere
moderno

LADY
IMPRESA

Designer
Theo Nelki

Photographers
Max Cardelli
Dan Chavkin
Various

Art Director
Theo Nelki

Country of Origin
UK

Designer
Theo Nelki

Photographers
Various

Art Director
Theo Nelki

Country of Origin
UK

Work Description
Pages and spreads
from *Gli Album de la
Repubblica – Speciale
Moda* (see also
p.182–183) fashion
supplements published
twice yearly with *la
Repubblica* newspaper,
for the Milan Fashion
Shows

Dimensions
11¹/₂ x 18¹/₈ in
297 x 470 mm

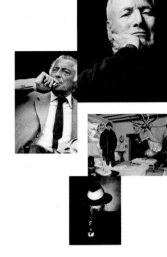

LA STAGIONE
DEI FORTI

Solo i vecchi hanno uno sguardo non conformista DI ROBERTO DI CARO

Attenti all'immagine

La griffe con gli stivali

Morbidi lacci alle caviglie e fibra in carbonio, un materiale preso in prestito dall'industria aeronautica. Ecco una riscrittura delle scarpe da tip-tap in versione romanticamente hi tech. Vulcanico, imprevedibile, Sergio Rossi, il maestro della calzatura made in Italy, mescola sapientemente il cuoio e il nickel, arrotonda le punte degli stivali e sentenzia: «La scarpa di lusso dai pellami alla manifattura si può produrre solo in Italia».

Numero uno mondiale dell'industria della calzatura il Bel Paese rivendica il suo ruolo principe in un mondo globalizzato. Lo conferma Diego Rossetti impegnato «nel continuo aggiornamento della scarpa classica». Una filosofia tutta tesa a trasformare il marchio Fratelli Rossetti in istituzione che rassicura il cliente spingendolo a tornare. Dice Rossetti: «Ci piace produrre solo in Italia con la qualità dei materiali italiani. In questo sono contro la globalizzazione».

Eppure la scarpa "meticcia" che strizza l'occhio ai colori e alle suggestioni del Mediterraneo e del mondo intero sta entrando prepotentemente nella nostra cultura. Emblematico l'esempio di Camper, la casa spagnola dell'isola di Maiorca che si è imposta per l'ironia e la spensieratezza dei suoi modelli. Un'intera collezione ispirata all'arte, la cultura i colori dei popoli altri e idee come Twins: le scarpe non sono "un paio" ma due calzature dal disegno diverso e complementare. Una vera coppia, dunque. Giorgio Lonardi

ACC

IN ALTO. Scarpe doc. Da sinistra, décor aborigeno per gli stivali Camper (da *Zapatos y arte indigena*, ed Camper) e la nuova campagna di Sergio Rossi (foto M. Alas e M. Piggot). Gioielli inconfondibili. Da sinistra, ciondoli a cuore in platino di Paolo Quagliotto (foto Leonardo Beglieri); la campagna della collezione Fiammiferi 2001/2 di Pasquale Bruni (foto Giovanni Gastel); Nastassja Kinski e Milla Jovovich testimonial con Chiara Mastroianni della campagna di Damiani (foto Peter Lindbergh). Occhiali italiani. Qui accanto, dall'alto, la campagna della collezione Max Mara prodotta da Safilo (foto Steven Meisel); lenti colorate e montature extra-large per John Galliano Eyewear (foto Nataniel Goldberg); occhiali da vista Emporio Armani by Luxottica (foto Aldo Fallai). Borse day and night. Da sinistra, la campagna invernale di Furla (foto Steven Klein); borse della linea Saké di Mandarina Duck; porta-euro in pelle: bluette di Borbonese e rosso lacca di Valextra (foto Famiglia 38); una foto di Iris Brosch dal nuovo catalogo Coccinelle. Tecno-orologi. In basso a destra, lo skipper Sir Peter Blake testimonial per Omega (Foto Patrick Wallet).

Sguard

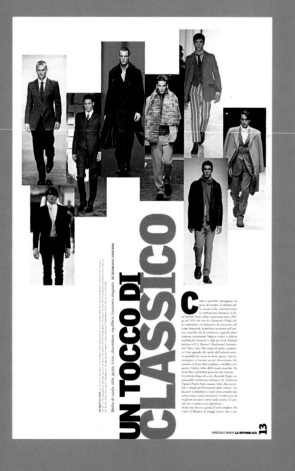

UN TOCCO DI
CLASSICO

C

cchi d'emozioni

Sono tutti d'accordo. In gioielleria quello che conta, dall'Africa ai nuovi mercati dell'Asia e dell'Est Europa, è l'unicità stilistica. Che va sottolineata dai negozi e dalla pubblicità.

«Le nostre campagne sono uguali ovunque perché, come i nostri gioielli, sono espressione di un prodotto unico, inconfondibile», dice Francesco Trapani di Bulgari, 130 negozi nel mondo e la previsione di aprirne 15 ogni anno in ogni angolo del pianeta. Gli fa eco Marco Sgoifo di Pasquale Bruni: «Il pubblico da noi cerca qualità e l'unicità del design. E la nostra immagine è globale. Al limite, si fa qualche piccola correzione, come è successo per la collezione Fiammiferi: per il mercato russo abbiamo dovuto tradurre il claim "accendimi" in cirillico; in Giappone, invece, è rimasto in italiano, anzi il suono made in Italy là è un plusvalore». Questione di emozioni, di entrare nell'immaginario del cliente, dunque. Lo conferma Wilma Viganò, amministratore delegato di Platinum International Italia. «In tutto il mondo il rilancio del platino è nel settore delle fedi matrimoniali, un'area di forte impatto emotivo. E stiamo conquistando anche l'India, dove il grande antagonista è l'oro. Il target sono i giovani, affermate. Ora lanciamo il ciondolo-cuore. Dai test su donne fidanzate è risultato, all'unanimità, che è "la prima idea di gioiello". Poi bisogna fare attenzione agli usi sociali. Le nostre ricerche rivelano che in Italia gli acquisti in gioielleria sono all'80% per regali, in Giappone, invece l'80% delle donne si comprano personalmente i gioielli. M.M.

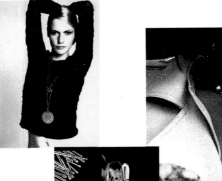

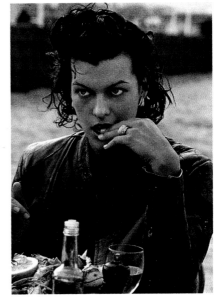

ESSORI PARTICOLARI
UNIVERSALI

carpe, occhiali, orologi o borsette. **Il design italiano conquista mercati sempre più ampi. Perché a vincere sono personalità e unicità**

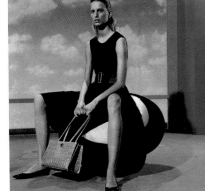

Borsa flessibile

La praticità unita al tocco glamour. Sì, infatti in una società dove regna la frenesia, dove la donna che lavora, spesso non passa da casa prima di andare a cena, è stata automatica la necessità di una borsa "totale". Quindi capiente ma anche bella per essere un passepartout per la sera. Un successo enorme, per esempio, lo hanno avuto le "bowling bag", che, lanciate da Prada, hanno fatto un boom di mercato per la loro flessibilità estetica. Ma si affaccia una nuova necessità all'alba della nascita "pratica" degli Stati Uniti d'Europa: il portamonete. Sparito dalle tasche degli italiani, tornerà per contenere Euro e centesimi che non sono più monetine insignificanti. G.C.

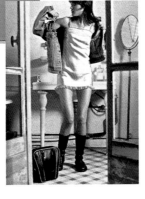

Tempi diversi

Orologi da tasca in oro e smalti, realizzati a Ginevra già due secoli fa per il mercato ottomano e cinese (spesso in coppie simmetriche, in modo che il proprietario potesse indossare un modello quando l'altro era in Svizzera per riparazioni), testimoniano quanto quello dell'orologeria sia un business esemplare per tradizione e apertura. L'attenzione ai commerci lontani, non è certo una novità arrivata oggi con la globalizzazione. Ma ora pare che il mondo dell'alta gamma si sia spezzato in due scuole di pensiero. Da una parte c'è chi continua per la propria strada, convinto che debba essere il resto del mondo ad accettare lo stile del Vecchio Continente. È il caso del lusso firmato Cartier, dello status-symbol tecnologico di Rolex, dei fenomeni di tendenza Luminor Panerai, Royal Oak Audemars Piguet o Monaco TAG Heuer. «Per Cartier», ha dichiarato Franco Cologni, presidente di Richemont Italia, «l'obiettivo è lavorare sempre di più sulla rarefazione delle collezioni, esasperando i concetti di stile e di rarità insiti nella tradizione del marchio». Il business planetario comporta anche strategie precise. Ecco allora Cologni e Nicholas Hayeck (presidente di The Swatch Group) nell'ammettere che, assieme al valore dei marchi acquisiti recentemente (Richemont ha comprato la manifattura Jaeger-LeCoultre, Swatch Breguet e Lemania) interessava il loro know-how in fatto di forniture meccaniche «il terreno su cui ci si darà battaglia in futuro». Dall'altra, c'è invece chi guarda ai ricchi mercati extraeuropei con attenzione agli usi e ai gusti locali. Vedi la predilezione degli arabi per le

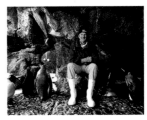

pietre preziose, e quindi per i più sfarzosi orologi-gioiello, o la minutezza dei polsi degli orientali, che richiede modelli piccoli. Tutti paradigmi cui si attiene la produzione di Franck Muller, Piaget o Patek Philippe. Fuori da questo gioco sono invece i marchi nati sull'idea di orientare la produzione sulle tendenze: è il caso di Swatch, da sempre attento ai profumi, ai colori e ai suoni del mondo. Dice Julian Gould, nuovo amministratore delegato di The Swatch Group Italy: «È proprio stato questo marchio a cavalcare per primo l'idea di un mercato planetario. Sono infatti nella natura di Swatch la produzione in grande serie e il basso costo a fronte di alta tecnologia e grande affidabilità. Qualità che però di per se stesse non basterebbero a farne il marchio d'orologi più diffuso al mondo: la strategia vincente è stata l'ampia diversificazione funzionale e di design». Paolo De Vecchi

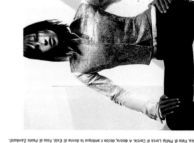

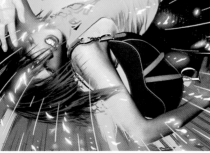
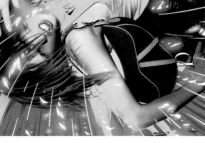

SE MI VUOI CERCAMI OVUNQUE

Pensare a una donna ideale, lavorare in team multietnici, giocare con le contaminazioni. Ogni designer ha una propria visione di come cambia lo stile nella società globalizzata

Chanel
Abbiamo deciso di rivolgerci anche a un pubblico diverso, nuovo. Portare la filosofia di Mademoiselle Coco anche a chi non indosserebbe mai un tailleur ma è affascinato dal nostro stile. Per questo è nata la linea sportswear. È un allargamento dei nostri orizzonti sia in termini di design, trasmettendo un'immagine più accessibile e giovane, sia dal punto di vista di mercato, guadagnandone una fetta che prima non avevamo. Anche per quanto riguarda la rete distributiva ci stiamo trasformando, con un completo restyling delle nostre boutique cominciando da quella di Hong Kong.

Bally
La visione di un individuo che vive nel mondo, che viaggia e si confronta con gli altri. Così anche che noi pensiamo a una moda in versione globale. Un guardaroba che ti accompagna tutto il giorno e per abbracciare la filosofia di una luxury-brand. Così un piccolo oggetto, che diventa di culto, può essere il mezzo per portare i beni di lusso alla portata di più persone.

Céline
Il mondo diventa sempre più piccolo perché le informazioni viaggiano in tempo reale e quindi è molto più facile. Spesso il consumatore si identifica nella griffe di lusso solo possedendo un accessorio firmato. Per cui la moda non solo non è più un fenomeno per pochi, ma, al contrario, aziende più commerciali sono spinte a migliorare la propria qualità, puntando su design, immagine e materiali. Così che i trend arrivano alla portata di tutti.

Gucci
Oggi un processo di globalizzazione delle genti è inevitabile. Si vive alla velocità della luce, si mangiano gli stessi cibi, si ascolta la stessa musica, in futuro finiremo per essere tutti di una stessa e nuova razza. Questo succede anche nella moda. Quando si pensa a una collezione si immagina un ideale di donna che è allo stesso tempo personale e universale. Letto in termini pratici significa creare uno stile identificabile sia in un solo capo o accessorio. Il trucco è la capacità di differenziarsi offrendo quello che gli altri non hanno e renderlo esclusivo.

Exté
La nostra moda ha una identità unica e ricercata. Il nostro messaggio si riferisce alle donne di tutto il mondo che possono identificarsi in esso. La moda vive ed esiste grazie alla creatività, al mutamento continuo e agli impulsi che arrivano dal mondo interpretato secondo l'individualità del pensiero dello stilista.

Roberto Cavalli
È il desiderio di far conoscere Roberto Cavalli a sempre più persone: la scommessa che è dietro all'apertura di ogni nuova boutique. Il mio personale amore per la moda e la creatività mi porta a immaginare senza limiti di nessun tipo né di locali né di libertà. A me piace la libertà.

Givenchy
Fare in modo che un marchio sia conosciuto e soprattutto apprezzato in tutto il mondo. Possiamo che questa definizione corrisponda al concetto di moda globale. Notorietà a livello mondiale che però non significa essere alla portata di tutti. Nasciamo come marchio d'élite e i nostri clienti pagano per avere un plus che solo noi possiamo dare.

Mila Schön
È strano, siamo un team di due italiani e due inglesi che porta avanti una tradizione tipicamente italiana. Ci siamo dati delle regole, ci siamo imposti di coniugare il nostro stile con la tradizione dell'atelier. Inoltre abbiamo in previsione un allargamento del mercato introducendo una nuova linea, Mila Schön Concept, rivolta ai più giovani di tutto il mondo e che rappresentare una sfida. Ma separatamente punteremo sul rinnovamento totale dell'immagine delle boutique (partendo dalla nuova in via Manzoni 45) che sarà un segnale della nostra voglia di comunicare in modo diverso, anche con realtà che prima non erano nel nostro target: Far East e espatriati Stati Uniti.

Emilio Pucci
Per moda globalizzata possiamo intendere un restringimento dei punti di riferimento, in quanto sono pochi i marchi che possono piacere a tutti. Noi lavoriamo su collezioni che possano rappresentare la nostra identità nel mondo. E ci adeguiamo solo per quanto riguarda la vestibilità in base alle esigenze delle diverse aree mondiali.

Ruffo
Il lato positivo della globalizzazione è quello che con essa ognuno può creare un look personale, riuscendo input visivi da ogni parte del mondo. La nostra è una collezione pensata con uno stile internazionale attraverso la conoscenza del mercato mondiale. Ma il modello è sempre unico: quello di una donna ideale nella quale si riconosce chi sceglie il nostro stile. Per questo possiamo essere in tutte le parti del globo senza perdere la nostra identità.

Christian Dior
Globalizzare significa richiamare le contaminazioni del mondo moderno. I cartoons, i videogiochi, le scritte dei ghetti neri hanno contribuito alla creazione del nuovo universo di Christian Dior. Una moda che sembra solo con i suoi accessori e i piccoli dettagli ha conquistato il mondo. L'ultima campagna pubblicitaria fotografata e rielaborata dal computer da Nick Knight ne è l'esempio. Un fashion-cartoon ispirato ai combattimenti dei Pokemon.

Fendi
L'idea della ragione nasce da un'unica immagine femminile che torna ossessivamente alla mente, le donne di tutto il mondo, poi, vi si rispecchiano. Quindi si deve saper concepire una visione personale che tenga conto delle emozioni della moda che si sono tutti portati dietro, che è difficilmente riproducibile. Una collezione può dare, a dunque.

Moschino
Con la tecnologia si è annullata la sorpresa e la magia di un tempo, quando ci aspettavano le vetrine dei negozi per vedere la nuova moda. La velocità delle informazioni, per esempio internet che mostra le sfilate già il giorno dopo, ha azzerato quasi tutto. La globalizzazione si può leggere, invece, come una voglia di rischiare: lasciare spazio a giovani e alle loro visioni moderne per dare una scossa al fashion system che, se rimane schiavo dell'economia, perde la brillantezza di un tempo. Ed è stata la nostra scelta. Moschino è un pool di giovani che, pur non avendo mai conosciuto Franco, hanno capito la sua mentalità: reinterpretandola secondo le esigenze di oggi.

A SINISTRA dall'alto, la fine è l'inizio di un bacio? È la domanda che ci si pone di fronte alla campagna di Bally fotografata da Sølve Sundsbø; immagine in stile posh americano per l'abito sottoveste scozzese disegnata da Michael Kors di Céline. Foto di Michael Thompson. A destra, l'immagine di Chanel per la nuova linea sportswear. La foto è di Karl Lagerfeld

IN ALTO a sinistra la campagna di Christian Dior autunno 2001/2 è ispirata ai combattimenti dei personaggi Pokemon: a Dragon Ball Z. La foto è di Nick Knight. Sopra, l'artista romantica e un po' decadente per lo stile invernale di Givenchy. Foto di Annie Leibovitz. Qui accanto, a sinistra l'immagine di Fendi per l'inverno 2002: surreale e artistica. Foto di Philip Lorca. A destra, decisa e ambigua la donna di Exté. Foto di Paolo Zambaldi.

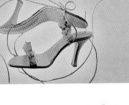

MERAVIGLIE E ALTRE EMOZIONI

Dagli Emirati alla Cina, all'America gli accessori made in Italy sono oggetti del desiderio. Sempre di più

SCARPE Semplicemente primi

Scarpe sì, purché di lusso. Pantofa di Carlo Pambianco, superconsumente dei made in Italy, che alle calzature italiane ha dedicato poche settimane fa un ponderoso studio. Eppene, oggi ogni tre paia di scarpe d'alta gamma vendute al mondo una è italiana. In cifre: 2000 miliardi di fine di giro d'affari ottenuti in larga parte all'estero. Lo sa bene Giorga Capella in questi giorni a New York per la collezione René Caovilla. «Per noi sa benissimo, è l'export porta da beninessimo, è l'export porta da 220 dollari per arrivare a 700 di un paio di stivali ricamati. Ovviamente in questa cifra si moltiplica per tre e 4 volte», dove, nei primi nove mesi del 2000, le esportazioni sono aumentate del 65%.

Scarpe sì, purché di lusso, ma anche controllati da Della Valle, ma anche protagonisti del marchio di Sergio Rossi, acquistato dal gruppo italiano Gucci, o di Polini, rinnato da Aeffe. A volte, infatti, una griffe forte coniene un positivo e perente della qualità si acquista un processo della qualità e del sistema di lavoro dei Ber Piane. «Il successo maggiore», assicura Antonio Bertoni, presidente dell'Anci, l'associazione imprenditoriale di settore e fatziari di Pakenburi, scarpe machoti di qualità.

«Fabbiamo avuto con Pakemori Couture una linea fatta a mano 150 paia prodotte ai giorni» e «rifinita» con l'abito di una imprenditoriale italiano storica aziendale. Dior-Nel 2000 la Fratelli Rosetti ha aumentato le vendite dei 15%. E per alcuni prodotti sempre miglioe Pakerson è passata dai 24 miliardi di giro d'affari del '99 ai quasi 30 dell'anno scorso. G.L.

GIOIELLI Brillanti risultati

I gioielli non hanno paura delle crisi economiche. Che siano scricci degli Emirati o nuovi ricchi americani della new economy, a seconda dei periodi storici, ed economici, da qualche parte del mondo c'è sempre qualcuno che compra gioielli per esibirli o come bene rifugio.

L'importante è essere così bravi da produrre creazioni che sbaragliano i concorrenti, conquistando così a favore degli potenziali clienti. C'è da dire che in questo mestiere gli italiani vanno piuttosto forte, visto che nel 2000 le esportazioni del settore orafo-argentiero hanno raggiunto quota 11.500 miliardi di lire, superando i 2000 miliardi incassati l'italiano nel 1999.

[... testo continua ...]

LINGERIE Sensualità in attivo

Sottoveste che sembrano vestiti da sera, complicitini intime che non stignizzerebbero sulle spiagge più frequentate dal bel mondo. Da qualche stagione è tutto un fuorire di tanga, reggicalze, reggiseni a balconcino o push-up.

Resta che ad avere la meglio sui mercati internazionali sono sempre le aziende di fascia alta, poiché le altre subiscono la concorrenza, forte, dei produttori a bassa costi. Soprattutto nella maglieria intima. «Stiamo subendo la concorrenza dei paesi dell'Estremo Oriente», spiegano gli esperti di Sistema moda Italia, «Cina e India in primo di Europa dell'Est, in seconda battuta. Il che significa qualità magari inferiore, ma a prezzi decisamente più competitivi».

[... testo continua ...]

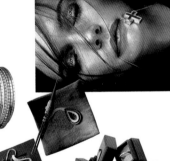

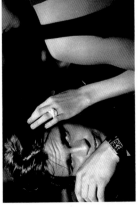

Designers
Ben Mangan
Robyn McDonald
Jason Grant

Design Company
Inkahoots

Country of Origin
Australia

Work Description
Front covers (right and below right) and spreads from *Culture Matters*, a quarterly magazine for the Queensland Community Arts Network

Dimensions
8¹/₄ x 11 in
210 x 280 mm

CM

Culture Matters Environmental Issue 02 2000 QUEENSLAND COMMUNITY ARTS NETWORK

CONTENTS Environmental Issue

02 Editorial • 03 News from the Network • **Articles** • 04 Place of Healing Karen Backus • 06 Art - Enviroment - Sex Steve Capelin • 09 Tree Dressing Tamara Playne • 12 On Common Ground Sue Clifford • 18 Part of the Change Leann Wilson • 21 Registering Water Reform Annie Bolitho • 26 In Tune Kim Polistina • 30 Women's Business Boni Robertson • 33 Waterworks - A Brave Dive Catherine Murphy • 38 How a Kingfisher Created a Splash! Kari • 42 Local Hero Mark Crocker • **Updates** • 44 The Botanical Book Project Gavin McCullagh • 46 Queensland - Keeping it Green Felicity Wishart • 48 **Obituary** For Dr Kumantjayi Perkins • 47 **Letter to The Editor** • 48 Network Resource Library

'Who said go

Registering Water Reform Annie Bolitho

20

21

CM

Culture Matters Magazine Issue 01 2000 QUEENSLAND COMMUNITY ARTS NETWORK

CONTENTS COMMUNITY DEVELOPMENT

2 Editorial • 3 News from the Network • **Articles** • 4 Dancer, Dance a Dance of Fire Trevor Jordan • 6 A Farewell to Dr Karen Tonny • 8 Discursive Struggles for the Future of Community Ann Ingamells • 12 In the Thick of It: A Conversation with Mary-Denese Holmes • 16 Community Art, Community Development - The Goal of Democratic Culture John Wiseman • 20 Changing Face of Community Culture Deborah Mills • 22 Keeping it in Context John Harvey • 25 Beyond the Cottage Garden Noal Price • 29 There We Were All in One Place, A Generation Lost In (Public) Space Hugh Watson • 31 A Few Damp Squibs of Subversion John Mongard • 38 Inside Looking Out Steve Capelin • 38 From Private Concern to Public Action Carmel Dawson • 42 Naming and Changing Our World Chris Pye • **Updates** • 44 Networking Arts and the Community Ngaere Blair & Emma Forley • 46 Whatever it Takes: Talking with Dulcie Cordrey Debra Bennet McLean • 48 Don't Stop Here Saren Starbridge • 50 Defiance: Political Theatre in Brisbane 1930-1962 - a review by by Richard Fotheringham • 52 Network Resource Library

On Common Ground Sue Clifford

At the beginning of September QCAN held an 'Environmeet, Local Communities, Public Art and Cultural Development' forum in conjunction with Brisbane City Council. One of our speakers was Sue Clifford from UK based group Common Ground who through model projects, exhibitions and publications link nature and culture, focus on the local and champion popular involvement and celebration as starting points for local action to improve the quality of everyday places. This is an edited version of Sue's presentation.

"It's a great pleasure to be here. I'm going to talk about a range of Common Ground's work. But first of all I should tell you a little about the organisation: we're very small, we have no members, we have no core funding, we struggle all the time with all those things that I think a lot of you will understand. The thing that burdens me all the time is where the money is going to come from to do the next project. However, it seems to have kept coming since 1983, when we first showed ourselves to the world. We are an environmental organisation and our focus has always been towards locality, towards the idea of place, towards that thing which we feel is ultimately important – the involvement of people in their own

'...we're trying to catch people who may never have come towards an environmental argument: what we do is celebrate, explore, make strange bridges, do odd things, always working with an aspiration towards quality.'

A granite boulder which had 'always' been there suddenly opens up. Granite Song, sculptor, Peter Randall-Page 1991. Along the Two Moors Way beside the River Teign, Devon. Photograpy Chris Chapman.

knowingness of place in West End, because it is also my long time home.

There is no place like home to fix the smells, colours and forms in your memory, particularly if you love that place.

For me, every single decision about what to do (and what not to do) in West End was difficult because of this knowing.

What colours are West End?

The community specifically asked for non gentrification colours. Ironically, the blue, black and orange have been appropriated by numerous cafes on the street.

We decided to spend the small budget on furniture, a new toilet and park and a reclaimed public space on the street (the lizard stage area).

We left the paving because we didn't want the place to look too new: dirt and age are part of the 'thinginess' of West End. I'm glad now that Brisbane City Council didn't maintain the furniture we designed very well: this adds to the durtification.

There are many other damp squibs in this story. For me, some crucial questions about the politics of public placemaking are:

Does the placemaking address the contemporary culture evident in the street?

Do the 'dwellers' who have few choices have a role and a place?

Will the placemaking be a catalyst for people to come together and be a community?

What social and political issues can be addressed within the realms of the project?

The Lizard, West End. Photo: John Mongard.

Broadway Street, West End. Photo: John Mongard.

Every space is a political space. Every artist or designer working in public space is a cultural worker, an 'agent' of community development. We are all involved in the same thing, which is placemaking – making the spaces where we dwell.

The governments, economies and global enterprises of the world generally want to control and unify public place to suit themselves, and this requires subversion! Favour localness and diversity, repel control and privatisation. Create places where there is a possibility for joy and laughter because therein lies the true poetry in placemaking.

INSIDE LOOKING OUT

INSIDE LOOKING OUT STEVE CAPELIN

Bear with me for a paragraph while I get a couple of definitional necessities off my chest and then I'd like to talk about the relationship between community cultural development and community development.

There is an ongoing debate about the relationship between community art and community cultural development. If there is a difference, and I think there may be, then it's about the intention and the developmental framework underlying the work in each case. One is project limited and primarily arts based, the other is longer term and with broader and more ambitious developmental goals (often with a community rather than an individual focus). Of course there are always hybrids which defy this simplistic definition. In my experience the very best community art invariably leads participants and communities along a developmental path.

I have deliberately left 'art' out of the definition of community cultural development as does the term itself. I am going to argue that this creates a fundamental problem which has lead practitioners to become confused about the work in which we're involved. And this confusion is directly related to the community cultural development /community development relationship.

While community art is clearly about artists making art alongside and in partnership with community members, community cultural development, sans the art, could foreseeably be about working with any community to support the development of a stronger sense of identity/control/capacity to respond positively to issues etc, using whatever processes and tools are appropriate. This is, by my definition, and using the term culture in its broadest sense, actually community development.

I would argue that art and art processes and the expressive vocabulary which art offers, are at the very core of community cultural development. This, fundamentally, is the key distinction between community cultural development and community development.

I think we've become confused about the meaning of the term 'culture' in the community cultural development context.

The word culture has more than one meaning. In the context of community cultural development I take it to mean the expression of culture through the transformation of the lived experience into another expressive form having a heightened meaning ie, theatre, dance etc. Culture, on the other hand can also mean 'everything which is lived as part of the experience of a particular group, community, nation'. Cricket is part of our culture for instance, and assisting a cricket club to offer better facilities for use by the community in an area deprived of facilities may be an important part of a community development strategy. I think, however, that it is best done by a sport and recreation officer or a community development officer or a local council or a neighbourhood centre, but it doesn't seem to be at the core of community cultural development. Cricket is an expression of culture but it does not transform

or interpret it, though it could very well become the topic or subject of an art work or an arts and cultural development project.

If we lose the expressive/transformative element in community cultural development work, it risks losing focus and becoming largely meaningless; the concept potentially covering any community work in any context providing it has some developmental outcome.

At some level I am suspicious of the whole concept of community development. It always sounds a little patronising as if we're the saviours and we can help the poor unfortunate community find their culture. My experience has always been one of the privileged guest sharing my skills to assist in finding new ways to give expression to an already existing community culture. You can't really develop culture, you can only express it, live it.

So my thesis would be that in our roles as (let's call ourselves) artists or arts officers (everyone understands those terms) we fulfil many functions. We often oscillate between different roles from hour to hour in our work. A skilled arts officer has the capacity to understand when to give advice from a community development perspective and when to focus on the arts paradigm. Often the two will coincide and sometimes one needs to have the wisdom to pass the task to someone with a better developed understanding of non arts based community development work or with specific experience in working with particular communities.

Now some artworkers would make the claim that after ten, fifteen, twenty years in the field they probably know as much about community development as most of our social work trained comrades and I don't doubt that. And sometimes there is little distinction between the work of the two. What I am suggesting is that if you want to work in community cultural development then you are choosing to work within an arts/cultural framework rather than in the absence of the arts/cultural component. At times the work may not be cultural development. And at times you might need to ask yourself whether someone else might not be better off doing a particular piece of work or acknowledging that at this point in time 'art' may not be first priority. You may find yourself quite appropriately working in community development mode.

In some sense you might argue that all community cultural development is community development but not all community development is cultural development.

I'd like to use a few examples of where the two areas meet, cross and define their differences by referring to my experience in working in a multidisciplinary community development team within the Brisbane City Council.

The CD teams are made up of five discipline areas covering arts, sport & recreation, health, parks planning and community development.

32

33

keep me.

mono

Studio 2, East Block, Panther House, 38 Mount Pleasant, London WC1X 0AP

T: +44 (0)20 7833 4084 **F:** +44 (0)20 7833 4084

E: staff@monosite.co.uk **www.monosite.co.uk**

Designer
Chris Kelly

Art Director
Chris Kelly

Design Company
Mono

Country of Origin
UK

Work Description
Cover (left) and spreads from *Keep me*, a self promotional book for Mono

Dimensions
13⁵/₈ x 9 in
350 x 230 mm

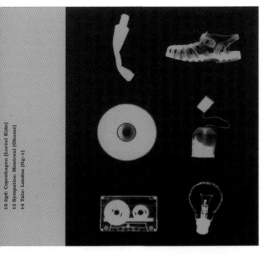

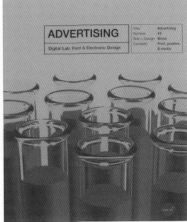

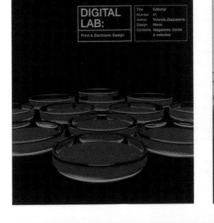

DIGITAL LAB: Print & Electronic Design

ADVERTISING Digital Lab: Print & Electronic Design

NG Solution

This End Up:
Original Approaches to Packaging Design

mono are a contemporary design practice producing a diverse range of work within publishing, fashion, music and new media

mono produce title sequences, printed matter, web sites, books, signage and typography

mono creates work which is bold, original and conceptual, addressing the specific requirements of our clients

mono work both directly for clients and in conjunction with other agencies on a broad range of projects

mono produce a wide variety of work, of which only some is contained within this, our first 'book of work'

to view further examples and to find out more about us please visit our website

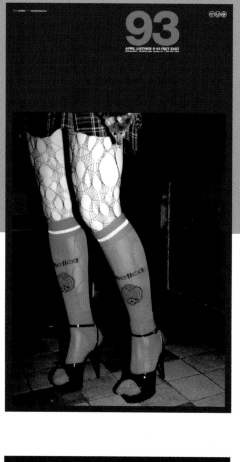

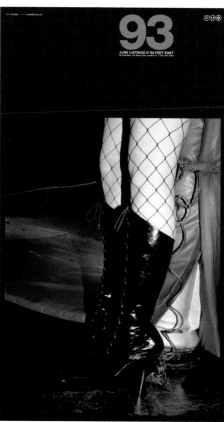

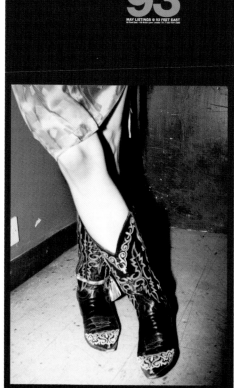

93

OCTOBER LISTINGS @ 93 FEET EAST
93 Feet East · 150 Brick Lane · London · E1 · T 0207 247 3293

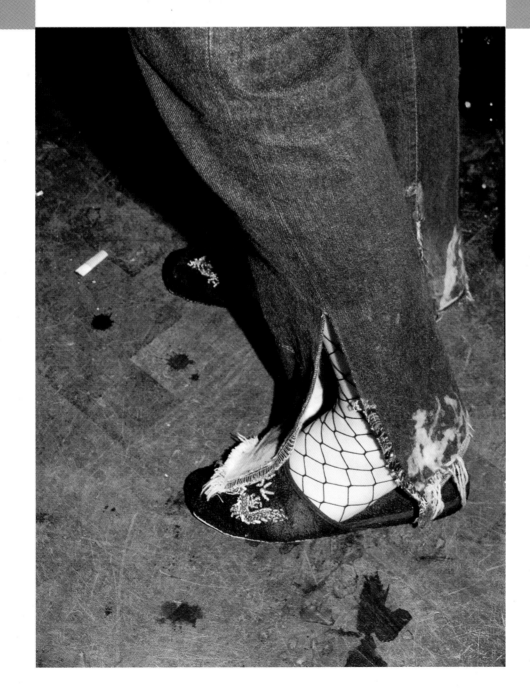

Designer
Paul Humphrey

Photographer
Matt Carey

Art Director
Paul Humphrey

Design Company
www.insect.co.uk

Country of Origin
UK

Work Description
Front covers from
93 Feet East
monthly club
programs

Dimensions
16³/₈ x 9³/₈ in
420 x 240 mm

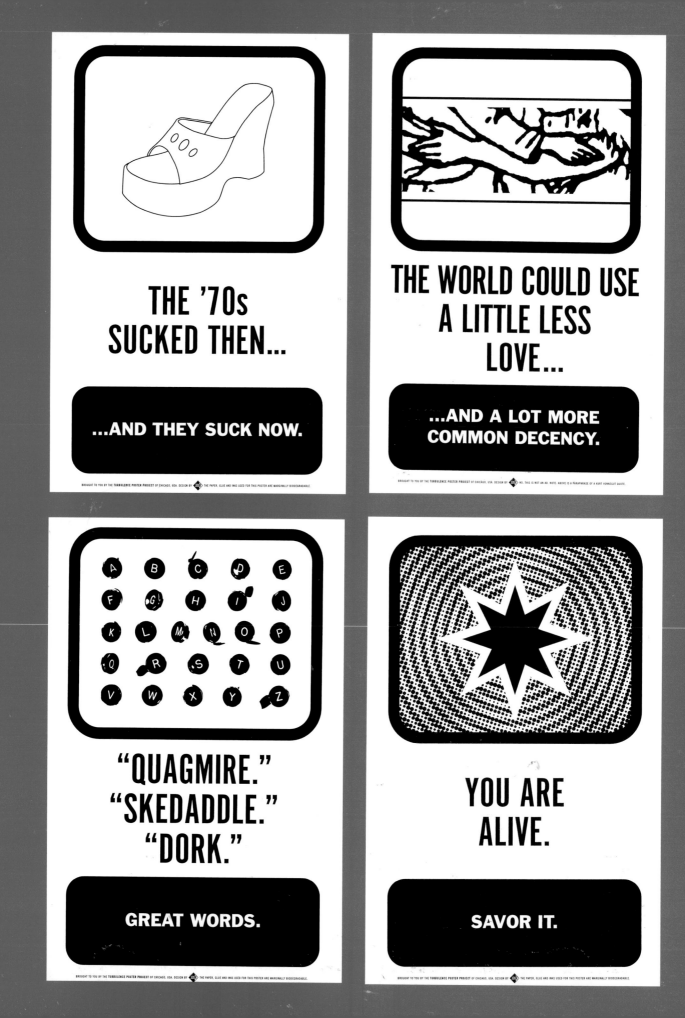

THE '70s
SUCKED THEN...

...AND THEY SUCK NOW.

THE WORLD COULD USE
A LITTLE LESS
LOVE...

...AND A LOT MORE
COMMON DECENCY.

"QUAGMIRE."
"SKEDADDLE."
"DORK."

GREAT WORDS.

YOU ARE
ALIVE.

SAVOR IT.

COMPASSION IS NOT WEAKNESS.

IT IS THE STRONGEST WEAPON AGAINST OUR OWN DESTRUCTION.

BROUGHT TO YOU BY THE **TURBULENCE POSTER PROJECT** OF CHICAGO, USA. DESIGN BY ⬥JONR⬥ THE PAPER, GLUE AND INKS USED FOR THIS POSTER ARE MARGINALLY BIODEGRADABLE.

Designer
John Resh

Art Director
John Resh

Design Company
Viper Press

Country of Origin
UK

Work Description
Series of posters
from the
*Turbulence Poster
Project*, Chicago

Dimensions
11 x 17 in
279 x 432 mm

Designers
Tnop
Anisa Suthayalai

Illustrators
Tnop
Anisa Suthayalai

Art Directors
Carlos Segura
Tnop

Design Company
Segura Inc.

Country of Origin
USA

Work Description
Logo (far bottom left) and posters from the *Twisted-7* concept campaign for Chicago's Q101 radio station

Dimensions
24 x 36 in
610 x 914 mm

Contemporary
Techniques
in Architecture

Ɐ WILEY-ACADEMY

D

Young
Blood

WILEY-ACADEMY

Stuart

Stuart Monro's work over the last two years
has developed a trajectory that deals not only
with architectural objects but also with their
attendant spacescape. His propositions are
always trade-offs between an object, its field
geometry and where it thinks it is going. Like
a fly in your living room, it is seldom allowed
to go where it wants.

Monro

New Realism in Film Architecture

Digital Fiction

The designer of a whole new generation of architectural film sets, Eric Hanson chronicles recent developments in computer-aided design in the cinema and suggests the important new role architects may take in 3-D film design. He shows examples of his work in creating large-scale digital environments for the simulation-ride film *Mars Odyssey* as well as on Luc Besson's *The Fifth Element* and Disney's new *Fantasia 2000*.

The Void that is Subject

Libeskind's Jewish Museum, Berlin

Designer
Christian Küsters

Art Director
Christian Küsters

Design Company
CHK Design

Country of Origin
UK

Work Description
Covers (far top left and far bottom left) and spreads from *AD Architectural Design* magazine

Dimensions
$8^1/_2$ x $11^1/_4$ in
220 x 290 mm

LO FIDELITY ALLSTARS

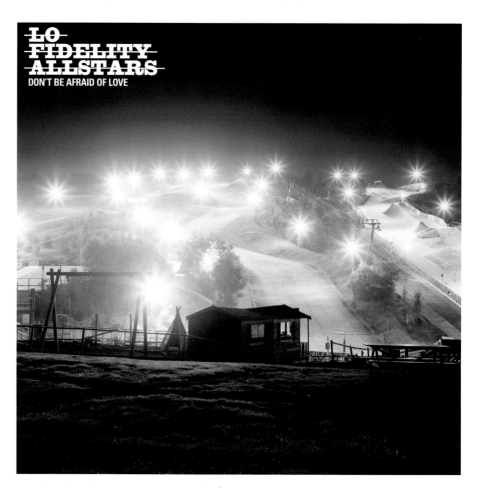

LO FIDELITY ALLSTARS
DON'T BE AFRAID OF LOVE

Designer
Peter Chadwick, Zip;
Initial research and
logo by Red

Photographer
Dan Holdsworth

Art Director
Peter Chadwick

Design Company
Zip design

Country of Origin
UK

Work Description
LP cover (opposite),
CD cover (above) and
CD booklet spreads
from the Lo Fidelity
Allstars campaign

Dimensions
Various

BRASSIC 22CD
WWW.LOFIDELITYALLSTARS.CO.UK
© SKINT RECORDS 2001. ℗ SKINT RECORDS 2001.
℗ SKINT RECORDS, PO BOX 174, BRIGHTON, BN1 4BA, UK. MAIL@SKINT.NET
WWW.SKINT.NET WWW.LOFIDELITYALLSTARS.COM
PHOTOGRAPHY BY DAN HOLDSWORTH. THANKS TO THE SHEFFIELD SKI CENTRE. LOGO AND
INITIAL RESEARCH BY RED DESIGN. DESIGN AND ART DIRECTION BY WWW.ZIPDESIGN.CO.UK

WHAT YOU WANT 01
DEEP ELLUM... HOLD ON [FEAT. JAMIE LIDELL] 02
LO FI'S IN IBIZA 03
SOMEBODY NEEDS YOU [FEAT. GREG DULLI] 04
DON'T BE AFRAID OF LOVE 05
FEEL WHAT I FEEL 06
ON THE PIER [FEAT. BOOTSY COLLINS] 07
JUST ENOUGH 08
TIED TO THE MAST 09
SLEEPING FASTER 10
DARK IS EASY 11

LO FIDELITY ALLSTARS
DON'T BE AFRAID OF LOVE

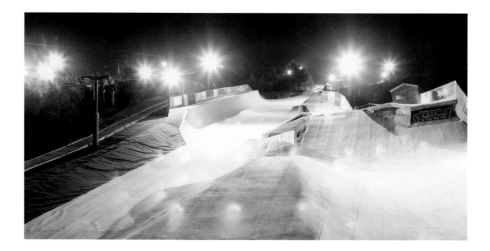

LO FIDELITY ALLSTARS
SLEEPING FASTER

THE NEW SINGLE. CD/12" RELEASED 21ST
JANUARY 2002 FEATURING ORIGINAL, LAID REMIX
& SLEEPING WITH BYRON (HOTBOX REMIX
FEATURING BYRON STINGILY) ENHANCED CD ALSO
CONTAINS VIDEO. TAKEN FROM THEIR 2ND LP
'DON'T BE AFRAID OF LOVE' OUT FEBRUARY 2002.

WWW.LOFIDELITYALLSTARS.CO.UK
WWW.SKINT.NET

ON TOUR IN JANUARY 2002
WED 16. MANCHESTER. ROCK BOX
THUR 17. NEWCASTLE. STONE LOVE @ STAGE 2
SAT 19. GLASGOW. QMU
SUN 20. EDINBURGH. LIQUID ROOM
MON 21. LEEDS. COCKPIT
TUES 22. COVENTRY. COLLOSSEUM
WED 23. BRIGHTON. CONCORDE II
FRI 25. LIVERPOOL. BUGGED OUT
THUR 31. LONDON. SCALA

Restart: New Systems in Graphic Design

Restart: New Systems in Graphic Design by Christian Küsters + Emily King. Imagery by Sølve Sundsbø.

Designer
Christian Küsters

Art Director
Christian Küsters

Design Company
CHK Design

Country of Origin
UK

Work Description
Poster promoting book launch and lecture for *Restart: New Systems in Graphic Design*

Dimensions
$16^3/_8$ x $23^1/_8$ in
420 x 594 mm

Christian Küsters and Emily King

With over 600 illustrations 176 pages. £16.95 Published by Thames & Hudson in October 2001.

set up a range of ad hoc systems.

Christian Küsters and Emily King co-authors of Restart: New Systems in Graphic Design, join designers

Anthony Burrill, Graphic Thought Facility, Scott King and Peter Saville to talk about contemporary

graphic design. In the chair is David Crowley, Senior Lecturer at the Royal College of Art.

Talk

Making Boundaries Tuesday 2nd October 6.45pm ICA Cinema 1

Phone 020 7930 3647 for bookings or further details.

The formal excess of late 1980s and early

1990s graphics led many designers to search for a sense of restraint. This has not proved

easy: how do you make sense of limitations when all boundaries have been

Thames & Hudson

INDEX

Added Attractions 20

Allemann Almquist & Jones 144

Almquist, Jan 144

Anderson, Peter 18

Anna B. Design 23–25

Another Magazine 62–65

Architecture California 56–59

Aufuldish & Warinner 56–59

Aufuldish, Bob 56–59

Bailey, Jonathan 80

Bailey, Stuart 158–161

Bare magazine 68–71

Bartlett, Brad 66

Bendeler, Guusje 146

Berkenbusch, Anna 23–25

Berliner Akzente 23–25

Biasatti, Daniel 70

Big Smoke Projects Ltd 80

Bilak, Peter 158–161

Billiards Digest 10

Blueprint magazine 18

Bowlers Journal 11

Buero NY 62

Burn 152–157

Büro Destruct 52

Busch, Kristoffer 118

Camerawork 28–31

Carslake, Scott 44–47

Chadwick, Peter 196

Cheuk, Deanne 120–123, 166–169

CHK Design 42, 194, 198

Ciavardone, Crystina 144

Cohen, Tamar 176

Crow, David 48–51

Cumbria Institute of the Arts 74

DankRealms 106–109

Davies, Luke 170

De Leo, Anthony 44–47

Deep Creative 172–175

D–Fuse 52–55

dotdotdot 158–161

Dotson, Tammy 94

Drohan, Paul 140–143, 146

Droit & Patrimoine 22

Ekhorn, Kjell 162–165

EkhornForss/Non-Format 162–165

envision+ 32–35

Époxy communications inc 92, 96–99, 110

Fehler 52–53

Fenwick, Richard 54–55

Fiscalini, Andrew 120–123

Fluid design 148

Fok, George 96–99

Forest of Signs 48

Forss, Jon 162–165

Fortin, Daniel 96–99

Foushee, Danielle 20, 66, 82–85

G, Mickey Boy 100–105

Gingras, Yohan 92, 110

Givens, John 28–31

Gleadow, Annie 68–71

Gleadow, Annie 70

Godfrey, Andrew 106–109

Grant, Jason 184

H55 (H Fifty Five) 36–41

Hand, David 152–157

Harry, Dirty 80

Hays, Shelly 146

Helling, Sebastian 118, 132, 150

Henschel, Antonia 76

Higson, Ness 90

Hitchen, Jonathan 48–51

Ho, Hanson 36–41

Hollis 140–143, 146

Hollis, Don 140–143

Horridge, Peter 22

Humphrey, Paul 170, 188

i–D magazine 134–137

Inkahoots 184

insect 170, 188

Interfield 18–19

Jacobsby, Ellen 150

John Brown Publishing 68–71

Jones, Terry 134–137

Kashiwagi, Nobi 62–63

Kelly, Chris 186

Küsters, Christian 42, 194, 198

Langley, Dean 134–137

Leeyavanich, Akarit 86–89

Lewis Interactive 90

Line magazine 14–17

Liverpool School of Art & Design 48–51

Mair, Daniel 118

Mangan, Ben 184

Martini, Alexandra 112

McDonald, Robyn 184

McKenzie, Nick 42

McLellan, Luke 110

Mediacell Ltd 100–105

Mildenberger, Esther 32–35

Miller, Danny 100–105

Mono 186

More, Gregory 42

Mytnik, Vadim 124

Na'el, Shahrokh 12

Nelki, Theo 178–183

NeoMu 120–123

Nistico, Sal 144

Oostra, Martijn 26

Patten, Cindy 94

Peter Horridge Designs 22

Phunk Studio 114–117

Pongkasem, Supreeya 56–59

Potter, Jerermy 80

Rankin 172–175

Raw–paw 52–55

Reed, Ranoy 90

Resh, John 10, 126–131, 190

Robinson, Rhiannon 74

Royal College of Art 118, 132, 150

Scene the magazine 44–47

Schek, Icatrin 23–25

Schwarz, Phillip 120–123

Segura Inc 60, 86–89, 192

Segura, Carlos 86

Shahrokh 1345 Ltd. 12

Shields, Alex 124

Sieu, Tom 28–31

SIGN Kommunikation 76–79

Singapore Architect 36–41

Slatoff + Cohen Partners Inc. 176

Slatoff, David 176

Stoltze Design 94

Stoltze, Clifford 94

Surtie, Lucas 120–123

Suthayalai, Anisa 192

Suwannatat, Permsak 86–89

Switzer, Brian 32–35

Technoculture 1 – Mnemosene 48–51

The Fashion Institute of Design & Merchandising 20, 82–85

themepark 32–35

Tnop 60–61, 86, 192

Tom & John: A design collaborative 28–31

Toussaint, Pierre 166–169

Towers, Daniel 74

Turnstyle Design 66–67

Van Grecken, Khan 106–109

Viper press 10, 126–131, 190

Voice 44–47

Wallpaper* 14–17

Ward, Sandy 74

Weik, Dave 86–89

Wende, Tina 23–25

Willey, Kirsten 70

Wilson, Sam 14–17

Wire 162–165

Wootton, Sarah 54

X–Tra 66

Yacono, Jean Christophe 92, 110

Zip design 196

FUTURE EDITIONS

If you would like to be included in the call for entries for the next edition of *Typographics* please send your name and address to:

Typographics
Duncan Baird Publishers
Sixth floor
Castle House
75–76 Wells Street
London W1T 3QH

or email roger@dbairdpub.co.uk